# Edith Wharton's
# LENOX

# Edith Wharton's
# LENOX

*Cornelia Brooke Gilder*

THE
History
PRESS

Published by The History Press
Charleston, SC
www.historypress.net

First published 2017

Manufactured in the United States

ISBN 9781467135177

Library of Congress Control Number: 2017931824

*To Louisa, Nannina and George*

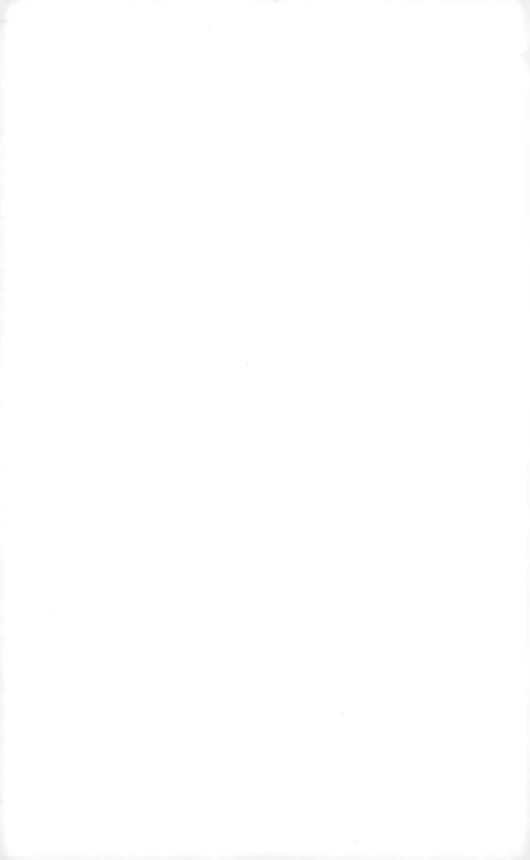

# Contents

# *Acknowledgements*

T his book evolved from a decade of conversations in the 1990s on Thursday mornings with my invalid mother, Louisa Ludlow Brooke, and her friend and retired librarian Julia Conklin Peters. They were both in their eighties and vividly remembered Lenox after Edith Wharton's departure in a way no research on the Internet or in archives could provide.

Since then, how can I name all those who have helped piece this story together? I often looked back at old notes of conversations with the late Scott Marshall of The Mount staff and wish he could see this book. Many provided a specific detail or image, and their names are buried in footnotes and photo credits. Others had their specialties. Any question about coaching or horses could be answered by Mary Stokes Waller; about fashion (important for dating photos), Sarah Goethe-Jones; about Newport, Paul Miller; and about Pau, David Blackburn. My daughter Louisa Gilder provided perceptive canine points, but that was only part of her incredible contributions linking Edith's writings to my narrative. Others added key perspectives in more general ways, like our old plumber Findlay MacLean; my mother-in-law, Anne Palmer; Susan Wissler; Anne Schuyler and Marjorie Cox at The Mount; John Brooke; Nina Ryan; Deborah Coy; Doug Bucher; Charlie Flint; Robbie Harold; Ned Perkins; Barry Cenower; Jennie and David Jadow; Julia Channing Bell; Christina Alsop; Kate Auspitz; Susan Lisk; Sophie Howard Palmer; Holly Ketron; Jean-Claude Lesage; and Steve O'Brien, Lenox police chief. The staff of the Local History Department at the Berkshire Athenaeum have

creatively solved many a strange genealogical or historical question that I brought to them in distress.

The quest for historic images is a huge component of a book like this. Of the hundred-some photos, one-third came from the wonderful scanned collection in the care of the unsung heroes of the Lenox Library, director Amy Lafave and librarian Christy Cordova. The rest of the images are from so many sources—often fragile, private albums, requiring a level of photography and scanning skills that I did not have. My calm and capable daughter Nannina Stearn came to the rescue. Lenox artist Bart Arnold has created the exquisite map evoking Edith Wharton's era in a way that surpasses any words.

Wharton scholars Alan Price and Irene Goldman-Price helped to shape and improve this work in so many ways. Other early readers of the manuscript—Tjasa Sprague, Richard S. Jackson Jr. and Cris Raymond— each made valuable corrections and suggestions. Tabitha Dulla, Karmen Cook and now the unruffled Chad Rhoad of The History Press staff each nudged this project along over the last two years. Thank you all!

Finally, thanks to George Gilder, my writer-husband, who sets high standards for us all and provides generous and loyal support to all we do. Four of his great-grandparents—Richard Watson Gilder, Helena deKay Gilder and Adèle and Robert Chapin—enliven the pages of *Edith Wharton's Lenox*.

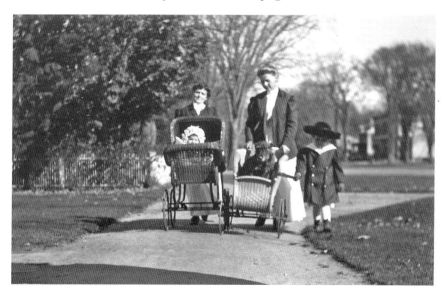

The author's mother, Louisa Ludlow, surveys Main Street from her pram. Her older brother, Richard, has relinquished his carriage to the family Scottie. Fall 1910. *James B. Ludlow.*

# Introduction

In tackling her long and complicated life, Edith Wharton's biographers have often glossed over her connections to the Lenox community, where she and Teddy settled in 1900. The biographers have the perfect excuse: the brilliant writer preferred to import her own company. This idea is followed by the assertion that the Lenox social circle was not worthy of her.

By the early 1900s, Lenox was a well-established resort with an intellectual history. A graceful New England village in the hills of western Massachusetts, it was neither a mill town nor a market town but a former county seat with noble colonial architecture and tree-lined streets frequented fifty years earlier by the shy Nathaniel Hawthorne working out the plot of *The House of the Seven Gables*.[1] Since then, the resort had grown and attracted urbane and cultivated families—mainly New Yorkers and Bostonians—with leisurely pursuits ranging from collecting rare books or Belgian lace to breeding Jersey cattle or Japanese spaniels.

Edith Wharton would not be the first talented woman writer in Lenox. From the 1820s on, novelist Catharine Sedgwick (1789–1867) was the center of a salon and a revered local icon. Her celebrity friend Fanny Kemble (1809–1893), a Shakespearean actress by financial necessity but an author and poet by inclination, frequented Lenox through the 1870s. Well acquainted with British and American country life, Fanny Kemble particularly enjoyed the Lenox atmosphere, where "we ride, drive, walk, run, scramble and saunter and amuse ourselves extremely."[2] As Fanny faded from Lenox, Constance Cary Harrison (1843–1920) arrived. She was a southern belle who enchanted Lenox in the later 1870s, '80s and '90s with a stream of novels

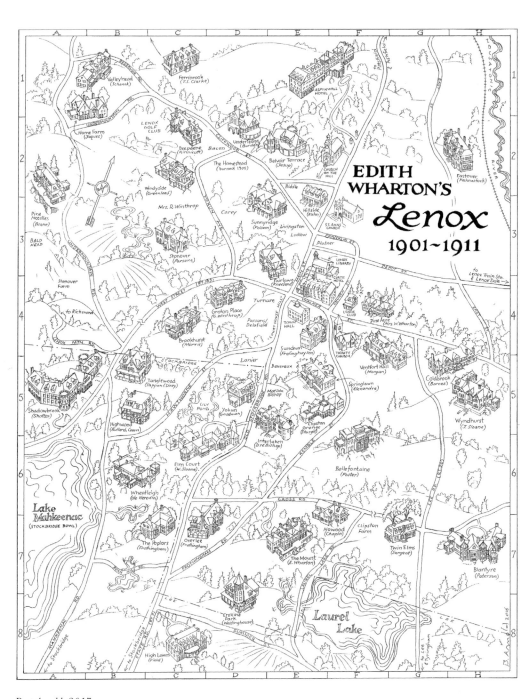

Bart Arnold, 2017.

(often set in Lenox) and plays (often translated and adapted by her from French). Harrison produced these plays in the summertime on the Sedgwick Hall stage at the Lenox Library, mixing local talent with professionals before taking them to the Madison Theater in New York City.

Retired from the pulpit of Lenox's Church on the Hill, Reverend DeWitt Mallary summed up this literary legacy in his 1902 book *Lenox and the Berkshire Highlands.* He made the then-bold, now-comical, suggestion that the recently arrived Edith Wharton, also "distinguished in letters," might surpass the memory of the prolific Mrs. Burton Harrison.[3]

The Lenox social set already knew the sporting, well-dressed, amiable Teddy Wharton, who had spent some twenty summers there since his teenage years. But Teddy's "clever," sophisticated, younger wife—still an obscure short story writer and architectural critic—was an enigma, certainly not the conventional Mrs. Edward Wharton they might have expected.

Buoyed by the bracing climate and less-pompous social atmosphere, Edith welcomed Lenox after Newport. She immediately entered into local social occasions. (She preferred small lunches and teas to big gatherings.)

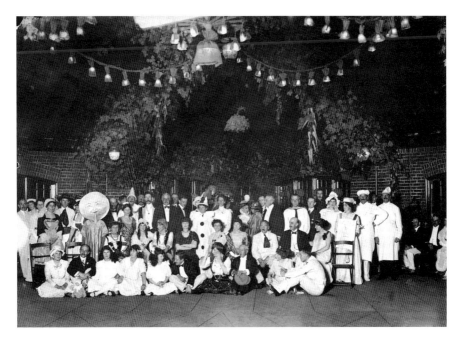

Dressed as milkmaids, clowns, sailors, suffragettes, gypsies and devils, Lenox cottage families, including Sloanes, Fosters, Folsoms, Parsons, Frothinghams, Shotters, Turnures and Alexandres, pose at an autumnal costume party in the garage at High Lawn. Kate Cary came as the moon, circa 1910. *Lenox Library Association.*

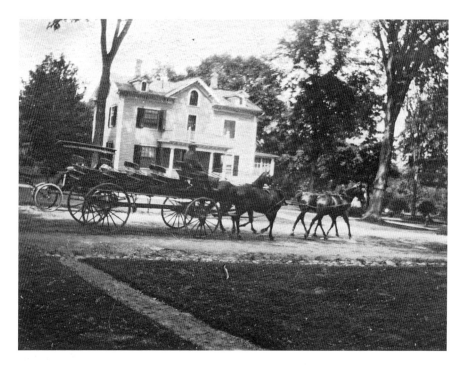

An open livery carriage or "charabanc" passes Sunnyholme on Lenox's Main Street where Edith Wharton's first cousin, once removed, Byam Stevens (1836–1911) and his wife, Eliza, lived. *Channing collection.*

She competed in flower shows and brought her vision to local institutions, especially the Lenox Library (walking up the same worn marble steps we use today) and the French Reading Room in Lenox Dale. She would find herself in the midst of the inevitable mix of kindred spirits, imperious grande dames, delightful eccentrics and inescapable "bores"—all wonderful fodder for a fiction writer.

Edith and Teddy both had relatives in Lenox. Teddy was devoted to his mother and sister, who lived at Pine Acre, which still stands on Walker Street (enlarged as condominiums and known as The Gables). Edith was less family oriented. She seems to have ignored her numerous Lenox relatives—the Schermerhorns, the Byam Stevenses and the Newbold Morrises.[4] She was, however, upset in September 1904 when a favorite uncle, Frederick Rhinelander, with whom she shared aesthetic sensibilities, had a sudden fatal heart attack while staying at the Red Lion Inn in Stockbridge.[5]

Edith Wharton's Lenox decade would be filled with architectural and professional triumphs in the joyful achievement of The Mount in 1902 and

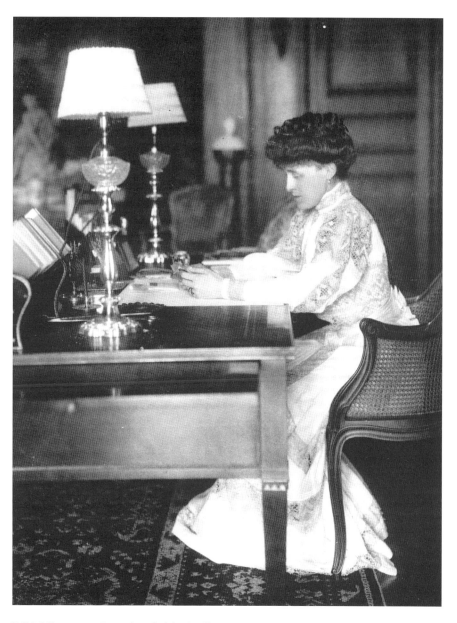

Edith Wharton posing at her desk in the library at The Mount, 1905. *Beinecke Rare Book and Manuscript Library, Yale University.*

the exhilarating success of her first "big" novel, *The House of Mirth*, in 1905. The time in Lenox also saw the most painful emotional period of her life, as her aging husband Teddy's mental illness progressed, and her heart was captured by an unworthy fellow writer in Paris: Morton Fullerton.

This book puts Edith Wharton's decade in a new perspective. Characters, episodes and plots in some of Wharton's best-known works, *The House of Mirth* and *Ethan Frome*, as well as the still-relevant and underappreciated *The Fruit of the Tree* and *Summer*, evolved from her observations during this fertile Lenox decade. The established and sophisticated social local community included two of her editors and many fellow intellectuals, horticulturists, bibliophiles and animal lovers.

Most important of all was the presence of her wise doctor, Francis P. Kinnicutt, ready to advise on the fictional medical problems of Lily Bart and the very real ones of her husband, Teddy Wharton.

# French Periodicals and Fine Points of Punctuation and Perennials

From his parents' house, Coldbrook (now part of Cranwell Resort), on a neighboring Lenox hilltop, journalist and editor James Barnes (1866–1936) provides the modern reader with an eyewitness account of Edith Wharton as she joined the Lenox social scene. Barnes reminisced years later:

> Mrs. Edward Wharton lived at Lenox and we had become very good friends. She had not as yet burst on the public as a great novelist and perhaps the greatest stylist among women writers of the English language: but she was socially charming and had already begun to yearn for self-expression…..No one suspected the power that was behind that well-formed forehead or the strength and scope of visualization that was to be translated into the written words by those slender—almost fragile—fingers.

Jim Barnes was observing Edith Wharton at short range, a mile from the newly constructed Mount. His parents had built Coldbrook, a rambling

Charlotte Barnes (*far right*) with her mother, Susan, and sisters, Cornelia and Edith, at Coldbrook, circa 1912. Edwin Hale Lincoln, photographer. *Mary Barnes Crowther.*

shingled house, in several stages in the 1880s. The architects, Peabody and Stearns, decorated the façade with anchors and sea serpents in honor of the imperious father of the household, John S. Barnes, a Civil War navy captain. James had four surviving siblings: Sanford, Edith, Charlotte and Cornelia. All the Barneses were athletic and had known Teddy Wharton since childhood. They were fiercely competitive at the Lenox Horse Shows and gymkhanas and in local golf tournaments and tennis matches at the Lenox Club, where their father presided. The Lenox Club was a favorite haunt of Teddy Wharton. The club books record his signing in various Mount guests, including international lawyer Walter Van Rensselaer Berry, to play tennis. These books also enumerate Teddy's caddie charges for numerous golf rounds.

Sixteen years younger than Teddy, Jim Barnes wrote of Teddy and his elder brother William with awe as "two of the best looking men that Boston high circles could boast of." He remembered, "William was dark, Edward was fair. They were exquisite in manner, tone, and appearance. When

the fashion of wearing long Dundrury whiskers departed, they were still better looking. Edward Wharton appreciated good taste and his gifted wife provided it in every form."[6] The Whartons' Lenox creation, The Mount, according to Barnes, was "perfection, not only in its planning and interior decorating, but also in its surrounding gardens." At Coldbrook, the Barneses adopted Edith's classical precepts when they endowed their garden with an elegant Palladian pavilion.

One of Jim's sisters, Charlotte, was a serious gardener, and in Edith Wharton she found a kindred spirit. Their rapt dialogues were recalled by Edith's literary houseguest Daniel Berkeley Updike as "interminable, and to me rather boring, conversations on the relative merits of various English seedsmen and the precise shades of blue or red or yellow flowers that they could guarantee their customers."[7]

Aside from gardening with Edith and golfing with Teddy, there were other common endeavors between the Coldbrook and Mount households. Edith served on the Lenox Educational Society—a mysteriously ephemeral institution—with Captain Barnes, and she enthusiastically joined Cornelia and Charlotte Barnes in supporting the forty-year-old French Reading Room in Lenox Dale.[8] This establishment, distinct from a larger English language library and reading room in the "Dale," was oriented toward the French-speaking residents, many from Brittany, who came to work on Lenox estates or in the iron or glass industries in Lenox Dale. Ever generous with books and French periodicals, such as *Le Petit Journal*, Edith also contributed toward the expenses of maintaining the room and collaborated with Cornelia and Charlotte Barnes and other fluent French-speaking cottagers on lectures

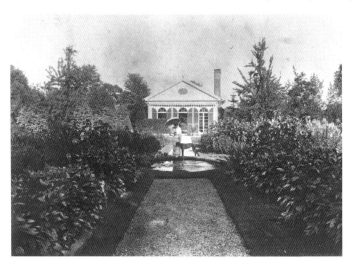

In the Coldbrook garden with its new pavilion, Charlotte Barnes leans to pat her greyhound Creed with an eye on her two white poodles, circa 1912. Edwin Hale Lincoln, photographer. *Mary Barnes Crowther*.

and programs.[9] The library was initiated in 1868 by an earlier celebrated Lenox francophone, Annie Haggerty Shaw, a few years after the death of her husband, Civil War hero Robert Gould Shaw.[10]

Coming up to Lenox from his editorial job at Appleton and Company in New York, James Barnes prized the opportunity to converse with Edith about writing. "She was a good listener—in my case, a very patient one." Just at the time of the publication of *The House of Mirth* in 1905, he was seeking material for the company's short-lived literary monthly, *Booklovers' Magazine*.

*Presuming on my friendship, I had asked her for a story. When it arrived I read it with a high pulse and sent it to the composing room, forwarding the galley proofs to her as soon as they had been returned to my desk. Here is the letter that she wrote me and it shines like a star.*

*Dec 8th [1905][11]*
*The Mount*
*Lenox, Mass*

*Dear Mr. Barnes,*

*I have sent the corrected galley of* In Trust *back today, but your printers and proof-reader combined have wrought such havoc with my punctuation that I shall have to ask you to let me see the revised proofs. Every colon has been swept away and replaced with a comma, hyphenated words have been run together, or quite separated, and in short, everything has been done that could be done to unpunctuate my poor story…and while my pen is in the ink, may I breathe one word of protest about the spelling of the galleys? I am resigned to color and such (though how much more historic colour goes with that* u*) but dear Mr. Barnes—*traveler *[traveller],* center *[centre],* clew *[clue]!…[O]h, please, good kind editor, give me back…my* ue*!*
*Yours (I don't know how to spell my own name in the new way!)*

*Edith Wharton[12]*

The situation was rectified, and not long after, Edith renegotiated her exclusive contract with Scribner's and began publishing with Jim Barnes's Appleton and Company. Appleton produced eight of her late novels, including *The Age of Innocence*.

## 2

# *The Whartons Before Edith*

E dith Wharton's biographers have depicted Edward "Teddy" Robbins Wharton (1850–1928) as a provincial Bostonian,[13] but in fact, much of his boyhood, like Edith's, was spent in European hotels and villas.[14] In the late 1850s, his parents went through an anti-American phase, on par with Edith Wharton's later ones.

In 1859, when Ted, as he was known to his family, was nine, a Brookline neighbor, Elizabeth Cabot, wrote about his parents, Nancy and William Wharton:

> *The Whartons have almost driven their friends distracted by their undisguised disgust at their own country, and their open hesitation whether they should not return to Paris this autumn and leave America permanently....I have ceased to desire that anyone, even so nice a person as Nancy Wharton, should live here unless they want to; this talk about the superiority of European climate, education, clothes, food, and morals would make one think it was the inner gate of Heaven.*[15]

Such an upbringing indicates that at the time of their marriage, Edith and Teddy shared far more common ground than Edith's biographers depict.

The travels abroad began when Ted was seven. He was the youngest of the extended family group of five adults and four children, all of whom were living around Jamaica Pond in then-rural outskirts of Boston. The chief organizer appears to have been his uncle Edward Newton Perkins.

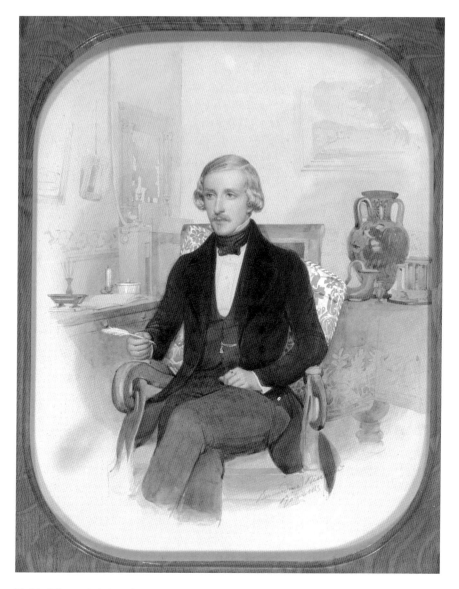

Teddy Wharton's beloved uncle, surrogate father and role model, Edward N. Perkins, painted surrounded by antiquities in Rome in 1845 by Riccardi. *Boston Athenæum.*

Clearly, Ted's own father, William Craig Wharton (1811–1891), was already suffering from mental instability, guided at times by what Edward Perkins would describe as "an evil star."[16] Ted's mother, Nancy Spring Wharton (1820–1909), and Edward Perkins's wife, Mary, were

sisters. The wealthier, childless Perkinses were always attentive to "poor Nancy" and her children. The other forceful adult in the group was Sarah Perkins Cleveland, Edward Perkins's widowed sister. Sarah Cleveland was a prodigious correspondent with Fanny Kemble, Charles Eliot Norton and his sisters and a host of intellectuals of the day. Her daughter Eliza "Lilly" was eighteen, the eldest of the children on this family trip. Ted's sister Nannie was twelve and William ten. Seven-year-old Ted was still sometimes called "Tiny" by the family.

In the summer of 1857, there were happy times in England, with the Wharton children riding donkeys in Herefordshire and a long visit on the Isle of Wight with school headmistress and author Elizabeth Sewell.[17] Then they crossed the Channel, and there were anxious weeks in the Westminster Hotel in Paris when Ted nearly died of typhoid fever. Lilly Cleveland was keeping a travel diary at the time:

*November 15, 1857:* [W]*e are rejoicing among ourselves, that dear Tiny has passed safely through a dangerous illness & is now convalescing. A week ago last Friday he was* very, very *ill: there were three doctors in consultation, but now Deo Gratias, the dear little fellow is beginning to be like himself. He is very weak & will be in his bed for some time longer....He has been very lovely, through his illness. I think you know how remarkably he has always loved his mother. The other day when his mother was at dinner, he wanted her for something, but finding she was busy, he said "oh don't* hully *her."*[18]

The Whartons had numerous well-placed relatives abroad, and these would yield important connections for Edith Wharton in later years. In the 1860s, one of Ted's uncles, Charles Callahan Perkins, settled with his young family in Italy at Villa Capponi, a fortified stone farmhouse on a hillside with a walled *giardino segreto* overlooking the rooftops of Florence. Here Perkins became an expert on Ghiberti and wrote and illustrated two books on Italian Renaissance sculpture.[19] In later years, while researching *Italian Villas and Their Gardens*, Edith and Teddy would revisit Villa Capponi.

Nancy's cousin Elizabeth Willing Ridgway was a grande dame of the "smart set" of Americans in Paris.[20] Her children, Henri and Emily, became immersed in French society. In 1893, Henri sent French novelist Paul Bourget to Newport with a letter of introduction to Teddy and Edith, thus beginning one of Edith's most important early intellectual friendships and a lifelong one.[21] Emily Ridgway married the Marquis de Ganay and reigned over

the grand Château de Courance south of Paris, a place reminiscent of the château in Edith Wharton's *The Reef* in which a young American woman, Anna Leath, lives trapped in a rigid code of French aristocratic expectations.

A bevy of Wharton relatives were part of the Anglo-American community in the French Pyrenees resort of Pau.[22] Beginning in the 1850s, Pau was a destination for Teddy's family in their European travels. Henri Ridgway became the master of foxhounds there, and other Willing and Lawrence relatives came for golf, tennis and polo in the winter. By 1907, when Edith and Teddy arrived on a "motor-flight," it was likely that they had visited Henri Ridgway's imposing new classical villa on the Avenue des Lilas.

If the Civil War had not intervened, Nancy and William Wharton might have moved to Europe, but around 1862, they bought a newly constructed Boston townhouse, 127 Beacon Street, a block from the Boston Public Garden, and seem to have settled on American life and schooling for their growing children. In 1869, they sold their farm in Brookline, which must have increased tremendously in value, as the streetcars made the once-rural Brookline easily accessible for Boston commuters.[23]

Teddy's close relationship with his mother developed over the years. After his brother William went into professional life as a lawyer and married in 1877, her less high-powered second son, Ted, became her male companion and source of emotional support. Always one for endearing nicknames, he called his mother "Duck" (and Edith became "Puss"). He was, as Edith would later discover, a cheerful travel companion. In 1874, after his undistinguished career at Harvard, Ted made a long European trip with his family.

On returning to a particular garden with Edith thirteen years later, Teddy reminisced in his breezy style to his elderly "Avunculus" Edward Perkins:

> *I have been thinking of you and dear Aunty…poor Puss down with a cold… so I had lots of time in the two days to walk over the queer old place.…I longed to get out and dig for Roman bones, but restrained myself.…The old garden at Certosa was as peaceful and lovely as I remembered it in '74, when Duck was so alarmed by an awful looking old rake of a monk who showed us over it.*[24]

Around the time of Ted's post-Harvard trip abroad, the Whartons, still based at 127 Beacon Street in the winter, began to look to the Berkshires for their American summers. Mrs. Wharton was related to one of the most distinguished founding Berkshire families, the Bidwells, in Stockbridge,[25] but it was Mr. Wharton's niece, Nancy Wadsworth Rogers, who seems to have

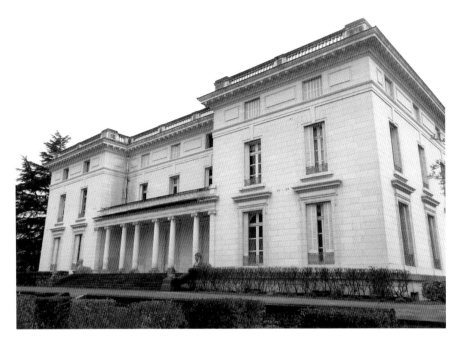

Villa Ridgway in Pau, built in the early 1900s by Teddy Wharton's French cousin, Henri Ridgway, on designs by architect Joseph Larregain. *David Blackburn.*

encouraged them to Lenox.[26] Her husband, Captain M. Edward Rogers, an enthusiastic clubman of Philadelphia, was deeply involved in the summer life of Lenox. Captain Rogers led local leisured and professional men to expand their little reading club located over a store to a full-scale male institution. As president of the Lenox Club, Rogers began a building drive to construct a clubhouse on Walker Street in 1876.[27] The club was built, and they were constructing a bowling alley in 1878 when William C. Wharton became a season member and his son Ted became a regular club habitué.

At first, the Whartons stayed at the Curtis Hotel, but they soon began to rent village houses in Lenox. Their favorite was the Platner cottage on Main Street, where they lived for over a decade.[28] In 1886, the local paper commented approvingly, "The old colonial pale yellow and white which Mrs. Wharton has painted the Platner cottage produces a very pleasant effect on Main Street."[29] In 1890, the *Valley Gleaner* noted, "Mrs. Wharton and daughter from Boston are here looking after the Platner cottage which they are to occupy as usual this season."[30]

The porch of Nancy Wharton's rented house, the Platner cottage, was a perfect vantage point on Main Street for the Tub Parade, circa 1893. *From* Picturesque Berkshire.

McLean's Hospital in Somerville, where William C. Wharton, Teddy's father, spent the last nine years of his life and died in 1891. *From* Early Years of the McLean Hospital.

But where was Mr. Wharton? After years of keeping up appearances, it became clear in the early 1880s that something was seriously wrong. In April 1882, his brother-in-law Edward Perkins described the situation to a friend:

> *Mr. Wharton's increased melancholy* [has] *became such as to render his leaving home necessary. He went to the McLean Asylum voluntarily three weeks since. Of course this has been a great trial as well as a relief to his family, my sister Nancy and Nannie and the sons have felt it keenly.*[31]

According to Sarah Perkins Cleveland, the summers in Lenox were a respite for Nancy Wharton. But back in Boston, she and her adult children shared "the same awful burden of poor Wharton who never leaves his bed & whom they visit twice a week."[32] The asylum was on the Charlestown waterfront in Somerville, two miles from their Beacon Street house.

This was the Wharton family situation that Edith Jones entered when she accepted Ted's proposal in January 1885. Later in life, she sadly remembered the doctors assuring her that her father-in-law's manic depression was not hereditary.[33] At that time, the word *gene* was not in medical vocabulary. Scientists in 1883 were actually cutting off the tails of mice to see if in a few generations they might produce tailless offspring. Breeding horses for speed and dogs for beauty and temperament had long been practiced, but a well-bred gentleman had something to do with his code of honor, the cut of his jacket or the tone of his voice. By 1905, when Teddy's symptoms had become fully apparent, the term *genetics* first came into professional use.

# 3

# *The Whartons and Edith Newbold Jones*

"Teddy was like sunshine in the house," one of Edith Wharton's oldest friends later remembered.[34] She was looking back to the 1880s when Edith and Teddy were engaged. The marriage delighted Edith's mother, Mrs. Jones, at the picturesque, half-timbered Pencraig, in Newport. Edith's beloved brother Harry had helped bring the couple together, and he and his mother would cheerfully join the newlyweds on their wedding trip to Paris. But how was the news received at 127 Beacon Street, the stern brownstone Boston home of Teddy's mother?

Although Nancy Spring Wharton's own letters from this era are lost, umbrageous doubts reverberated among her friends—the so-called Beacon Street Aristocracy. From a desk overlooking Jamaica Pond, Teddy's "favorite aunt" and family matriarch, Sarah Perkins Cleveland, wrote Grace Norton at Shady Hill in Cambridge, "You will have heard of Ted Wharton's engagement to Miss E. Jones of New York. He will be a tremendous loss out of his house."[35]

"The Nortons and Whartons were of that same Boston group, very small in earlier years, which grew up in friendly intimacy," as Elizabeth Norton later explained to Edith's first biographer, Percy Lubbock. "But Teddy's New York wife came from a more or less alien society to these somewhat rigid and austere New Englanders.[36]

In time, the deeply intellectual Nortons would embrace Edith more than the Wharton family. Sara Norton, Elizabeth's sister, would find common ground with Edith in books and ideas, and their father, Professor

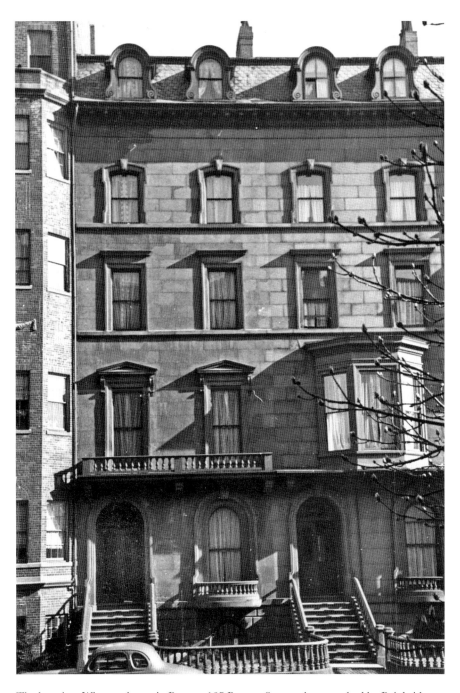

The longtime Wharton home in Boston, 127 Beacon Street, photographed by Bainbridge Bunting in the 1940s. *Boston Athenæum*.

Charles Eliot Norton of Harvard, would delight in her brilliant mind and creative genius. But initially both the Nortons and the Whartons associated Edith with the "fast-changing" Newport of conspicuous wealth. These Boston families remembered fondly the "old" Newport, but the Nortons now retreated in the summer to a quiet farmhouse in Ashfield and the Whartons to a modest village house in Lenox. Though shy and still lacking confidence, the newly engaged Edith was in Elizabeth Norton's words "outwardly worldly." She was stylish and had expensive tastes. It looked, at first, as if the gentlemanly, generous, playful and loyal Teddy would fit better in her world than she in his.

How would the married Ted be a loss to his mother? His lawyer brother William F. Wharton was serving in the Massachusetts House of Representatives and clearly a success in the world. By today's standards, the thirty-five-year-old unemployed Teddy seems aimless and anachronistic—a gentleman on an allowance. He was, however, the strong shoulder on which his mother was leaning in the midst of a family crisis. Since a winter day skating on Jamaica Pond in the mid-1870s when he rescued two younger Perkins cousins from death in the icy waters, he had the reputation of the strong, athletic hero of the family.[37]

Ted was not only his mother's companion and champion, he also adored her. A year before his marriage, he wrote in a jocular letter to his aunt Sarah Cleveland, after a morning of helping his mother with the springtime ritual of covering upholstered furniture with light slipcovers, "Without prejudice she is the most attractive person I know, apart entirely from the fact of her being my mother."[38]

"Nancy has severe trials one upon another & Ted is an unspeakable loss in their lives," Sarah Perkins Cleveland repeatedly wrote Grace Norton a few months after the wedding.[39] Her brother Edward Perkins continued to chronicle William Wharton's decline at McLean's in Somerville: "Little or no change in poor Wharton. His mind and body are really deteriorating." Perkins then grimly predicted, "He will never leave Somerville until in good time he is carried forth to Forest Hills [the Wharton family plot in the gracious cemetery in Jamaica Plain]."[40]

The ill-starred Mr. Wharton finally died on May 22, 1891. His death certificate states "melancholia" as the cause of death, but architect and close friend Ogden Codman later indicated that the eighty-year-old committed suicide. The hospital records are sealed.

Amidst spring blossoms and newly green trees, the Whartons gathered for Mr. Wharton's private burial at Forest Hills Cemetery in Jamaica Plain.

On a sloping greensward along Asphodel Path near his grave were stones remembering beloved family members: Nancy's sister Mary Perkins, whose slow demise they watched in 1882, and Charles Callahan Perkins, who died so suddenly in a carriage accident in Windsor, Vermont, in 1886. William Wharton's grave was beside his daughter-in-law Fanny Pickman Wharton, the first wife of his elder son Willy. She was only twenty-three when she died just months after giving birth to their son in 1880. This adored little boy was now eleven years old and on the verge of entering Groton School.[41]

There are no newspaper accounts of William Wharton's funeral or burial on that May day in 1891, but presumably, his widow was accompanied by her daughter Nannie and both sons, Teddy and Willy. Was Edith there? It seems likely, although she never mentioned it. Also probably among the mourners was the new "Mrs. Willy," Susan Carberry Lay.

After a decade of mourning Fanny, Willy had found a new and much younger mate in Washington, D.C., and they were married four months before his father's death. Forty-four-year-old Willy Wharton was at the peak of his political career, serving as assistant secretary of state under James G. Blaine in the Harrison administration. Twenty-five-year-old Susan Lay Wharton, with her uncomplicated, patient nature, assimilated easily into the Wharton fold.[42]

"He that overcometh, will inherit all things," Nancy Wharton inscribed her husband's gravestone with a hopeful biblical verse from Revelations. In these years, Edith was impressed by her mother-in-law's positive outlook despite obvious sorrows. "She is a most soothing person & always restores one's failing faith in the happy side of life," Edith wrote her governess-turned-secretary, Anna Bahlman.[43] That spring of 1896, Edith was in Europe and was trying to mastermind congenial company in Lenox for Bahlman. She urged her to look up Mrs. and Miss Wharton now settled in their own house, Pine Acre, on Walker Street:

> *Their house is nearly opposite the church, in a very central position, so that you will have no difficulty finding them, & I know they will be very gratified by your looking them up. I need not tell you how cordial & friendly they both are & how much they enjoy being dropped in on & showing their pretty house & garden to any of our friends.*[44]

Independently wealthy, after her husband's death, Mrs. Wharton purchased her own Lenox house, Pine Acre, in 1892. It was a family transaction. The spindled Victorian cottage, next door to the Lenox

A woman in black, possibly Nancy Wharton, perches on the porch steps of Pine Acre on Walker Street, 1899. *Jay Album, courtesy of William Patten.*

Club, had been built recently by her widowed niece, Nancy Wadsworth Rogers. The cozy, cluttered Pine Acre was the embodiment of everything Edith Wharton and Ogden Codman scorned in *The Decoration of Houses* (1897). Designed by a utilitarian Pittsfield architect, Charles Rathbun, Pine Acre had no architectural pretensions but was convenient and more commodious than the Platner cottage for entertaining guests—among them, Cora Crowninshield, the John Kanes, Annie Robbins and Reverend Leighton Parks, the clergyman of Emmanuel Episcopal Church, Nancy's Boston church.

Frequently, the Jamaica Plain cousins, the Perkinses, would stay in Lenox while en route to Albany, New York, where their notable half brother, William Croswell Doane, was now the Episcopal bishop. Doane's ambitious Gothic cathedral was beginning to take shape on Swan Street not far from his residence on Elk facing the New York State Capitol. The principal benefactor of the cathedral was J.P. Morgan, and Doane's fundraising skills were legendary. (In Albany, they used to joke that when a little boy swallowed a coin, he told his distressed mother, "Call Bishop Doane, he can get money out of anyone.") The towering Bishop Doane and his Saint Bernard dog,

Cluny, sometimes came to Pine Acre, but the fussy Victorian house was not Edith's first choice of a place to visit in Lenox. In October 1896, she was planning to stay with Adele Kneeland at Fairlawn. More of a kindred spirit, Kneeland had recently added a grand new reception room designed by Ogden Codman.

As time went on, the lack of common ground between Edith and her old-fashioned mother-in-law was increasingly evident. Their differences were on a spectrum of values from the lofty to the trivial, what Edith described as a "triple display of window-lingerie." Years later she reminisced, "[A]mong the many things I did which pained and scandalized my Bostonian mother-in-law, she was not least shocked by the banishment from our house in the country of all the thicknesses of muslin which should have intervened between ourselves and the robins on the lawn."[45]

Edith and Teddy's constant companion at the time, Ogden Codman ("Coddy" to them both), observed that Edith had endeavored for years "to weed out" of Teddy "all the dullest of regular Boston ideas" learned from his mother.[46] In the 1890s, while the three of them were bicycling together in Newport and France, scouring antiques shops together and redecorating

On Mrs. Wharton's shaded porch at Pine Acre, Colonel DeLancey Kane reclines in a wicker chair beside two bicycles on a bike rack, 1897. *Jay Album, courtesy of William Patten.*

the Whartons' second Newport house, Land's End, Ogden was noticing that Teddy was acting strangely. Even as early as January 1896, while collaborating with Edith on *The Decoration of Houses*, he complained to his mother about Teddy, who is "an awful goose I realize more and more and I fancy she [Edith] does."[47]

In March 1899, when Edith Wharton's first short story collection, *A Greater Inclination*, came out, Teddy's family must have been chilled to read in "A Journey" a vivid depiction of a marriage losing its adhesion due to mysterious changes in the husband's character.

> *This irritability, this increasing childish petulance seemed to give expression to their imperceptible estrangement. Like two faces looking at one another through a sheet of glass they were close together, almost touching, but they could not hear or feel each other; the conductivity between them was broken....*
>
> *She still loved him, of course; but he was gradually, undefinably ceasing to be himself. The man she had married had been strong, active, gently masterful: the male whose pleasure it is to clear a way through the material obstructions of life; but now it was she who was the protector, he who must be shielded from importunities and given his drops or his beef-juice though the skies were falling...*
>
> *There were moments, indeed, when warm gushes of pity swept away her instinctive resentment of his condition, when she still found his old self in his eyes as they groped for each other through the dense medium of his weakness.*[48]

The construction of an exquisite classical country house in Lenox, The Mount, would be a way Edith and Teddy could grope toward the old days when Teddy was "strong, active and gently masterful." For several years, they could be distracted and bonded by the thrill of finding the right land, siting the house and driveway, dealing with architects and builders, shopping for mantels and furniture in Paris, planning and planting gardens and building a working farm. While Codman was concluding Teddy was "crazy," many others in this period remembered Edith and Teddy as the most gracious and kindly of hosts.

For the conservative household at Pine Acre, the scale of The Mount looked expensive, and when it was finished, the senior Mrs. Wharton was embarrassed to hear of the many unpaid bills to architects, both Ogden Codman and Francis Hoppin, and the Newport builder Robert W. Curry.

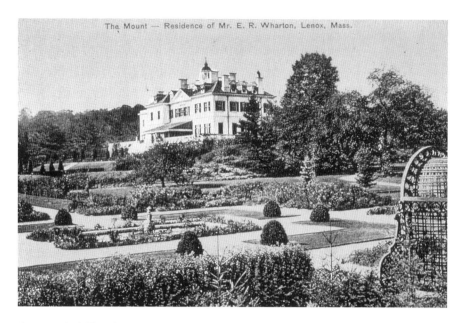

The Mount — Residence of Mr. E. R. Wharton, Lenox, Mass.

A postcard of The Mount soon after it was completed. *Lenox Library Association.*

Codman wrote his mother of the squabbles and even lawsuits between the Whartons and their creditors over traveling expenses, change orders and commissions. When visiting Lenox with his new wife, Leila, in October 1905, Codman found himself in the odd position of avoiding his old friends, Edith and Teddy, but dining at Pine Acre with Leila's friends, Mrs. Wharton and Nannie, whom he had previously scorned as "bores":

> *The old Whartons told Hattie* [Leila's sister], *they did not want to be dragged into the quarrel, and have asked us to dine there next Thursday. I do not much care to go, but Leila thinks we ought as they show they are not on Teddy's side by asking us there. Nancy and her mother are such old friends of Leila's and Hattie's.*[49]

During that fall of 1905, the expenditures at The Mount were ongoing. With royalties from *The House of Mirth*, Edith was expanding the garden to create a magnificent walled enclosure with a fountain. On the lower part of the property along Laurel Lake Road, Teddy was supervising the construction of a group of farm buildings—some of the most decorative in Lenox.[50] Here he could pursue his dream of being a gentleman farmer with purebred Jerseys and some token pigs and chickens. Their Lenox–New York

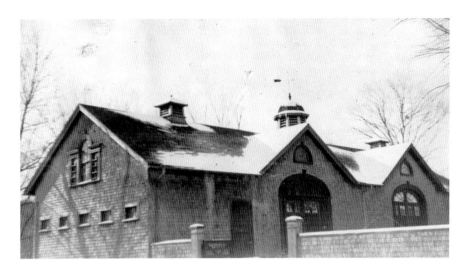

Grand shingled farm barns worthy of The Mount with classical motifs—cupolas and arches and a prominent Palladian window—built by Teddy in 1905. This photograph dates from the 1940s. *Lenox Library Association.*

friend and advisor Dr. Kinnicutt urged Edith that this was the best therapy for the ailing Teddy.[51] As events unfolded, the Wharton farm would have only a short, active life—probably only five years.

While Edith and Teddy's marriage was unraveling, Teddy's mother, Nancy, was in decline. Her final Lenox summer—1909—was spent not at Pine Acre but at the nearby Curtis Hotel. She had come up in the spring to stay in the hotel when opening Pine Acre, a ritual of many summer cottage owners. But she became ill and, after a three-month struggle, died of pneumonia in her hotel room on August 17.[52] The funeral was at Trinity Church in Lenox led by her faithful Boston clergyman Leighton Parks, now at St. Bartholomew's Church in New York.[53] Lenox shops closed on the afternoon of her funeral, a rare gesture allowing tradesmen, as well as cottagers, to attend the funeral of this respected member of the community.[54] Teddy was there, but where was Edith?

Still infatuated with her faithless lover Morton Fullerton, Edith never left Paris that summer of 1909. The Mount was rented to the Albert Shattucks, and Teddy, grappling with the inevitable loss of both mother and wife, dipped into Edith's accounts to finance a Boston flat where he was said to be keeping a mistress.

In her will, Nancy Wharton left both daughters-in-law, Edith and Susan, $1,000 legacies (Edith gave hers to the Lenox Library for more

book purchases), and she canceled debts for money her three children had borrowed during her lifetime—Nancy $3,650, William $7,000 and Teddy $16,000.

Right to the end, Nancy Wharton was a doting mother who was blind to the obvious fact of Teddy's mental illness. The problem, in her mother-in-law's eyes, as well as many Lenox observers, was Edith's behavior. As an emerging celebrity author, she was sidelining Teddy for her adoring circle of intellectual male friends—Howard Sturgis, Walter Berry, Henry James—to say nothing of disappearing to Paris for an affair with Henry James's journalist friend Morton Fullerton.

Nancy Wharton had lived a life of steadfast loyalty to a manic depressive husband. She was surrounded and encouraged by a network of supporters—her own three children, the Jamaica Plain Perkinses, the Clevelands, her Boston clergyman Reverend Parks, Albany's Bishop Doane. She could cope with her husband's hospitalization at McLean's, but divorce was never an option.

When history repeated itself with Teddy, Edith had none of these old-fashioned supports. She had no children; both her brothers were distant and, at times, estranged; she disliked her relatives, except her sister-in-law Mary "Minnie" Cadwalader Jones (whom her brother Frederic had divorced); and she avoided conventional spiritual consolation. Her network was her very loyal staff—secretary Anna Bahlman, butler Alfred White, housekeeper Catherine Gross and chauffeur Charles Cook—and her intellectual friends, from the volatile aesthete Ogden Codman to the cultivated networker Walter Berry and the self-centered but sympathetic fellow author Henry James.

In 1910, Henry James wrote Howard Sturgis, "Poor Edith…has been having in every way a hell of a time—& there's more to come. I make out that Teddy, after great 'gay' pranks in the U.S., is about to be returned on her hands as finally demented.…I hope there may be some help in the fact that his Sister (wholly free by the Mother's death) is now in Europe."[55]

For Edith, as long as the much-admired Nancy Wharton lived, divorcing Teddy would be inconceivable, but old Mrs. Wharton's death in August 1909 opened that path. Edith would be leaving Teddy and his problems to the Whartons.

4

# Angel at the Grave and Innovator in the Garden

## Miss Georgiana Sargent

Edith Wharton's short story "Angel at the Grave" depicts an intelligent, aging spinster dedicated to the memory of her intellectual male forebear. Edith writes wittily that the great man's reputation "among the evergreen glories of his group, had proved deciduous."

Seeking a model for the "angel," Wharton scholars are reminded of Sally Norton. However, in 1901, when Edith was crafting this story, Sally's father, Charles Eliot Norton, was very much alive and still revising his work on Dante. At the time, however, the Whartons were "negotiating" a land purchase with another New England woman, whose once-honored father's reputation was waning. Georgiana Welles Sargent in her elm-shaded house on the Cross Road (now Plunkett Street) surely provided some material for Edith's title character.

In July 1901, Edith and Teddy bought 116 acres of glorious rolling farmland tamed twenty-five years earlier by Sargent's father, John Osborne Sargent, a lawyer, editor, Whig politician, classicist and gentleman farmer. Here in the ensuing year, The Mount would be built overlooking Laurel Lake.

Like Edith Wharton, Georgiana Welles Sargent (1858–1946) relished early childhood memories of life abroad. The winter Edith was born, Georgiana was a two-year-old toddling around parks, hotels and ancient ruins in Paris, Marseille, Rome and Sorrento.[56]

Young Georgiana's father could retire at the age of forty-five when he married a Boston heiress, Georgiana Welles. The artistic Mrs. Sargent

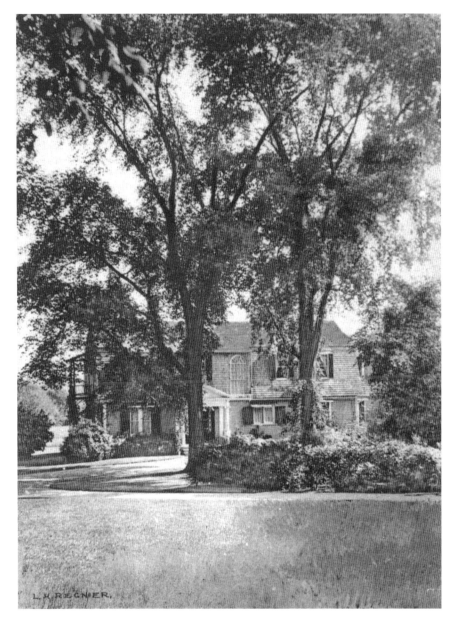

Georgiana Sargent's Twin Elms, postcard by Louis H. Regnier, circa 1915. *Lenox Library Association*.

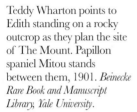

Teddy Wharton points to Edith standing on a rocky outcrop as they plan the site of The Mount. Papillon spaniel Mitou stands between them, 1901. *Beinecke Rare Book and Manuscript Library, Yale University.*

suffered from a lung ailment, and for twelve years, the family led a privileged, nomadic life abroad, returning intermittently to their house in New York City.

By the time little Georgiana was five, she was familiar with horse races in Hyères, had scrambled in and out of gondolas in Venice and explored countless cobbled streets and marketplaces on early morning walks with her father. She had heard her parents negotiate with cab drivers, hotel staff, doctors and shopkeepers in a host of European languages as, between April and November of 1863, they progressed through some thirty-six different hotels in different locales, including Cannes, Lake Como, Trieste, Gratz, Zurich, Baden-Baden, Dresden, Berlin, Bruges and Paris.[57] (Also leading a boyhood life abroad at this time was Georgiana's fourth cousin, the future painter John Singer Sargent [1856–1925].)

In 1872, when young Georgiana was fourteen, the Sargents discovered the Berkshires. They bought 240 acres of overgrown farmland in Lenox on a spectacular site overlooking Laurel Lake. In July 1873, Mrs. Sargent sketched the terrain of their new property from a high vantage point on the Old Stockbridge Road. They built a quaint, two-story, gambrel-roofed house with shed dormers looking out over the lake that still stands today near the junction of Plunkett Street and Route 20. The house closely resembled the one Edith Wharton's future friend Grace Kuhn had just finished near the Church on the Hill. The fickle local press, the *Gleaner and Advocate*, which had been so outraged by Kuhn's hillside eyrie, judged the Sargents' lakeside variation suitable and "modest."

John Sargent's enthusiastic land improvement impressed the *Gleaner* columnist. In two short years between 1874 and 1876, the energetic, well-heeled city intellectual rid his property of "hard-hacks" (swamp bushes) and "brakes" (thickets) and was winning blue ribbons at local agricultural fairs with his Cotswold sheep.[58]

On Easter Eve 1878, Mrs. Sargent died in their New York house. This loss was a temporary blow to Sargent's farming zeal, but by 1883, his old friend Dr. Oliver Wendell Holmes (who years earlier had delighted in "draining his fields and his pockets" at Canoe Meadows in Pittsfield) had written, "I am glad, my dear John, to know that you are taking comfort in the midst of your own acres in my dear old Berkshire."[59]

In his "rustic vine-covered cottage" with sloping lawns and pastures down to Laurel Lake, Sargent and his "accomplished" daughter Georgiana became fixtures in Lenox farming and social circles.[60] Georgiana's architectural watercolors surpassed her mother's drawings and reflect an assured grasp of perspective and an unconventional mind. She had an eye for the unusual industrial structures, including a dilapidated furnace of the Lenox Iron Works in Lenox Dale and the new marble electrical plant on the Laurel Lake causeway of her inventor-neighbor George Westinghouse. The future novelist Owen Wister, who as a Harvard undergraduate visited the Laurel Lake Farm in 1881, found her a formidable opponent at the game of "twenty questions."[61]

John Sargent, with his sprightly wit and scorn of ostentation, was a hospitable entertainer.[62] A visitor at dinner would be inspired by a verse,

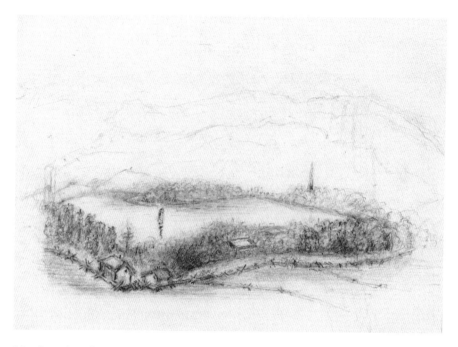

Mrs. Georgiana Sargent's sketch of Laurel Lake with the Lee Congregational Church in the distance, July 1873. *Lenox Library Association.*

executed in elegant Arts and Crafts lettering, over the fireplace to "Seek not the future, study how/to make the most and best of now," from one of Horace's odes to his enlightened patron Mæcenas, translated by their host. Sargent dedicated his last years to translating the Latin poet's odes and shared Horace's disdain "of luxurious living and prodigal expenditure," equating Gilded Age America with Imperial Rome.[63]

Edith Wharton, regrettably, never met him, but Teddy's quiet, reserved mother, Nancy, was a special favorite of Sargent. Mrs. Wharton, recently widowed, missed Sargent's eightieth birthday party in September 1891, but on her return to Lenox, she was touched to receive a slice of his birthday cake and a Horatian ode awaiting her at the Platner cottage.[64]

Two months after his festive birthday in Lenox, Sargent died in his New York City house at 28 East Thirty-Fifth Street.[65] Georgiana, like Paulina Anson in "Angel at the Grave," dedicated herself to her father's legacy. She collected his translations in a beautifully bound volume, *Horatian Echoes,* published by Houghton Mifflin in 1893 with an introduction by his lifelong and aged friend Dr. Holmes. She endowed the John O. Sargent Classics Prize, which is still awarded at Harvard over a century after his death.

Parasol in hand, Georgiana Sargent, in her late twenties, stands on the steps of their vine-shrouded back porch in Lenox. Her seventy-five-year-old father (*seated*) pats the family dog, 1886. *E.A. Morley.*.

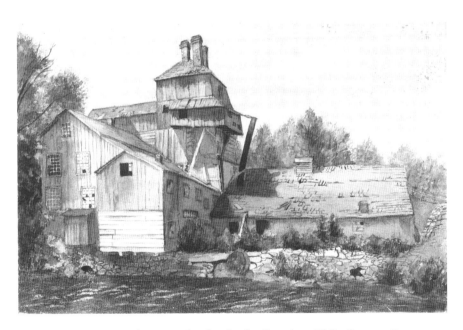

Lenox Furnace Iron Works watercolor drawing by Georgiana Welles Sargent. *Lenox Library Association*.

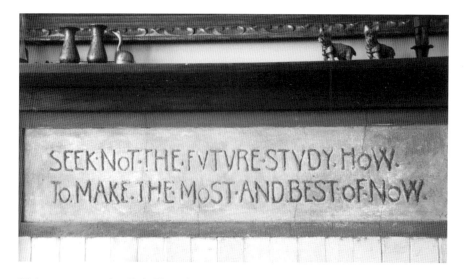

SEEK·NoT·THE·FVTVRE·STVDY·HoW.
To.MAKE·THE·MoST·AND.BEST·oF·NoW.

Dining room mantel at Twin Elms. *Cornelia Brooke Gilder.*

Sargent continued to spend her winters in the New York house and come to Lenox as soon as she could start the gardening season. Averse to ostentation, she lived simply but comfortably, dedicating herself to the needs of her close cousins, the Huntington family. She financed the education of the boys with vigilant concern that they become realistic about supporting themselves. The affection between the family and their "Cousin Georgie" is told in her surviving letters to family members—delighting over the boys' neatly packed gifts of spring flowers from their garden in Hanover, New Hampshire, offering to send her chauffeur to pick up Mrs. Huntington for a flower show excursion together, recounting travel adventures. Like Edith, she was caught in England at the outbreak of World War I. After the invasion of Belgium, she wrote movingly to her cousins at home of the experience of standing amid a huge, somber throng outside of Buckingham Palace when the king and queen came out on the balcony.[66]

Georgiana's life was mostly centered on the garden in Lenox. She auctioned off her father's pedigreed Jersey cows and Cotswold sheep and retained control of one hundred acres in view of the house by leasing it to well-heeled horse-breeding Newporters—first Ogden Goelet and later Frank Sturgis.[67] Then, in 1901, a decade after her father's death, at the peak of Lenox's property values, she sold the magnificent lakeside farmland on the other side of Laurel Lake Road to her old friend Teddy Wharton and his literary wife, Edith. As the Laurel Lake Farm of her father's day was

divided, Georgiana Sargent began to call her elm-shaded, gambrel-roofed home Twin Elms.[68]

Wharton's "The Angel at the Grave," with its reference to "the shuttered mind of maiden ladies," might have nipped in the bud any quiet dinners with Edith and Teddy by Sargent's literary fireside at Twin Elms. Ever since "The Line of Least Resistance" in the October 1900 issue of *Lippincott's Magazine* (which required Teddy's quick mission of apology to the Sloanes at Elm Court), the Lenox social colony was becoming wary of finding themselves between the lines of Edith's writings. Lenox cottagers read every new story and novel with avid fear and curiosity. Edith, herself, held dear her

A lifelong traveler, Georgiana Welles Sargent's passport depicts her wearing a stylish toque, 1925. *National Archives and Records Administration.*

own privacy, but her literary invasions of others (both real and perceived) were going to become a problem in Lenox.

With their shared love of gardening, it is a shame Edith Wharton did not befriend Georgiana Sargent. Far from "a shuttered mind," Sargent was a passionate hands-on gardener and innovator. Grafting a hawthorn, she created a new variant named *Crataegeus Georgiana Sargent* in the Arnold Arboretum's *Botanical Gazette* of 1902. Her lime tree *Tilia Georgiana Sargent* was recognized in the pages of the *Gazette* in 1918.[69] Experimenting, digging and teaching others, she would be remembered at the end of her long life as "a public-spirited citizen who was able to turn her personal hobby to the advantage of the community."[70]

In 1911, the year Edith Wharton finally closed the door at The Mount, a new local institution that she would have enjoyed—the Lenox Garden Club—came into being. The petite, blue-eyed Sargent energized the group, serving first as secretary, writing minutes in her fluid legible handwriting and then graduating to a slightly wobbly typewriter in 1917. From 1923 to 1934, she took on the presidency, and at the time of her death in 1946, she was still considered the club's honorary president.

Many of Edith Wharton's old friends—Mary and Daniel Chester French, Adele Kneeland and Mary Parsons—were members. When they attended Lenox Garden Club meetings at Twin Elms, they admired Sargent's old-

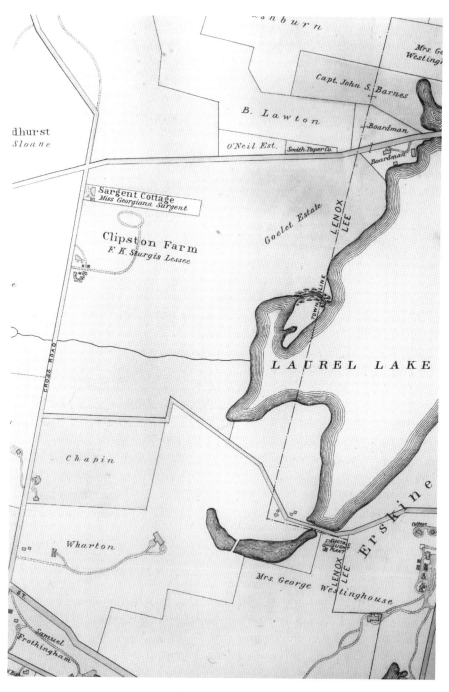

Georgiana Sargent's property subdivided after the Wharton sale and the Sturgis lease.
*Barnes and Farnham Map of Berkshire County, 1904.*

fashioned perennial beds with familiar and obscure blooms, such as the malodorous, goosefoot-leafed *Chenopdium hybridum*. Her "wild garden," punctuated with beehives and birdhouses, was an inspiration for others. While more conventional club members made three-minute presentations on growing irises, Sargent would expound on *Vincitoxican*. She challenged members with horticultural quizzes and was a skilled model-maker. When the club had a competition of model gardens, Sargent's Lilliputian English cottage garden was the only entry. She planned the layout of a flower show in the park beside the Congregational Chapel (now Lilac Park) with another model, complete with miniature tents. The Lenox Selectmen mildly objected to such a use in the town park, to which Georgiana Sargent responded in firm and slightly condescending tones.[71]

Georgiana Sargent succeeded Edith Wharton on the Lenox Library's Associate Board of Managers, serving from 1915 until her death thirty years later. Like Edith, she took initiative in building up the library's collection. She avidly contributed gardening books during her lifetime and left a fund for the continued purchase of works on horticulture long after her death. A young librarian in the 1940s, Judy Conklin, cherished the memory of Sargent, then in her eighties, breezing into the library with freshly picked autumn crocuses to adorn the charging desk.

Like Teddy's mother, Georgiana Welles Sargent actually died in a Lenox hotel. In her commodious Buick 8 sedan, with chauffeur John Connors at the wheel, she had come up from the city with her maid to open Twin Elms for the summer of 1946. She was staying at the Village Inn when she was stricken by a fatal heart attack. On hearing of his cousin Georgie's serious condition, Reverend Paul Huntington, Episcopal minister in Red Hook, New York, raced up to Lenox, only stopping in the Twin Elms garden to pick a bouquet of early summer flowers. When she saw his offering, Sargent died with a grateful smile.[72]

A European childhood, an erudite approach to gardening and books and most of all the very land where Edith Wharton made her Lenox life intertwined Georgiana Sargent and Edith Wharton. There is no direct evidence of their opinion of each other, but it is likely that, as an old friend of the Wharton family, Sargent would have been among those in Lenox who felt Edith had failed her ailing husband.

In June 1931, while still president of the Lenox Garden Club, Georgiana Sargent heard member Emily Lyman regale the club on "Mrs. Wharton's gardens at Hyères."[73] Two years earlier, in the winter of 1929, Edith Wharton's hillside gardens in the south of France had been devastated by

wind and snowstorms. Soon afterward, Edith, in her late sixties, suffered a serious stroke. Any lack of sympathy in the past between Sargent and Wharton was likely forgotten. The fellow horticulturalist must have been impressed by Edith Wharton's determination in restoring her splendid garden at St. Claire in Hyères, a Riviera town known to Sargent from her own itinerant childhood back in the age of innocence.

# 5
# *Showing Off The Mount*

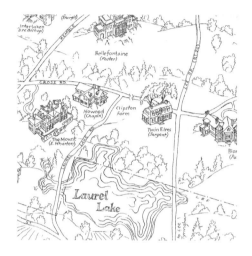

The new, still unnamed, house overlooking Laurel Lake was just finished in September 1902, and Edith Wharton was clearly excited. Writing Helena deKay Gilder, wife of her editor at the *Century Magazine*, Edith anticipated showing them around her new creation: "We shall be delighted to see you and Mr. Gilder on Saturday if you can come to luncheon." In these last days before the automobile, the Gilders' journey from Four Brooks Farm in Tyringham to The Mount was seven uphill miles through Lee. "I hope in this cool weather you will not mind driving over in the morning. If so, will you meet me at the new place at 12 o'c? If you will enter by the gate near the gardener's cottage (just beyond Mrs. Chapin's entrance) you can drive straight to the house, where you will find me."[74]

Another early visitor was Teddy's friend since childhood, Ellen Tappan Dixey of Tanglewood (now the famed summer home of the Boston Symphony Orchestra).[75] Ellen's husband, Richard Dixey, brought his camera. Edith was an early Kodak enthusiast and must have been pleased when he took a series of architectural shots of The Mount's interior.[76]

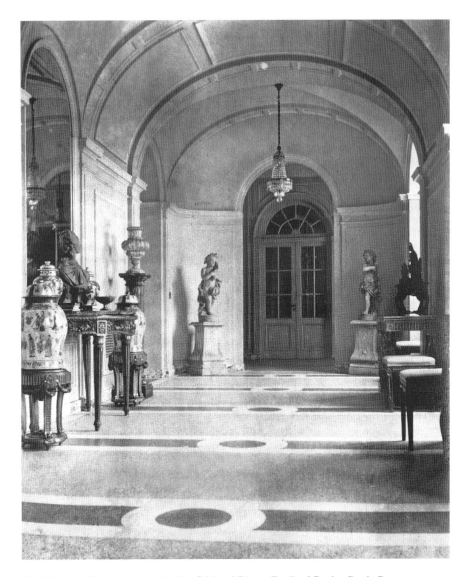

The Mount gallery, photographed by Richard Dixey. *Family of Daphne Brooks Prout.*

Soon, others like Joseph Choate would come bringing their houseguests. The Austrian ambassador, in Choate's entourage for one lunch party, exclaimed from the terrace, "Ah Mrs. Wharton, when I look about me I don't know if I am in England or in Italy."[77]

The landscape at The Mount was as important as the house, and the first year, The Mount's garden was not a success. After a big investment

in perennials in the fall of 1902, Edith came back the following spring to a depressing spectacle. Her expensive new plants had not wintered well and were retarded by a dry spring. She fired her gardener and was fortunate in the next one, M. Thompson Reynolds (1874–1959), a twenty-nine-year-old Englishman, known as "Thomas." Reynolds had immigrated nine years earlier after training as a boy in Surrey with his father, a professional gardener. He first came to work in Lenox under two top practitioners: Alfred Wingett of Charles Lanier's estate, Allen Winden, and Alfred Loveless at John Sloane's Wyndhurst. Becoming head gardener at The Mount in 1903 was a big promotion in responsibility and prestige. The newly finished architectural gem of a gardener's cottage at the gate provided palatial bachelor's quarters. The small, by Lenox estate standards, but practical and convenient greenhouse was near his house, as was the vegetable garden. Over the next eight years, Thomas Reynolds earned Edith's admiration and respect.[78] All aspects of the property—even Edith's 1908 experiment with raising swans—were under his jurisdiction.[79] He seems to have been able to work not only with a demanding and creative employer but also with her many formidable landscaping visitors.

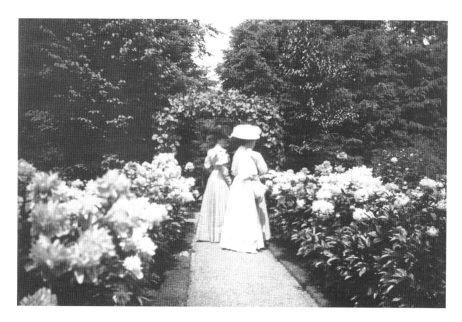

Edith Wharton and friends admiring a bed of peonies in a Lenox garden, probably Stonover. *Parsons' Collection, Lenox Library Association.*

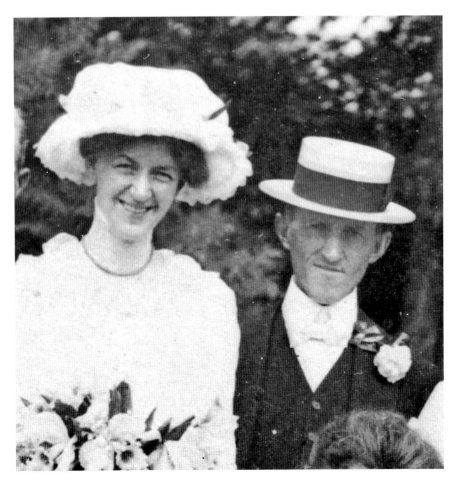

Edith Wharton's gardener, Thomas Reynolds, with his Lenox bride, Eliza Weston, 1914. *The Mount Archives, gift of Dorothea Hellman.*

Edith's niece Beatrix Farrand, embarking on her own illustrious career as a landscape architect, was a frequent houseguest. Her hand is found in The Mount's beautiful front driveway and also in the formal and visible kitchen garden, where Reynolds and his assistants worked in parterred beds and trained vines on the arbors that framed the garden.

Another visitor was Maine nurseryman George B. Dorr. One of his visits to The Mount must have been early in Reynolds's tenure, and it led to several new projects. Edith reported to Dorr in September 1903, "Your path is finished…and the task of planting its borders now confronts me; & we are just about to attack the laying out of the path from the flower-garden

to the little valley which is to be my future wild garden."[80] As a boy in the 1860s, Dorr had summered in Lenox at his family's place (now the Blantyre property). A philosopher as well as a horticulturalist, the bachelor Dorr would have been a favorite neighbor for Edith, but by the time he inherited the Lenox place, he had settled in Bar Harbor. There he established the Mt. Desert Nursery, patronized by discriminating local and distant gardeners, including Beatrix Farrand, and was also sinking his fortune and energy into a new dream on Mt. Desert Island: Acadia National Park. But he did enjoy returning to Lenox from Maine to see old friends and especially his elderly uncle, Samuel Gray Ward, the grand old man of the village resort.[81]

Sculptor Daniel Chester French, who was also an amateur landscape designer, was passionately interested in the progress of Edith's gardens. Mary French remembered that "when we went to her place, she and Mr. French would wander about the grounds, exchanging ideas." The conversations would continue at Chesterwood. "Each new development in our little place, Mrs. Wharton always came to see, and brought her friends to see it—among others, Mr. Henry James, whom Mr. French had known years before in London."[82]

From the greeting of the Whartons' dapper butler, Alfred White, at the door to the yapping and skittering dog paws on the terrazzo floor in the gallery above and the pungent summer aroma of bouquets of phlox, arriving at The Mount was a luxurious and delightful experience. The first documented lunch party at The Mount—as reported in the social pages of the *New York Times*—was on September 28, 1902. The group was a mix of Lenox neighbors and New York houseguests. Most importantly, Emily and William Sloane of Elm Court came.

A year earlier, Coddy had predicted social doom for Edith Wharton for brazenly alienating the Sloanes.

6

# The Whartons, the Vanderbilts and the Sloanes

In 1900, Edith Wharton published a short story in *Lippincotts Magazine* called "The Line of Least Resistance." It depicted a domineering, self-centered, social climbing and unfaithful wife and her stuffy, dyspeptic and spineless husband "with a small thinking faculty." Many of Edith's social circle leapt to associate the story with Jessie and Henry Sloane, whose divorce had been the talk of Newport and beyond.

Early in their marriage in the late 1880s, Henry and Jessie Sloane had spent five summers in Lenox, renting Nestledown on West Street. In those years, the four Sloane brothers were taking Lenox by storm. While Henry and Jessie rented at Nestledown, two other brothers, William and John, built houses and settled with their large families on conspicuous sites on the Lenox landscape—William Douglas Sloane with his wife, Emily Vanderbilt, at Elm Court (begun in 1886) and John and Adela Berry Sloane at Wyndhurst (1894). The fourth brother, Thomas, never made it. In June 1890, while renting Dr. Kinnicutt's house, Deepdene, on Cliffwood Street, Thomas Sloane collapsed with a sudden heart attack. It was a hot day and he had been out house hunting.[83]

By this time, Henry and Jessie Sloane had moved to Newport. Henry wanted to sail, and Jessie wanted to see more of Perry Belmont. It was at Newport where Wharton witnessed the rents and reconcilions in their marriage. Within hours of her divorce settlement from Sloane in 1899, Jessie married Belmont.[84] Taking full custody of his daughters, Henry Sloane defected from Newport to the greater isolation of summers on a Maine island, Isleboro.[85]

"Her story about the Sloanes finished her," Ogden Codman gleefully predicted to his mother. "Mrs. Willy Sloane is the local queen of Lenox so everybody in the place sided with her." Having already spent enough time with Edith and Teddy to see their own conjugal stresses, "Coddy" nastily concluded, "People in glass houses shouldn't throw stones."[86]

In October 1900, when "The Line of Least Resistance" appeared in print, the Whartons had just spent the summer renting The Poplars, an adjoining property to the William Sloanes' Elm Court.[87] The Mount was still only a dream. The Whartons would purchase the land overlooking Laurel Lake the following spring.

"Mrs. Willy," the stylish and radiant redhead Emily Vanderbilt Sloane (1852–1946), was a force in Lenox, known for her brisk and hospitable ways and her deep love of family. Promptly, each morning at 9:00 a.m., she and her dogs embarked on a two-and-a-half-mile walk, often along the Old Stockbridge Road up and down two significant hills to pick up her mail at the post office.[88] Her upright posture either walking or sitting perched on the edge of a chair was indicative of her alert and lively nature. At meals, she did not linger over the courses. Herbert Stride, the Elm Court butler, would whisk away the plates at the signal from Mrs. Sloane. Woe to a slow eater in the vast Elm Court dining room. Matilda Gay described Emily Sloane's charming effect at a lunch party of friends and family: "We were 32 at table, and the sweet nature of Mrs. Sloane pervades the atmosphere, rendering the conflicting elements harmonious."[89]

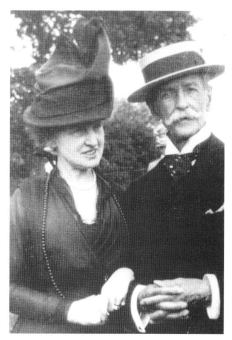

Emily Vanderbilt Sloane and William Douglas Sloane, circa 1910. *Osgood Field.*

The bumpy start between the Sloanes and the Whartons was apparently soon forgotten. There were letters of apology from Edith, the offending story was withdrawn from a forthcoming collection and the genial Teddy, who had become adept over the years at making amends for Edith's slights, made a

diplomatic call at Elm Court.[90] In the course of 1902, The Mount took shape, overlooking Laurel Lake with the two Sloane estates like bookends on either side. Elm Court was less than a mile to the east, and the castellated and turreted Wyndhurst graced a hill one mile to the west.

The Whartons and Emily's Vanderbilt brothers had known each other for years. On the fateful night when the Breakers burned to the ground in Newport in November 1892, the Whartons had been dining with Cornelius and Alice Vanderbilt.[91] When the Vanderbilts rebuilt on an even bigger scale, the Whartons recommended an up-and-coming new architect, Ogden Codman, to design the bedrooms, a breakthrough commission for Coddy. In the coming years, Edith and Teddy would spend Christmas with another of Emily Vanderbilt Sloane's brothers, George, at Biltmore, his fabulous country house in Asheville, North Carolina, and rent his beautiful Parisian apartment at 58 Rue de Varenne.

It was obviously important to be on good terms with the Sloanes, and Edith, for all her piercing observations about the foibles of rich Americans, actually enjoyed the comforts they could share. She invited Emily and William Sloane to the first lunch party at The Mount and soon was secure enough, or bold enough, to ask to borrow a Sloane family car "stabled" in France.

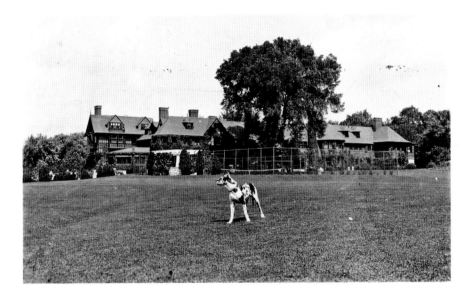

A big dog for a grand property, the William D. Sloanes' harlequin Great Dane roams the lawn at Elm Court. *Lenox Library Association.*

The John Sloanes' Wyndhurst. *Lenox Library Association.*

The Sloane family, with its many branches and deep pockets, had been entrenched in Lenox society for twenty years. Initially, the scale of their colossal houses—Elm Court and Wyndhurst—and their domestic entourages, including liveried footmen, had caused some alarm among the "old guard." Disdained for their "new money" derived from the W&J Sloane Company (beginning as an importer of oriental carpets but soon the leading New York furniture company) and the shipping and railroad empire of the Vanderbilts (Emily Sloane was a granddaughter of the Commodore), the Sloanes raised the bar in Lenox.

Constance Cary Harrison, Lenox's reigning local novelist of the three decades before Edith Wharton, represented the earlier, more genteel style of living. She first came to Lenox in early 1870s and reflected in her autobiography:

> *I lived there long enough to see a mighty change. The rural hill-sides and pastures, bought up at fabulous prices, were made the sites of modern villas, most of them handsome and in good taste. The villas were succeeded*

*by little palaces.…Instead of trim maid-servants appearing in caps and aprons, one was confronted by lackeys in livery.…Caviare and* mousse aux truffles *supplanted muffins and waffles.…Stables were filled with costly horses…bearing pedigrees sometimes longer than the owner.*[92]

As Edith and Teddy built The Mount, the long-established Sloanes were still expanding their Lenox houses. A huge shingled and half-timbered "Hammond wing" at Elm Court in the 1890s accommodated the visiting children of daughter Emily and her husband, John Henry Hammond, and at the adjoining High Lawn, a beautiful Georgian house, designed by Delano and Aldrich, was under construction in 1909 for daughter Lila and her husband, William Bradhurst Osgood Field.

The open hayfields at High Lawn were the scene of the Lenox Horse Show, where both Teddy and Edith competed,[93] and the expansive lawns of Elm Court were favored by the Lenox Cricket Club. Teddy Wharton was an avid cricket spectator, cheering on his superintendent Thomas Reynolds and providing silver trophies. Edith, too, was a patroness of the cricket team.

Edith Wharton could laugh with the bibliophile William B.O. Field about the quality of books in his parents-in-law's library at Elm Court, ordered by the yard as one did wallpaper. The Sloanes, however, were serious minded, public spirited and generous. Between 1886 and 1915, they built and funded operating costs for a pioneering maternity hospital in New York. With each new wing at Elm Court, they also expanded the Sloane Hospital for Women on Amsterdam Avenue and Fifty-Ninth Street. Under the leadership of founding director Dr. James W. Lane, the hospital was a teaching facility and developed new methods for treating toxemia and hemorrhaging and instituted the use of crucial new instruments, thus saving lives of mothers and babies. Many patients, living on the fringes of city life, were treated at no cost. As a teaching facility, the influence of the Sloane Hospital went well beyond the city.[94]

In Lenox, Edith served with the Sloanes on a short-lived Lenox Educational Society, and Emily Sloane was a donor to a fund for Anna Bahlman, suggesting that Edith's beloved and highly educated governess-turned-secretary taught some of the Sloane daughters or granddaughters.[95]

Elm Court albums of the first years of the 1900s are filled with photographs of the younger generations of Fields and Hammonds driving primitive automobiles in Lenox and abroad. On October 10, 1903, after two difficult months of Teddy's bouts of depression, Edith Wharton implored Willie Field's assistance in planning the coming winter:

Lila Sloane Field of High Lawn, circa 1900. *Lila Wilde Berle.*

*The doctor has ordered my husband abroad again for the winter + we are starting for Italy in a few weeks. We are anxious to do some automobiling + I believe it is difficult to buy one without a delay of several months. I write to ask if by any chance you would be willing to let us have yours for two or three months. I know the George Vanderbilts had it for the summer.*

She concludes with a quaint equation of the car to the horse: "I thought if you + Mrs. Field are not going abroad for the winter you might be willing to give your machine a little exercise in the meantime."[96]

It appears the Fields did not want their car "exercised," but the correspondence continued. Edith's next letter of November 3 asks Field on the matter of automobiles "for advice about hiring a good touring car from Charron [the leading French auto manufacturer of the day]. As we are both new at it + as my husband is not well, it would certainly save trouble to hire, if we could get a good machine unless we find, as some people say, that it is much more expensive than buying."[97] In January 1904, the Whartons bought their first car in France.[98] Motoring around in the open air on their own time restored Teddy's spirits and launched the elated Edith into a new writing project, a series of travel articles, eventually collected in *A Motor Flight through France*.

That fall, the Whartons bought their first American car, and in those days, when automobiles were a rarity, they were a conspicuous sight on country roads in the Berkshires. One observer was Ogden Codman now visiting Lenox, financially secure and—to the surprise of many—a married man.

At forty-one, Codman was successful in his own career, and his wife, Leila Griswold Webb, brought him an entrée to many fashionable Lenox households, including the Alexandres at Spring Lawn, the Joseph Burdens at Underledge and both the Elm Court and the Wyndhurst Sloanes.[99]

In the fall of 1905, when Codman was temporarily estranged from the Whartons over unpaid bills at The Mount, he regaled his mother with news of his friends' legal woes with contractors in the aftermath of construction:

> *We see the Whartons driving constantly, but have not met them yet. Mr. Pendleton their lawyer has been staying with the [John] Sloanes, so the Whartons had their consultation without paying his travel expenses?! Eliot Gregory,*[100] *who was at the Sloanes, told me Pendleton was much annoyed about the case, and with the Whartons for dragging him into it.*[101]

While Codman was spying on, but not speaking to, the Whartons, he was sketching plans to redo another charming house with a view of Laurel Lake that had just come on the market.[102] It was a bold plan for often-tactless Codman, considering his current falling out with the Whartons. The property he was eyeing was Adèle and Robert Chapins' old house, Nowood, next door to The Mount.

The Codmans never moved to Lenox. After Leila's death in 1910 and Edith's divorce in 1913, the old collaborators of *The Decoration of House* reconciled. In May 1938, the frail Edith was visiting Coddy at his château outside of Paris when she had a serious heart attack. Her parting crack to him from the ambulance was, "This will teach you not to ask decrepit old ladies to stay!"[103]

# *Yuki Morgan*

One story that was the talk of Lenox in Edith Wharton's day was the surprising 1904 marriage of J.P. Morgan's nephew, the handsome, overprivileged scion of Ventfort Hall, George Denison Morgan (1870–1915), to a mysterious, winsome geisha, Yuki Kato (1882–1963). This would be a story involving a super-prominent New York and Lenox family that Edith left to others to describe and embellish on stage and print.

George's two-year courtship of Yuki in 1902 and 1903 was scandalous fodder for the Japanese press, but it was not until their actual marriage in Yokohama in January 1904 that the news hit New York and Lenox. "Is anything unexpected?" the groom's father, George H. Morgan, responded grumpily when cornered by a *New York Times* reporter. Morgan defended his son George: "Like many cultivated men, he likes the repose and tranquility of Japan and the politeness of the people, which is so in contrast to the hustle and bustle of New York."[104]

For over a decade, reports of young George's romantic escapades reverberated through the paneled rooms of Ventfort Hall and 6 East Fortieth Street, the Morgan houses in Lenox and New York. At Yale, George concentrated on billiards, and on Wall Street, he failed to distinguish himself at his Uncle Pierpont's bank. His parents dispatched him abroad to "sow his wild oats" in 1892. A broken engagement in Lenox in 1896, an illegitimate son in London in 1902 and George's checkered career must have caused plenty of anxiety for the staid Morgan family.

# MORGAN'S NEPHEW WEDS JAPANESE

## George D. Morgan Takes for Life Partner Miss Yuki Kato, of Kyoto, the Ceremony Being Performed at Yokohama.

George D. Morgan, nephew of J. Pierpont Morgan, has taken as the partner of his joys and sorrows Miss Yuki Kato, of Kyoto, Japan, at Yokohama. The ceremony was performed on Jan. 21 by

*Above*: A February 2, 1904 *New York Evening World* article.

*Opposite*: Yuki in a Parisian evening dress, circa 1910. *Ventfort Hall.*

George first discovered Japan in 1900 in a series of long visits. In 1902, when entering a Kyoto teahouse, he first laid eyes on Yuki Kato. She was a petite, exquisite twenty-one-year-old geisha, daughter of an underemployed samurai sword maker in the era of gunpowder. The gambling, womanizing George, now in his early thirties, was entranced. But Yuki coldly and repeatedly refused to marry the "barbarian" as she proffered tea in elaborate rituals, played the shamisen and danced. She was in love with a law student her own age, and George Morgan's lavish tips went to supporting her lover's tuition payments. Yuki would not be swayed, even when, according to one account, George threatened suicide with a pistol at his head.

George is said to have departed from Japan distraught, pressing into her hand the proverbial stamped self-addressed envelope to beckon him if she would ever reconsider. When the law student graduated in 1903 and dumped poor Yuki, she contacted George. He dashed to Kyoto on the first ocean liner. And so in January 1904, dressed in kimonos, they were married by Reverend E.S. Booth in the presence of the U.S. Consul General Bellows in Yokohama. The Japanese press made much of the story, dwelling on the unimaginable costs George Morgan incurred buying out Yuki's contract as a geisha and providing an allowance for her genteelly impoverished parents.

On the eve of the outbreak of the Russo-Japanese War, in early February 1904, Yuki and George set sail, complete with Yuki's dachshunds, to meet his family. The San Francisco papers described Yuki hiding from photographers behind a white silk scarf. In Chicago, Yuki, with George translating, indicated to the press she was ready to live wherever her husband chose but doubted she would ever wear western clothes.[105] They arrived in New York in a snowstorm, and George enveloped his delicate bride with her bamboo sandals in his overcoat and carried her over the threshold of 6 East Fortieth Street. Here she is said to have been met with a stony welcome, not

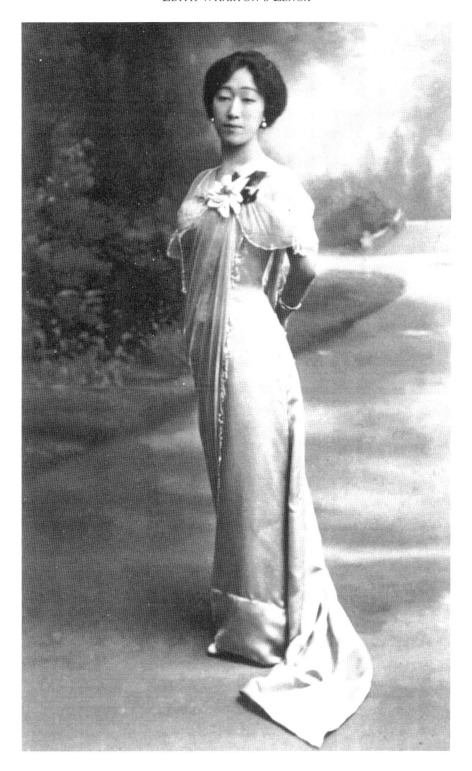

George D. Morgan poses with Yuki's family at the time of their wedding. Two American friends, possibly the clergyman and the consul, sit at the far right. *Ventfort Hall, gift of Margaret Morgan.*

by George's father, but by his relatively new stepmother. Within months, the papers were reporting that the senior Morgans were separating over Mrs. Morgan's callous treatment of Yuki.[106]

Outside the family circle, the glamor of this marriage was embraced by East and West. The Japanese began celebrating "Marrying into Wealth Day" on the date of George and Yuki's wedding anniversary. In the West, it was considered a real-life variant of the *Madame Butterfly* story. Puccini's opera, already a success in Europe, premiered to packed houses in the United States in the fall of 1906.

Ultimately, like Edith Wharton, Yuki and George sought the cosmopolitan life in Paris. They never had children and returned to the United States from time to time, but it is not known if Yuki ever came to Lenox. Impeccably chic in any culture, Yuki transitioned into western clothes, became fluent in French and, after the initial rejection by her new American family, became admired and protected by her Morgan nieces and nephews in later years. As members of the relatively small expatriate community in Paris, Edith

Wharton might well have met Yuki, and she surely knew all about the womanizer George.

Like many a leading man in a Wharton story, George Denison Morgan never rose to the occasion. During World War I, while others of his ilk were driving ambulances to the trenches, he died of a heart attack in the arms of a mistress in Barcelona. Yuki, on the other hand, as Edith might have depicted, played the cards she was dealt with dexterity and dignity. She died almost fifty years later, long after World War II, a Catholic convert living in Japan, still supported by the Morgan family.

# The Lenox Sporting Life

## Pages from the Ambassador's Album and Diary

The lanky and genial British ambassador Sir Henry Mortimer Durand (1850–1924) spent three summers in Lenox with his family during Edith Wharton's time. In his long diplomatic career in the Indian subcontinent, Durand had negotiated border disputes between Afghanistan and present-day Pakistan. (The so-called Durand Line is the cause of dissension today.) A sporting man, he took part in many a golf game and tennis match while in Lenox and also widened the local interest in cricket and introduced the Berkshires to a memorable equestrian event from the subcontinent—the gymkhana.

Here the Indian-born career diplomat photographed the natives, including Teddy Wharton, at play. The American sport baseball was new to him, and he captured both men's and women's teams playing on the lawns of Lenox.

In 1904, his first Lenox summer, Durand introduced local horsemen to cavalry training exercises, well known in colonial India, including "tent-pegging" (picking up a small target or tent peg with a lance at a gallop) and "lime-cutting" (cutting a lime, precariously balanced on a stick, with a sword at a gallop). After a few practices on the Dixeys' lawn at Tanglewood, a full-scale gymkhana was held there on September 7, 1904.[107] Women's classes included an egg and spoon race at a gallop and, most entertaining of all, a race of pet agricultural animals—pigs, ducks and sheep—to a finishing line.

Renting the Kinnicutts' house, Deepdene, for the next two summers, overlooking the Lenox Golf links, Durand earnestly worked on his golf game. His diary includes self-deprecating accounts of his games, including

Teddy Wharton (*accoutered in bow tie, vest, jodhpurs, riding boots and an ordinary leather glove for catching the ball*) with Lenox men's baseball team: William B.O. Field (*catcher*), Freddy Schenck (*holding the ball*) and John Sloane Jr. The boys are John E. Parsons's grandsons Percy (*holding the bat*) and John Morgan, 1905. *Durand Family Papers, SOAS, University of London.*

one in Stockbridge on October 18, 1906: "Nellie [Cornelia] Barnes and I v.s. [Walter] Nettleton & Mabel Choate. Nettleton was much better than I was, but Nellie Barnes saved us."[108] Lenox Golf Club caddie account books show that Teddy Wharton was a regular on the course. The *Berkshire Resort Topics* photographed Teddy in action in 1904. His stylish coolie hat looks like something Durand might have brought from India.

In Lenox, Durand was delighted to discover that cricket was being played by British-born tradesmen and estate staff. When the ambassador joined the games, other cottagers wanted to join; thus, Durand had a democratizing effect, mingling the talented estate employees with their aspiring employers.

Before Durand's day, the Lenox cricketers were pitted regularly against a Pittsfield team. With Durand's enthusiasm and influence, increased numbers made it possible to organize multiple Lenox teams. Often it would be "Married v.s. Single," at other times "Gentlemen v.s. Players" or "North of Lenox v.s. South." Teddy was not a player but a keen spectator. At an Elm

Ladies' baseball game in Lenox, 1905. *Durand Family Papers, SOAS, University of London.*

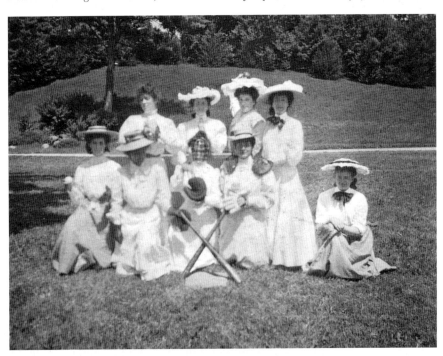

Ladies' softball team poses for "Sir Morty." Durand's daughter Jo stands behind the catcher, Evelyn Sloane. *Durand Family Papers, SOAS, University of London.*

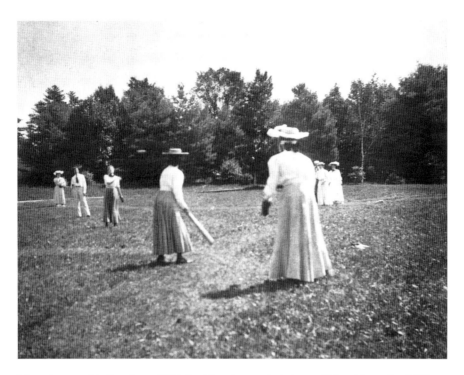

Mary Arrowsmith (daughter of Trinity Church rector) pitches to Helen Alexandre, 1905. *Durand Family Papers, SOAS, University of London.*

Court match in August 1905, he presented a handsome silver stein to the highest-ranking bowler.[109] The Mount's head gardener, Thomas Reynolds, often played (but regrettably did not make any of the team pictures). His future brothers-in-law Fred Heeremans and George Weston of Elm Court were teammates.

On Monday, October 22, 1906, Lady Durand officiated at a ceremony in the Trinity Church Parish House celebrating the past cricket season. Fred Heeremans of Elm Court and Thomas Page of Ventfort Hall had the highest averages in batting and bowling. According to the newspaper, the donor of the commemorative cricket bats awarded to the men was "the novelist Edith Wharton."[110]

The newspaper reported that the ambassador was present at the ceremony, but why was he not more active? The leader of the Lenox Cricket Club had just received a stunning blow from the British Foreign Office. The day before, he had received a letter at Deepdene from British foreign secretary Sir Edward Grey recalling him as ambassador, thus abruptly ending his lifetime career with the British colonial service. According to Durand's successor,

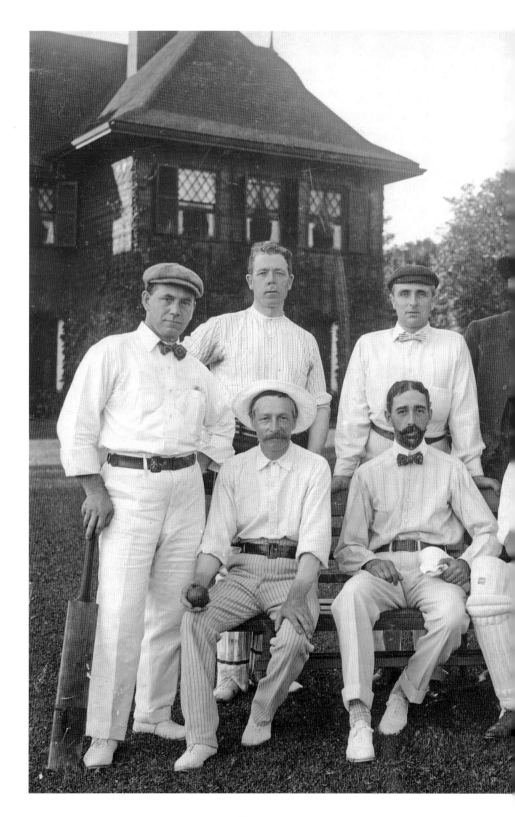

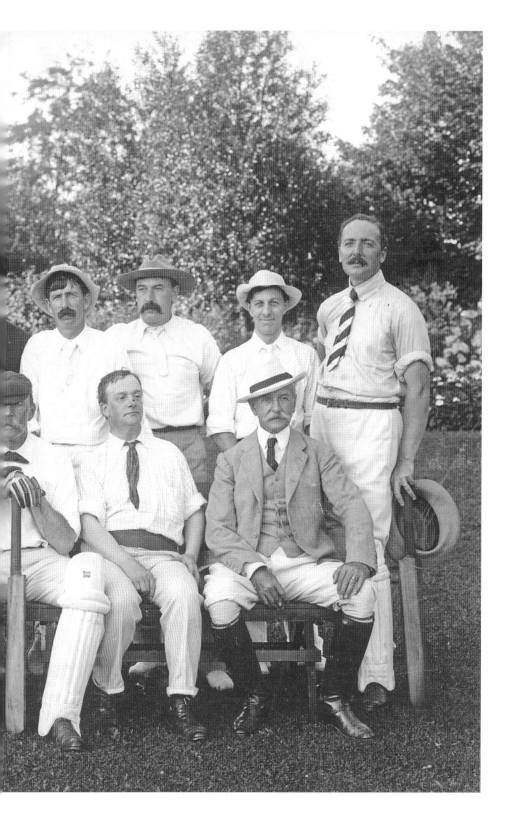

*Left*: The 1904 gymkhana program with silhouette by Arthur Dixey of Tanglewood. *Lenox Library Association*.

*Right*: Teddy Wharton on the golf course in Lenox. Berkshire Resort Topics. *November 1, 1904.*

Sir Esmé Howard, the courtly old-fashioned Durand and spontaneous and unconventional President Roosevelt were "incompatible."[111] It is possible that Sir Mortimer had avoided Washington too long, enjoying the sporting life in Lenox. He was let go without even the security of an ambassador's pension. In disgrace, Durand could not even afford to keep his beloved horse, Lancer. He had him shot.

On Durand's last day in New York before boarding the *Umbria*, he had visits from many old Lenox friends: the Barnes "girls," the Thatcher Adamses and the Choates.[112] Most moving of all was the arrival of two star cricket players—Jeffcott, Thatcher Adams's butler, and "old Whittenham," the Alexandres' butler—bearing a clock inkstand inscribed to him from the Lenox Cricket Club. Durand wrote, "It was good of the men."

*Pages 70–71*: The Lenox Cricket team poses at Elm Court. Standing are (*left to right*) William Sale (Elm Court staff), Patrick Devanney (Bellefontaine coachman), Mr. Elliott (Elm Court butler), Alfred Peters (Lenox painting contractor), Edwin Jenkins (Bellefontaine superintendent), Fred Heeremans (Elm Court superintendent) and William B.O. Field (owner of High Lawn); seated are William Cameron (sexton of Trinity Church), Carlos de Heredia (owner of Wheatleigh), Sir Mortimer Durand, James Whittingham (Spring Lawn butler) and William D. Sloane (owner of Elm Court), circa 1905. *Lenox Library Association*.

# 9

# *Hot House Nectarines from Baby Giraud*

O n a midsummer afternoon in 1904, Edith Wharton returned to The Mount to find a basket of luscious peaches and nectarines awaiting her on the hall table. They came from the greenhouse of the Fosters at Bellefontaine (today the home of Canyon Ranch). She immediately put pen to paper, addressing their six-month-old baby:

> *My dear Giraud,*
>
> *If you will permit such familiarity on the part of one who has not yet had the pleasure of knowing you.*
> *You could not have begun life in a more disinterested manner than by distributing your Mother's beautiful peaches + nectarines among her friends instead of keeping them all for yourself, as you must be sorely tempted to do.*

She went on to anticipate discussing this with the infant soon and, in true Edith style, closed with

> *meanwhile please allow me to call myself in anticipation what I am only awaiting the first opportunity to become—*
>
> *Your affectionate friend*
> *Edith Wharton*[113]

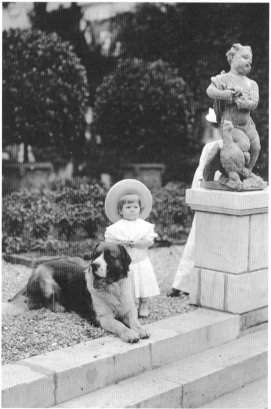

*Above*: Giraud Foster and Jean Van Nest Foster with Annie Oakley Delafield, known as "Tweetie," watching a tennis match at Elm Court, 1911. *Lenox Library Association*.

*Left*: Two-year-old Giraud "Boy" Foster poses at Bellefontaine with his Saint Bernard, Berry. His vigilant attendant steps behind a stone nymph, circa 1906. *Lenox Library Association*.

Giraud Van Nest Foster's miraculous birth on January 4, 1904, had been the talk of the Lenox colony. His mother, Jean Van Nest Foster (1860–1932), was forty-four years old—two years Edith Wharton's senior. In her twenties, a serious case of rheumatic fever left her without hair. She wore wigs and created impressive eyebrows with fine velvet strips, but it seemed unlikely that she would ever bear children. During their first ten years of marriage, she and her husband, Giraud, populated the house and grounds of Bellefontaine with marble goddesses, putti and nymphs.

In the fall of 1903, when the Fosters left Bellefontaine for Europe, the delicate Jean Van Nest Foster had no inkling she was pregnant. Neither did the French doctor, who told her that she had a malignant tumor and sent her home to New York to die. The American doctor reversed the diagnosis and delivered a healthy little boy. The astonished Fosters named him for his father, Giraud, but everyone used the nickname "Boy." At Bellefontaine, the staff called him "Master Boy," and in his Harvard years, it became "Master Giraud."

Of all the Lenox cottages, the Fosters' Bellefontaine was most faithfully operated on the formal scale of a British country house, with a large and loyal staff, as was the stately Renaissance Vernon Court in Newport, home of Jean's sister, Anna Gambrill.[114] At Bellefontaine, butler Auguste Chollet kept household life running smoothly with a second butler, Paul Roth, and a team of maids. In the lush greenhouse, superintendent Edwin Jenkins skillfully injected the melons with champagne for big parties. Boy Foster was mortified to arrive for his first year at Groton School with a domestic retinue, including his chauffeur and nanny.

The master gardener and estate superintendent at Bellefontaine was Edwin L. Jenkins (1873–1957). One year older than Reynolds, the Whartons' superintendent, he was also English. Edwin Jenkins came to work for the Fosters as a twenty-four-year-old when Bellefontaine was under construction in 1897. He spent his entire career on the place.[115] An avid chess, rugby and cricket player, he became involved in many sides of Lenox life: president of the local Shakespeare society, chairman of the Lenox School Committee and an active member of Trinity Church. In horticultural circles, he became well recognized. He served as president of the Lenox Horticultural Society, a member of the Massachusetts Horticultural Society and a fellow of the Royal Horticultural Society of England. His Swedish-born wife, Anna Hagberg (1866–1955), was remembered by Foster's grandson, Giraud Vernam Foster, as the best cook on the property. Between Christmas 1899 and Christmas 1900, three wives of head gardeners in Lenox, including

Edwin Jenkins (*fourth from right in back*) with other Lenox estate superintendents gathered for a meeting of the Lenox Horticultural Society in a local greenhouse. Front row in center are brothers-in-law Alexander MacConnachie of Tanglewood and William Henry of Groton Place, circa 1920. *Lenox Library Association.*

Anna Jenkins, were expecting twins, causing many jokes about the fertilizers in use on the estates.[116]

In Edith Wharton's day, the senior Giraud Foster (1856–1945) was immersed in the operation of his 150-acre farm, where he bred Jersey cattle and kept a stable of beloved pedigreed horses. He was a serious competitor against Teddy Wharton in Lenox horse shows and against Edith in the Lenox Horticultural Society shows. In 1904, his profusion of roses, chrysanthemums and carnations swept the prizes at the show in the auditorium of the new Lenox Town Hall. Upstairs, in the classes of vegetables, Bellefontaine's ten varieties of potatoes, six varieties of celery, three distinct varieties of tomatoes and six of cauliflower dwarfed all the competition.

Jean Foster died in 1932, but her husband survived her for another thirteen years. He was the longtime president of the Lenox Club and walked

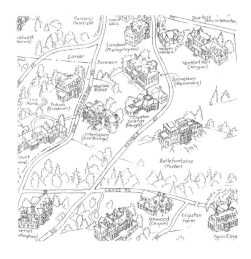

up Kemble Street every Sunday to Trinity Episcopal Church, where he was the senior warden. Although he employed a chauffeur, he often liked to drive himself. As his father's driving became more erratic, Master Giraud eventually arranged a speed trap with the local police on the Kemble Street hill to take away his father's license, with dignity.

On arriving at Bellefontaine on the evening his father died in 1945, young Giraud, now a man of forty-one, was greeted by the stooped, white-haired butler, Auguste, saying for the first time, "Welcome home, Mister Foster."[117]

# 9

# *Mrs. Chapin's View*

W hen Edith Wharton gave the Richard Watson Gilders directions to
the newly completed Mount, she told them to look for the driveway
just beyond "Mrs. Chapin's entrance." Mrs. Chapin's house, Nowood, was
a local landmark, and the Gilders' close friend Adèle Le Bourgeois Chapin
(1862–1936) was a literary, nature-loving, festive southern belle at the center
of Berkshire intellectual and social life.[118] In the 1880s, she brought the
fledgling Isadora Duncan to dance on Lenox lawns. She welcomed First
Lady Frances Cleveland to stay at Nowood in 1890 (between President
Cleveland's two terms in office) and entertained her at teas with friends and
walks through a local beauty spot, Stevens Glen in West Stockbridge.

In 1900, in the boat parade at the Stockbridge Bowl, Adèle Chapin
was Cleopatra, reclining under a canopy of Queen Anne's lace on a
barge bedecked with marigolds and goldenrod. Thirty years later, she
still remembered every detail. "I was seated among orange-coloured
cushions, arrayed in white with a saffron cloak, and veiled in floating,
white chiffon. I was rowed by four oarsmen, and at the prow sat a maiden
with a lyre."[119]

Adèle Le Bourgeois grew up at Belmont, a remote, colonnaded Louisiana
plantation on a bend in the Mississippi. She was educated first at home with
tutors preparing her three Yale-bound brothers and then at the select girls'
boarding school Miss Porter's in Farmington, Connecticut. In 1882, she
married one of her brother Edward's college friends, Robert W. Chapin,
scion of an old Springfield railroading family and cousin of the Barneses

of Coldbrook. She first discovered the Berkshires on their honeymoon at Broadhall, the old Melville house, now the Pittsfield Country Club.

In 1886, they bought Nowood (now Seven Hills Inn) in Lenox. For the next twenty years, through ups and downs in Robert Chapin's business life with the Ingersoll Rand Company in New York, London and Johannesburg, Nowood was the center of their family life. The simple wooden farmhouse, originally sited on open land, was named "No-wood" by the previous owners, Frederick and Elizabeth Sedgwick Rackemann, a play on the names of many grander country houses nearby—Tanglewood, Merrywood, Highwood.[120] The house was furnished with wicker and chintz and filled with books, bouquets and intellectual conversation. The view of Laurel Lake from the vine-festooned porch was across a "wild garden" of lupine, iris, mountain laurel and columbine in the crevices of tumbled stone walls. There was an orchard, and "when we went up first in the spring," Mrs. Chapin later wrote elegiacally, "I used to have a feast of apple blossom, decorating the house with them, and wearing them in my hair, and muslin dress, and having the children wear wreaths of them to receive their father when he came from New York."[121]

Nowood, the year the Chapins purchased it, 1886. A tennis net shows on the bumpy lawn to the left, and a maid eyes the photographer, Edward Morley of Lee, skeptically from an upstairs vantage point. *E.A. Morley,* Lenox.

Cecilia Beaux's portrait of Adèle Chapin and her baby daughter, Christina, circa 1900.
*From* Their Trackless Way.

When Belmont, battered first by war and then inundated by Mississippi floodwaters, finally burned in 1889, Mrs. Chapin's widowed father, Louis Le Bourgeois, joined his daughter's household in Lenox. A classical scholar in his college days at Georgetown, Le Bourgeois found a kindred spirit in the neighboring John O. Sargent, and the two cultured old gentlemen spent hours on each other's porches discussing translations of the Roman poet Horace.[122]

In 1900, after the birth of Mrs. Chapin's fourth and last child, Christina, Cecilia Beaux painted mother and daughter at Nowood. "She asked to do it," Adèle later remembered, "and said that I must not be unduly flattered; she wanted to paint us because I was so vast and old and experienced, and the baby so small and fair and inexperienced." Beaux posed them "in the bay window in the library where I sat every morning to read prayers, in a voluminous white muslin tea-gown, with the light behind me and on both sides of me through the muslin curtains."[123]

Cecilia Beaux was, at that time, summering with the Gilders in Tyringham, and in 1905, the Chapins put Nowood on the market and bought property in Tyringham. Ogden Codman considered buying Nowood, but eventually, it was Emily Spencer who purchased the place. With architect George de Gersdorff, Mrs. Spencer transformed the old house into a stuccoed and half-timbered villa she called Shipton Court (known today as Seven Hills Inn).

Intensely interested in people and intellectual conversation, Mrs. Chapin created salons wherever she lived—Lenox, New York, Johannesburg and, in later days, at 34 Kensington Square in London. Typical of her flair for introductions, in 1914, she greeted her Lenox cousin, journalist Jim Barnes, en route through London from the Congo, with a weekend invitation to stay with Lady Stanley, widow of the great explorer.[124] Her memoir, *Their Trackless Way*, is filled with personal anecdotes about fascinating figures of the era—Mark Twain, Saint-Gaudens, Sir Alfred Milner, John Singer Sargent, James McNeill Whistler.

But what did she make of her Lenox neighbor Edith Wharton? Not a word. They were exact contemporaries, born and died within months of each other. They had many friends in common—the Choates, the Gilders, the Kinnicutts and Henry James. Is it possible that the cupola of The Mount on its adjoining property was an offense to her view? Or was it, as her grandson later told me, that Mrs. Chapin disapproved of Mrs. Wharton for her treatment of Teddy?[125]

Or was it that there just was not room on the shores of Laurel Lake—or in her memoir—for two Lenox prima donnas?

## II

# *"Two Months' Agony"*

### *Ethel Cram*

To Ethel Cram…Edith listened," observed longtime friend Daniel Berkeley Updike years later, "and had she lived, perhaps Edith's life in certain respects might have been different." Reflecting on Edith's Mount years when her friend Ethel Latimer Cram (1868–1905) was a Lenox neighbor at Highwood, Updike wrote, "Ethel Cram was perhaps the person who had most influence with her at that period, for she had intellectual capacities that Edith respected and clear and unswerving views which gave her certainty on matters about which Edith was not so sure." Ethel was "a woman of the world without being a worldly woman."[126]

Ethel's father, Henry Augustus Cram, was an imposing—intimidating to some—mustachioed New York lawyer, remembered for "his distingué air, and the exquisite cut of his coat." [127] Her mother, Katharine Sergeant Cram, was also a formidable figure who orchestrated the careers of all her progeny. For some years, the Crams owned a spectacularly sited house in Newport called Land's End.[128] In the summer of 1891, Edith Wharton described her current educational challenges to her former governess: "[N]ext month Ethel Cram & I are going to begin Spanish together without a teacher!"[129] The Spanish initiative may have foundered, but two years later Edith and Teddy purchased Ethel's family house, Land's End.[130]

During Ethel's childhood in the 1870s and '80s, her family were not only Newport regulars but also spent seasons in Lenox. They always rented places—Bonnie Brae from the Barclays, Vent Fort from the Haggertys. After Mr. Cram's death in 1894, his widow began to rent Highwood on a

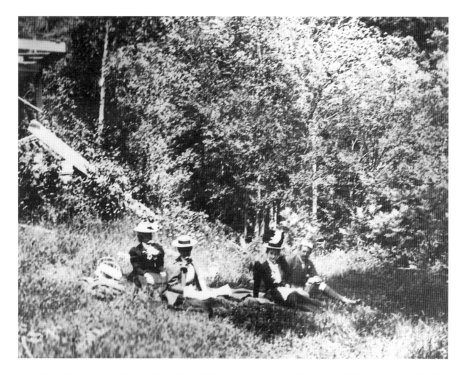

A striking figure in a plumed hat, Ethel Cram on a picnic with Annie Schermerhorn, Sybil Kane and Clinton Gilmore, 1897. *Jay Album, William Patten.*

regular basis from Louisa Bullard, sister of Charles Eliot Norton. Here Mrs. Cram, known in the family as "Marnie," would gather her children and grandchildren.

In 1900, the household at Highwood included Marnie's two unmarried daughters, Lily (in her early forties) and Ethel (in her early thirties). The middle sister, Henrietta (1863–1934), was married to J. Woodward Haven and with her small daughter Katharine also spent summers at Highwood. One son, J. Sergeant Cram, a New York politician and crack shot, nicknamed "Bang," came up occasionally from his life in the city. The recent death of another son, Harry, in Egypt in 1895 had been particularly hard on the steady, reliable Ethel.

Suffering from tuberculosis, Harry had gone to Egypt for the dry climate. When he became sicker, Marnie dispatched Ethel, then twenty-seven, to his side. Marnie instructed Ethel to nurse her older brother until he died, bury him in the English Cemetery in Cairo, plant ivy on his grave and bring back a piece for her. Ethel did as she was directed and came home with the ivy.

Harry's wife had already died in childbirth, and Marnie was in charge of bringing up their baby, Charlotte.[131] The two granddaughters, Kate Haven and the orphaned Charlotte Cram, were close in age, and their antics at Highwood in the early 1900s are vividly told in a combination of Kate's reminiscences and Charlotte's photographs:

*Our daily life at Highwood started for us children any time after dawn we felt like getting up, as a huge piece of bread and butter was always put by our bed at night....We usually sneaked out pretty early and went to help milk the cows. Then we had breakfast all of us and after that went up to Marnie's (Charlotte and I) where we joined hands with Marnie and marched from her bedroom door to a chair with a canné seat in front of the window singing the first verse of "Holy, Holy, Holy" (hymn #138). We would kneel around the chair and say our prayers plus the collect of the day. I often got bored and tied the string of the shade up thus rousing Marnie from praying too long. We then moved to the next window and Charlotte read the lesson for the day, in the King James Version of the Bible, and Marnie read it in her Greek Testament, criticizing the translation at great length. After that we were free.*[132]

Even to a child like Kate, her two unmarried aunts, Lily and Ethel, were a complete contrast.

*[Aunt Lily] hated men, had dreadful migraine headaches, cried a lot, tore up handkerchiefs, and had a series of female friends who came and visited her. She raised birds and her room was always smelly....When she was not sick she took Charlotte and me on lovely walks, bird watching and collecting wild flowers....When [she] was in bad shape she communicated with the rest of the family by notes delivered by Charlotte or me.*

*My Aunt Ethel was beautiful in a strange way. Dark red hair that touched the floor when she sat down very white face and bright green eyes. She played the piano almost professionally, was one of the first women to be interested in what is now known as social service. I remember her coming into Five East 38th Street [the Crams' New York City house] with her skirt badly torn after visiting the girls' prison on Randall's Island and Marnie sending her up to take a bath and wash her hair. She never married but there were always young men around obviously crazy about her.*

Kate Haven reading in a window seat at Highwood. Note the "window lingerie" scorned by Edith Wharton, 1907. *Cram/Haven Album, Susan Menees and Eliza Maybry.*

The perceptive little Kate Haven loved visiting The Mount, not because of her mother and aunt Ethel's friend Mrs. Wharton, but because "Mr. Wharton, Teddy, was terribly nice to us." "While Mummy [Henrietta] and Aunt Ethel enjoyed the intellectual and self-satisfied groups Mrs. W. gathered around herself," Teddy would take the girls off to the "very grand" stable to

inspect the carriages on display and "on Sundays a design in colored sand laid out on the floor." The Cram and Wharton households were closely linked at every level. Edith's maid, Catherine Gross, was the sister-in-law of Marnie's butler, Jean.

Kate could detect the generational divide between Edith and her kind, conventional mother-in-law, Nancy Wharton, who was Kate's grandmother's great friend. Overhearing the grown-up conversations, the little girl remembered that Edith found all Teddy's family "unbearably dull." Her grandmother, seeing the situation from old Mrs. Wharton's point of view, disapproved of the high-brow Edith, who "treated Teddy abominably." Kate assented, "Which she did."

The summer of 1905 turned into a nightmare for the Cram family at Highwood, and Kate remembered it all:

[Aunt Ethel] *had taken Charlotte and me up to the Lenox Library to do some book sorting and on the way home we met Mr. de Heredia pushing his motor, one of the first, up a hill* [on the Old Stockbridge Road]. *Our horse was frightened, shied, got the reins under her tail and ran away. My Aunt leaned forward to free the rein, her skirt caught in the wheel and she was dragged forward, the horse kicked the back of her head. She finally fell out of the cart. Charlotte and I clung on the seat until the horse turned sharp into the entrance drive of a cottage, and the braces broke leaving us unhurt in the cart. My Aunt was picked up by Mr. de Heredia and carried unconscious into the nearest house...as there were no telephones then,* [we] *waited until someone came along and drove us home.*

*When we got to Highwood, everyone was at lunch, and Marnie began to scold us for being so late. When we told her what had happened she ordered the express wagon brought at once, a mattress to be put in the back, climbed on the front seat, opened her parasol and said "I am going to bring my child home." She was old, over 70 then, and I can remember every detail of how wonderful she was.*

Ethel Cram hovered between life and death for seven weeks. At first, Edith Wharton, in a letter to Sally Norton, was hopeful. On July 25, she wrote:

*Yesterday the Drs. said they thought Ethel would recover + I am told they do <u>not</u> fear for her mind as the kick was behind the ear near the cerebellum. They did fear paralysis for that reason, but she moves*

# LATE NEWS

## THE DEATH OF MISS ETHEL CRAM AT LENOX

Injured by Kick of Pony on July 13 and Never Regained Consciousness—A CaseThat Attracted Much Attention Among Physiansand Surgeons.

Her Remarkable Physical Endurance— For Weeks She Took Liquid Nourishment Througha Tube— Fatal Wound Did Not Heal—Her Life in Lenox

Miss Ethel M. Cram, whose skull was fractured over the left ear by a kick from a pony on July 13 at Lenox, died in that town at 10:20 o'clock last night. For several days past it had been evident that the end was being only postponed and that death was a question of hours. At times since the accident it seemed that Miss Cram was rallying and that her rugged physique would be able to overcome the effects of the fearful blow she had

*Berkshire Evening Eagle*, September 15, 1905.

*perfectly, is fed through the mouth etc. She is still quite unconscious but that is perhaps well. If she recovers it will be one of the most remarkable cases in modern surgery, I believe.*[133]

But it was not to be. After agonizing vigils by her family, including her pregnant sister Henrietta, and many friends, the comatose Ethel Cram finally died on September 14. Edith wrote Sally:

*Ethel died this morning. One can only give thanks for the bitterness of death is long past. Even now, I shudder to think of the effect that this two month's agony must have on Henrietta and the future of her child. How often I have thought of that article of Dr. Baldwin's during these terrible weeks! I am sure I should have the "triste courage" in such a case, to let life ebb out quietly—should not you?*[134]

Ethel Cram's heartbreaking demise gave reality to Judge Simeon E. Baldwin's impassioned articles and speeches.[135] He saw new medical advances as a double-edged sword. In some cases, they "hold us back from the grave in a state of long-drawn agony, for a few days, a few months, a few years, to which the physician of antiquity was a stranger."

In her letters to Sally Norton, Edith did not reveal the drama after Ethel's death at Highwood that little Kate Haven remembered. "Pussy [Edith Wharton's nickname] arrived with a poem she had written in memory of [Ethel]." The distraught Marnie, who had always distrusted Edith's writing motives, was outraged. Did she intend to publish the poem, making their grief public? Kate's pregnant mother, Henrietta, wept, and "there was a terrible scene." The poem does not survive, but Edith's next

novel, *The Fruit of the Tree*, had much to say about new medical procedures prolonging the misery of terminal patients.

When Kate Haven's little sister was born five months later, she was named Ethel. With two daughters and a new inheritance from Woody's father, Henrietta and Woody Haven began house hunting for their own summer place. In 1909, they chose Emily Tuckerman's Ingleside in Stockbridge.

# Picnics with Edith Wharton

E dith Wharton loved a picnic. Her old friend Gaillard Lapsley, a Cambridge University don, recounted the "meticulous ritual" of these occasions. "[She] chose the position with the care and deliberation of a Roman general selecting a fortified camp."[136] Others, like Percy Lubbock, really would have preferred "sitting at a table under a ceiling." Over their thirty-year friendship, he was railroaded into too many of Edith's picnics:

Edith is clearly in charge. Dressed in a snappy madras skirt, she bends over the picnic basket while her minions, Henrietta Cram Haven, Adele Kneeland and Alice Munroe, await instructions. *Cram/Haven Album, Susan Menees and Eliza Maybry.*

Picnic over, Edith enjoys a cigarette in the open air. *Beinecke Rare Book and Manuscript Library, Yale University.*

*Some there may have been who felt her passion for a picnic was excessive; but she didn't stay to argue....If there is one thing on which she prides herself it is her unerring eye for a picnic spot...[t]hat found, Edith settled, the strapped hampers...are set by her side, rug spread, guests "star scattered" in their places.....Nobody at this point is to help her: she unpacks, distributes apportions all.*[137]

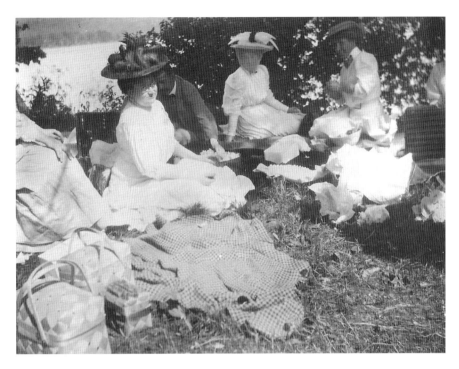

Napkins, plates, knives, forks, glasses, sandwiches and drinks distributed, the group settles down for lunch. From the left are the bespectacled Alice Munroe, Woody Haven reaching for a morsel and the fair Henrietta veiled against sun and bugs. Beside Henrietta, conservationist Mary Parsons is wearing a simple hat conspicuously undecorated with bird feathers. All the picnickers are old friends. In the previous decade, Woody's brother, George Griswold Haven Jr., had been Miss Kneeland's beau. Her forceful aunt Alice Taintor disapproved of the young man's character and discouraged the romance. *Cram/Haven Album, Susan Menees and Eliza Maybry.*

Fourteen-year-old Charlotte Cram's photos illustrate such a picnic beside a Berkshire lake in 1907. One of Edith's motivations for lunchtime picnics was to give her staff time off, and this al fresco meal with the Cram family would have given their interrelated servants a break together.

# *The Ingleside Story*

Few places in the Berkshires are as little changed since Edith Wharton trod its verdant lawns as Stockbridge's Ingleside, still a private house. And yet, few social lynchpins are so completely forgotten today as Ingleside's Emily Tuckerman (1853–1928). Painted in Newport as a vivacious twenty-year-old with a jaunty plumed hat by William Morris Hunt and in London as a contemplative forty-five-year-old leaning back in her chair by James McNeill Whistler, Emily Tuckerman was a confidante of a host of intellectuals, artists, architects, diplomats and writers on both sides of the Atlantic.

In August 1904, while Berkshire social life was at its height, and Scribner's was setting unwelcome magazine deadlines for her temporarily stalled novel, *The House of Mirth*, a weary Edith Wharton wrote Sally Norton: "Miss Tuckerman admonished me the other day that I ought 'never to be in a hurry.' I wondered how she had reconciled the problem of doing something and yet not too many things? I should like the recipe!"[138]

Emily Tuckerman may have never written a novel, but everything she undertook, she did well. In 1904, when advising Edith Wharton, she had recently founded the Instructive Visiting Nurse Association in Washington, D.C. She was managing two family houses her parents had built: Ingleside (1874) in the summer and in the winter a vast, Romanesque pile in Washington, D.C. (1885), next door to Henry Adams and a block from the White House. She was a legendary hostess with a dedicated circle—Harvard professors, artists, ambassadors and politicians, including two presidential

Oil portrait of Emily Tuckerman, 1870s, by William Morris Hunt. ©*1996 Christie's Images Limited.*

families, the Grover Clevelands and the Theodore Roosevelts. Like Edith Wharton, she was well read and a witty, thoughtful and erudite conversationalist in multiple languages: English, French, Italian and German.

Her Stockbridge friends, also well known to Edith, revered her. Joseph Choate jested she was "senatorial" material.[139] Daniel Chester French's wife, Mary, remembered "Miss Emily's high character and love of the beautiful" and described her as "a power in the life of the town."[140] The rarely daunted Edith Wharton, nine years her junior, wondered about her "recipe."

Emily Tuckerman was in her late teens when her parents, Lucius and Elizabeth Gibbs Tuckerman, gave up resort life in Newport for Stockbridge and bought property near their friends, Charles and Susan Butler, at Linwood.

Retiring from a successful career in iron manufacturing, Lucius Tuckerman seems to have hired in 1874 a then-fashionable Newport architect, Dudley Newton, to enlarge one of Stockbridge's grandest late eighteenth-century residences on the western outskirts of town at a scenic point in the winding course of the Housatonic River.[141]

Emily later wrote that her father wanted their Stockbridge house to be modest, "as simple as possible so he could turn the key on it at any time."[142] But when in December 1874 a reporter for the *Gleaner* passed through grand new rusticated stone gate posts with "Ingleside" in raised letters and peered into the gaping foundations, he predicted the Tuckermans were undertaking "a spacious mansion building."[143] By Berkshire standards of the day, the towering three-story house with its steeply pitched and clipped gable roof line was substantial.

"My parents were keenly interested in the development of the place," Emily later remembered, "in planting fine varieties of trees and watching their growth from year to year." James H. Bowditch, a landscape architect

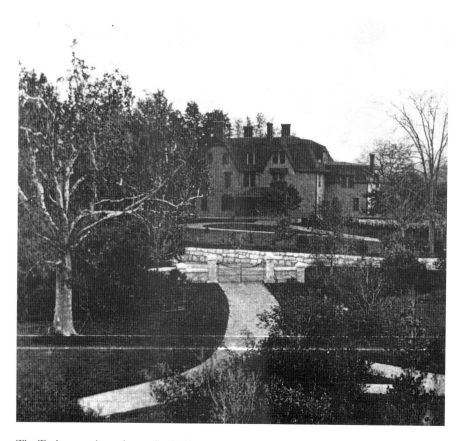

The Tuckermans' new house, Ingleside, as seen from Southmayd, circa 1880. *Historical Collection of the Stockbridge Library.*

from Pomfret, Connecticut, made the initial plantings, but soon Lucius Tuckerman was annoyed by the results.[144] Spurred by his wife, he turned to the eminent park designer Frederick Law Olmsted in the fall of 1881:

> *Mrs. Tuckerman and I have a place here of about 500 acres and for six years past have been trying to make it a pretty family home....We want a little advice and Mrs. Tuckerman says "Is it not possible to get Mr. Olmsted to come up to make us a visit of two or three days?" I did not suppose that you did any professional work for private persons now but Mrs. T. says to the contrary.*[145]

Tuckerman's offer of a guest room and a fee of twenty-five dollars per day as well as expenses did not get Olmsted up to Stockbridge that fall. But Mrs.

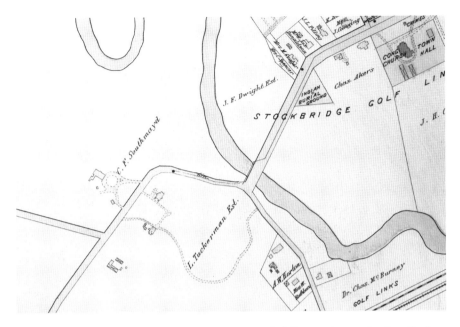

The Ingleside property showing the main house, farm buildings and grounds where Emily and her widowed mother lived, farmed, gardened and entertained. *Barnes & Farnham map of Berkshire County, 1904.*

Tuckerman was right; the great landscape architect was transitioning from public park commissions to private work, and by spring, Mr. Tuckerman had hired Olmsted for his son Walter's new property at Oyster Bay.[146]

Mrs. Tuckerman took on the farm management at Ingleside. Like so many others in the Berkshires—Dr. Richard Greenleaf, John O. Sargent and the two Richard Goodmans—she became a pioneer in applying scientific methods to farming. Her son Bayard remembered, "What was to be planted, and where, was entirely by her direction, and the suggestions of agricultural experiment stations were carried out on her place in spite of the conservative opposition of the farmer."[147]

Meanwhile, Emily was becoming a rosarian. She and her mother "kept up a great rivalry on our demands on the men for the farm or for flowers. I wanted them for my domain of roses, when she maintained that haying could not be postponed."[148]

The common love of roses, as well as literature, led to a twelve-year correspondence between Emily and an elderly Harvard professor, Francis James Child (1825–1896). Child was a Chaucer scholar who dedicated his later life to collecting Scottish folk ballads. He considered himself Emily's

"step-step uncle," as they were connected by marriage through the large and literary Sedgwick family.[149] She described him as "a benevolent little gnome…with gold rimmed spectacles and tight yellow curls," an infectious reader who would entrance his audiences reading out loud Chaucerian ballads and Shakespearean plays under a tree, by a brook or beside the Sir Walter Scott fireplace in the Ingleside library.[150] Roses suffused their letters, as they shared pruning advice, battles with insects and blights and the joys of perusing the latest catalogues. The Washington/Stockbridge "society hostess" and the Cambridge academic also traded their literary finds, ranging from a new English translation of *The Mighty Magician* by seventeenth-century Spanish playwright Pedro Calderón to "The Siege of London" and "Pension Beaurepas," the most recent short stories of their mutual friend, "Harry" James.[151]

Another older intellectual who came under Emily Tuckerman's spell in the late 1880s was English poet and critic Matthew Arnold (1822–1888). A highlight of his Stockbridge summer of 1886 was "botanizing" with Miss Emily. He would bring her bunches of wildflowers to Ingleside to identify, and she would lead him to obscure swamps and roadsides in pursuit of the cardinal flower or the fringed gentians. She lent him her well-worn copy of Asa Gray's *Manual of Botany* and later treasured Arnold's handwritten notes in the margins.[152]

Emily Tuckerman's Stockbridge life was spent with her roses, paddling on the Housatonic and long rides and drives with beloved horses. Her riding companions were her siblings, Walter, Bayard, Alfred, Lucy and Laura,

Two, of a set of six, Minton fireplace tiles depicting dramatic scenes from Sir Walter Scott novels. Installed in the 1870s at Ingleside for the Tuckermans. *Nannina Stearn.*

and their spouses and various neighbors—the delightful Joseph Choate, the long-term Episcopal minister in Stockbridge Arthur Lawrence, the eminent surgeon Charles McBurney. Then there were houseguests, including various Roosevelts, particularly Theodore's first cousins Alfred and Emlen, and President Cleveland's Secretary of Treasury Charles Stebbins Fairchild. On a ride with the house-hunting sculptor Daniel Chester French and his wife, Mary, in 1896, Emily Tuckerman took them on a back road in Glendale to see the old Warner farmhouse with its "soul-satisfying" view of Monument Mountain. Here the Frenches would create their own place, Chesterwood.

Architect Charles McKim was a frequent visitor. In the late 1870s, early in his career he had designed several commercial buildings in New York for Lucius Tuckerman, and he remained Emily's "valued friend."[153] Both in the Berkshires and Washington, D.C., Emily read Horace, Dante and Virgil with her father's long-lived schoolmate and co-founder of New York's Metropolitan Museum, Samuel Gray Ward (1817–1907). Once an able banker, Ward was also an amateur painter, poet and scholar. Emily considered the old gentleman "a man of the world…with clever brown eyes twinkling with humor.…We were great pals in spite of the disparity in years and I shall always feel deeply indebted to him for the most stimulating mental companionship."[154]

A traveler since her youth, Emily went abroad frequently. She had an extended trip to Italy with Charles and "Aunt Sue" Butler of Linwood in 1881–82 and accompanied artist Frederic Church and his ailing wife to Mexico in 1889. On the 1898 trip—when she sat for James McNeill Whistler in London—she cheerfully wrote her family from the sodden Lake District, "There is no danger of my marrying an Englishman, I had rather be an old maid and sit in the sunshine at home."[155]

On her English trips, Tuckerman would catch up with her old friend Henry James, whom she had first known as "a young fellow of such charm and promise." When staying with Edith Wharton at The Mount, James came to Ingleside for the first time in October 1904. Sitting in the dining room or on the lawn at tea, with the spectacular southern view of Monument Mountain as a backdrop for scintillating conversation, James was entranced. "I carry away a most charming impression" were James's farewell words to his old friend and hostess.[156]

Continuing that winter on a speaking tour to Washington, D.C., Henry James regaled Edith Wharton in condescendingly Jamesian terms. He called the nation's capital "the so oddly-ambiguous little Washington," but he did admit to enjoying the company of Henry Adams (with whom he stayed),

Drawing of Emily Tuckerman in 1898 by James McNeill Whistler. *Freer Gallery of Art, Smithsonian Institution, Washington, D.C.: bequeathed by Miss Emily Tuckerman and gifted to the Freer Gallery through Charles Adams Platt, F1925.1 a-b.*

LaFarge, Saint-Gaudens, Miss Tuckerman, Mrs. Lodge and also Mrs. Kuhn, Emily's first cousin and Edith's dear friend in Lenox.[157]

Later that spring, James was at dinner at the Tuckermans' 1600 I Street house, and the company planned a sightseeing trip. On May 1, a unique combination of enthusiastic tour guides—First Lady Edith Roosevelt, Charles McKim, Emily Tuckerman and French Ambassador Jusserand—escorted James by boat down the Potomac River to Mount Vernon for what Mrs. Roosevelt described as "a delightful wandering about the old house & garden."[158]

When World War I broke out, Emily Tuckerman responded to a plea from Edith Wharton. In a matter of months, she and Frances Folsom of Lenox raised $1,426 from among their circle of Berkshire friends to pay for the cost of an ambulance.[159] The ambulance was just the beginning. At the age of sixty-three, Emily set sail for France to serve as a nurse in the American ambulance corps in Paris.

Back in the winter of 1898, when Theodore Roosevelt's wife, Edith, was dangerously ill after the birth of her fifth child, Quentin, the Tuckerman family stepped in to help. The eldest boy, Ted, went to stay with Emily's sister Laura Lowndes, and in the big house on I Street, Emily and her mother took on the three younger ones: Kermit, Ethel and Archie. Two nurses came, too. Emily wrote, "T.R. would drop in once or twice every day to see his children on his way to and from the Navy Department." The Spanish-American War was brewing, and Theodore was "ardent for war and determined to enlist as of course he did."[160]

Twenty years later, World War I was being waged in Europe, and now young Quentin was in uniform with the U.S. Army Air Service. He was killed in air combat over Paris on July 14, 1917. Two of President and Mrs. Roosevelt's old friends who took Quentin out for a meal in Paris before his death were Emily Tuckerman and Edith Wharton.

Meanwhile, back in Stockbridge, Emily Tuckerman sold Ingleside in January 1909, a few years after her mother's death, and moved to another lovely village landmark, Old Place, on a smaller property with plenty of space for her roses but not acres of lawn and farmland.

The new owners of Ingleside were Edith Wharton's close friends Henrietta Cram Haven (1863–1934) and her husband, J. Woodward. Woody's wealthy father, George G. Haven, died in March 1908.[161] The younger Havens, who had long stayed with Henrietta's mother, Mrs. Cram, at Highwood, were finding that household a bit crowded. Now they were in a position to buy their own country house. They were also building

Drawing room at Ingleside created for Woodward and Henrietta Cram Haven in 1909. In 1921, *Century Magazine* editor and poet Robert Underwood Johnson bought Ingleside, and it remained in the Johnson/Deely family for nearly a century. *Christopher Little.*

a new house at 18 East Seventy-Ninth Street in New York with Edith's old collaborator Ogden Codman.[162]

There is no documentation that Codman had a hand in any changes for the Havens at Ingleside, but his influence is suggested in the elegant, classical drawing room of 1909. This charming "salon de famille," such a contrast to the rest of the Victorian Tuckerman house, is a space worthy of both the authors of *The Decoration of Houses*.[163]

# Codman's "Blue Room" in Lenox

## Miss Kneeland

I t is splendid to have a room in Lenox," Ogden Codman wrote his mother in February 1896, when Adele Kneeland commissioned him to design a new reception room at her grandfather's house, Fairlawn.[164] In recent years, Edith Wharton and Codman had worked together to bring classical ideas into her two Newport houses: the humble Pencraig Cottage on her parents' property and then "the incurably ugly" but spectacularly sited Land's End (John Hubbard Sturgis, 1865). In the course of 1896, while Codman was designing Kneeland's "Blue Room," he and Edith were swapping chapters back and forth on their evolving book project, *The Decoration of Houses*.

The towering—in both stature and personality—Adele Kneeland (1856–1937) was a remote relative of Ogden Codman. They became immediate allies and kindred spirits, shopping together in New York for sconces, fabric and mirrors for the Blue Room and laughing over the "forlorn" taste of others, including some of their relatives.[165] Codman, at the time, had a low opinion of Lenox and its "vulgarians," but he would, in years to come, actually enjoy the comforts of his sister-in-law Harriet Burden's place, Underledge, on Cliffwood Street.

In October 1896, Edith wrote her governess Anna Bahlman that Adele Kneeland invited her and Teddy to stay.[166] Edith was, no doubt, curious to see the progress of the Blue Room, where she would later attend various occasions—a wedding reception, dinner party or meeting of her and Kneeland's shared local causes, the Lenox Horticultural Society and the Lenox Library Association. Codman's beautifully proportioned room,

Ogden Codman's watercolor elevation drawing for the "Blue Room" at Fairlawn. *Metropolitan Museum of Art 51.644.75/15.*

paneled in French walnut, bedecked in blue and cream damask with a red marble fireplace, was a spectacular success, only to be rivaled in a few years' time at The Mount.

Adele Kneeland had inherited her grandfather's Lenox property on West Street where she had grown up.[167] In her forties and unmarried, she began transforming the place to make it her own. After the Blue Room, she took on the sloping gardens, first with John Huss, George Morgan's landscape gardener at Ventfort Hall, and later with her superintendent, Scottish horticulturalist Charles MacLean. They laid out wide gravel paths with shallow steps leading down a series of terraced lawns to a lily pond shaded by a picturesque willow. There were circular perennial beds, arbors, a secluded rock garden, a rose garden and a plum and apple orchard beyond.[168] Above the fruit trees, the domed treeless hill, known as Bald Head, loomed in the distance. Writing in the pages of *Country Life in America* in 1911, Thomas McAdam pronounced Fairlawn more successful than all the great Lenox estate gardens "because Miss Kneeland knows all the flowers and gives her garden the most intimate personal attention."[169] Louise Shelton featured Fairlawn in her 1915 book, *Beautiful Gardens of America.*

Adele Kneeland represented many in Lenox who were old friends of Teddy Wharton's mother but also embraced his interesting, young wife, Edith, as an addition to the local scene. In 1903, the three judges of the Lenox Horticultural Society Annual Show were a potent trio: Kneeland, Mrs. Carlos de Heredia of Wheatleigh and Edith Wharton.[170] At the annual event five years later, the competition was fierce. The *New York Times* reported,

Adele Kneeland, circa 1895. *Courtesy of Harry Munroe.*

"Mrs. Wharton made a sweeping victory in the classes for the best collection of annuals and perennials," but "Miss Adele Kneeland's showing of phlox was not approached by other exhibitors."[171]

At Fairlawn, a visitor might meet a wide array of interesting personages. Adele's sister Alice married into the Munroe family, Edith and Teddy's bankers in Paris. Anyone traveling abroad was glad to have a contact with the long-established banking house Munroe & Company. Adele Kneeland's friends ranged from landscape architect Fletcher Steele, members of the artistic Emmet family and high-ranking Episcopal clergymen to visiting aristocrats and diplomats. Even a well-dressed—but apparently deranged—"anarchist" called on Kneeland in the summer of 1904. He claimed to be a gardener

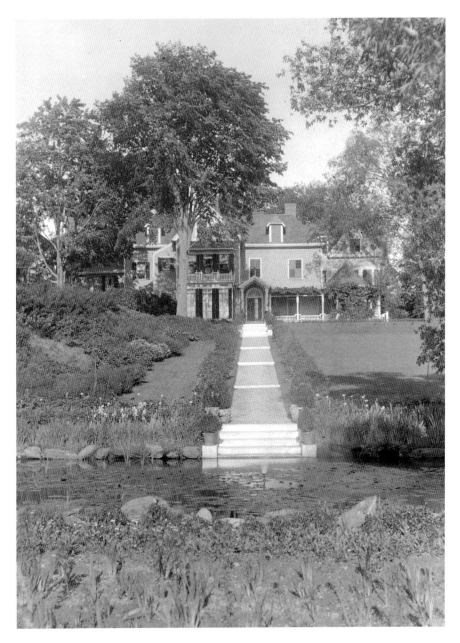

A postcard of the Fairlawn garden with a path descending to the lily pond, circa 1920. *Lenox Library Association.*

George Munroe puts an arm around his younger brother, Henry, on the Kneeland-Haven-Wharton lakeside picnic of 1907. Three years later, George died at Harvard. *Cram/Haven Album, Susan Menees and Eliza Maybry.*

seeking employment but might have been targeting the tenant of Henry W. Bishop's cottage across West Street, British ambassador Sir Mortimer Durand.[172] Police chief William Dunn came down from the nearby town hall and removed him before there was an international incident in quiet Lenox.[173]

Within the Fairlawn ménage, Kneeland harbored two, and even sometimes three, seamstresses and often Trinity Church's assistant clergyman. When the construction of Trinity Church in Lenox stalled in 1886, the Kneeland women—Adele, her sister Alice, their mother and Aunt Alice Taintor—financed the completion of the chancel in memory of Adele's brother George. George Kneeland had recently died of pneumonia at the age of twenty-four. For many years, Kneeland underwrote stipends for Trinity's choir members and made so many critical contributions to the church that local Catholics joked that the doctrine of the "Trinity" for Lenox Episcopalians was "Father, Son and Miss Kneeland."[174] She collected rare theological books and installed a private chapel in Fairlawn during the flu epidemic of 1918.

Charlotte Cram's photos of a Kneeland-Munroe-Haven-Wharton lakeside picnic in 1907 show two of Adele's nephews leaning against a tree: the handsome Harvard-bound George Kneeland Munroe in his white flannels with an arm around his solemn little brother, Henry.

Three short years later, this golden boy, George Munroe, was dead, the victim of an infection that would have been easily conquered today with antibiotics. He had accelerated through college in three years and was, in the spring of 1910, a history and political science graduate student at Harvard. He suffered a severe ear infection and died of complications after a mastoid operation.

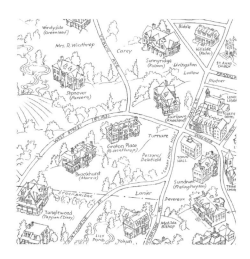

George's body was brought from Boston to Lenox and borne down the cypress-framed stone steps of the spacious family lot at the Church on the Hill. The impressive committal service was held in full Kneeland style, with the Trinity Church choir in vestments singing a cappella seven psalms and canticles.[175] Nearby lay the deceased boy's namesakes, whom he had never known—uncle George who died in 1883 and great-uncle George, in 1854. All three Georges died as young men in their twenties.

Leaving the cemetery, the grief-stricken Kneeland-Munroe family returned to the Blue Room at Fairlawn to mourn this fresh loss.

# The Court House Hill Coasting Accident, Kate Spencer and Ethan Frome

I had the story, bit by bit, from various people," Edith Wharton opens *Ethan Frome* with a narrator's quest. In the course of her activities on the board of managers at the Lenox Library, Wharton, too, must have made quiet inquiries after she first met Kate Spencer, the reticent and intelligent new assistant librarian. Why the scar on the side of the young girl's face, and why her difficulty hearing in the hushed tones required at the library in those days? What had really happened on that icy day in March 1904 when a happy group of high school students lost control of their sled at the bottom of Court House Hill?

Edith Wharton had been abroad in the winter of 1904 when Lenox was stunned by a crash on the fastest coasting hill in town—the same steep road where, a year later, her friend Ethel Cram had that fatal summertime accident.

Lenox's spectacular hilly terrain was, throughout the nineteenth century and first years of the twentieth century, an exhilarating winter coasting challenge. Back in 1844, a student at Elizabeth Sedgwick's school, the daredevil Louisa Adams, regaled her grandmother Mrs. John Quincy Adams of coasting exploits: "I believe nothing could be better fun than the pranks we cut up here." The thirteen-year-old schoolgirl wrote, "We are all kept pretty close till evening when we take our sleds and steer for the hill. It is half a mile long and we go down like a flash."[176] The coasters, like Louisa, could start at the Church on the Hill and maintain speed along the packed snowy surface of Main Street to rocket down Court House Hill on

Lenox's snowy Main Street with the Church on the Hill in the background, 1890s. *Lenox Library Association.*

the Old Stockbridge Road. It was exhilarating and even romantic. Louisa's grandmother might have raised her eyebrows when she read, "The German teacher Mr. Von Mandelslohe has got a sled and takes me with him very often. Sometimes we tumble into a snow drift and get up looking like ghosts with our faces quite covered with snow. It is glorious fun."

It was also treacherous, and the helmsman's control and judgment were crucial. In his boyhood days in the 1880s, James Barnes, later an editor of Edith Wharton's work at Appleton and Company, had a close call coasting with village friends.

*Court House Hill in Lenox was the steepest incline….When it was icy, sleighs and teams abandoned it almost entirely to the coasters.…It was dangerous for the reason that a good third of the descent was invisible from the push-off at the top. Never was the hill faster than on that cold brilliant afternoon when the crew of the lightning Clifford "bob" started—young Clifford, the carpenter's son, was steering. There were some shouts from ahead as we got going, all lying prone, packed almost on top of one another, I next to the steersman, clinging to the little handrail and holding him in. As we reached the top of the first dip, Clifford shouted, "Drag-drag!" I looked up…there, coming up, filling the whole road was an ox-team hauling a sled full of heavy cordwood! Despite outflung feet and hands, down the bob-sled*

*charged, its speed but slightly stemmed; the succession of snows had drifted to the right, making a steep, high bank—a sickening swirl and we almost turned over as we mounted it.... The next thing any of us remembered we were in a long wood-shed where there was just space enough to come to a halt between closely packed tiers of kindlings. Quick thinking and quick action had saved our lives—Clifford had taken the only chance![177]*

Coasting, in this era before automobiles, was a sport, comparable to skiing today. Visitors at the Curtis Hotel would join Lenox residents for wintery rides down the precipitous hills. This was an activity everyone could enjoy. The correspondent for the short-lived *Lenox Echo* wrote in March 1883, "Lads and maidens, even the 'old folks' are tempted out occasionally to take a rush down the hill and then climb once more."

All ages enjoy coasting atop Court House Hill headed down West Street. Guy Ward, the debonair stable manager of Clipston Farm, gives a boy the front seat while he manages the steering, pre-1906. *Lenox Library Association.*

The winter of 1903–4 was the coldest one on record for thirty-five years. The snowfall was not unusual, but it never melted. The temperature stayed relentlessly in the single digits without thaws.[178] The Mount was closed as usual, and the Whartons had taken refuge in warmer climates. Edith wrote from Rome that her aging husband, whose accomplished ice skating a decade ago had turned heads in St. Moritz, was reveling in every report of a blizzard back in New York.[179]

On the fatal Friday afternoon of March 11, 1904, the coasting conditions on Court House Hill were considered perfect—a sheet of ice. The steep section of road was "little used by teams at this season," so the coasters had the hill to themselves.[180] Many were out coasting that day, especially after school. Eighteen-year-old Kate Spencer brought her brother Herbert's "double ripper" sled, and five friends—Hazel Crosby, Chrissie Henry, Lucy Brown, Mansuit Schmitt and his sister Barbara—joined her. They were all from well-known local families—children of tradesmen, carpenters and estate superintendents.

The lone boy, Mansuit Schmitt, took charge of the navigation. The sled had been made by his carpenter father, Victor, and he knew how to manage it.[181] It had two sets of runners, one for the front section and another for the back. The helmsman controlled the steering by ropes. Throughout the afternoon, Hazel Crosby had begged for the front seat and a chance to steer. Mansuit finally gave in to his pretty classmate for the last run. His sister Barbara had a sense of foreboding and declined this run, leaving to go on an errand. The rest climbed on the sled, each holding the other's legs to keep their feet from dragging. Mansuit, relegated to the back, gave the sled its last push. The course was rutted, and as the sun began to set, the route was even icier. Their speed was later estimated at fifty miles per hour. Hazel was considered an experienced navigator, but she could not maintain control. The sled-load of terrified students slammed head first

Typical double ripper sled of Schmitt's design, circa 1900. *Lenox Library Association gift of Judge Charles Alberti (1981), on loan to the Lenox Historical Society, photo by Nannina Stearn.*

into a lamppost at the bottom of the hill. The coasters were thrown out in a heap of unconscious bloody bodies with fractured limbs and internal injuries. The sled, surprisingly unscathed, careened on down the road.[182]

The neighbors took the injured into their houses. Dr. Hale of Lenox was on a trip to Boston, but doctors came from Lee and Pittsfield.[183] Hazel was transported to the Pittsfield hospital, the House of Mercy, where she died that night. The girls closest behind her—Chrissie Henry and Lucy Brown—had broken bones and fractured skulls. Kate Spencer suffered a dislocated hip and facial injuries, and the delirious Mansuit Schmitt had head injuries.

Over that weekend, Lenox was shrouded in gloom, braced for more bad news. Would the survivors recover? The

Victor Schmitt of Cliffwood Street, carpenter of the sled in Kate Spencer's accident. *Kate Kane Naylor.*

most seriously injured was Chrissie Henry, daughter of Grenville Winthrop's estate manager. She hovered in and out of consciousness, bleeding from her eyes and nose, in the family house on West Street. Still ignorant of her friend's death, she would relive the trauma, crying out, "O Hazel!" The *Eagle* also reported that poor Mansuit was wracked with guilt, "feeling that

## MASS., SATURDAY, MARCH 12, 1904.

# LENOX HIGH SCHOOL GIRL
# DASHED TO HER DEATH

*Berkshire Evening Eagle* headline, March 12, 1904.

Christmas tags from Edith Wharton to librarian Kate Spencer, probably once attached to a present of carefully chosen books. *Lenox Library Association.*

he was entirely responsible for the accident."[184] On Monday, the entire high school student body filled Trinity Church for Hazel's funeral.

Three months after this appalling accident, Kate Spencer, the only high school senior on the sled, stood thin, but erect, in the center of her graduating class photo on the steps of the Lenox Academy. Her hip appears to be on the mend, but she is still using a cane, which she hides behind her classmate's skirt to the right. The scars on the side of her head are not visible from the front. Her shorn hair is growing back in an uneven bang. Her expression conveys the look of a survivor.

Surrounding Kate are others who have been devastated by the accident. Wearing white, Barbara Schmitt (Mansuit's elder sister who had refused to take that last run) stands to Kate's left. Behind Kate, with his bow tie askew, is Harold Crosby, Hazel's brother. Next to him, assistant teacher Louise Parsons may have seen the worst. Her family house overlooked the accident scene, and the Parsons family rescued three of the injured: Lucy, Kate and Mansuit.[185] Hazel and Chrissie were carried into the Witherspoons' house next door.

Soon after graduation, Kate Spencer was hired as assistant librarian at the Lenox Library. Serving on the all-women associate board of managers, formed in 1903, Edith Wharton came to know this accident survivor. They seem to have bonded over the love of books, and in the library archives are decorative Christmas present tags inscribed to "Miss Spencer" in Edith's clear hand. Ethel Cram was also on the board, and she was driving from the library with her nieces on the day of her fatal accident in July 1905. Her friends established a book fund in her memory, and of the 350 books purchased, many were choices Edith Wharton is likely to have made.[186]

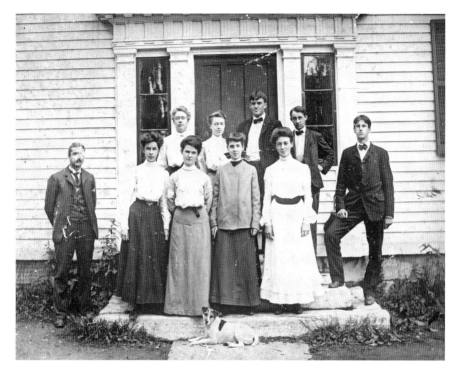

At the doorway of the Lenox Academy, accident survivor Kate Spencer poses with her teachers and classmates in a 1904 graduation picture. *Lenox Library Association.*

Overall, between 1903 and 1910, the Lenox Library accessioned over 6,000 new books. More shelf space was needed. Henrietta Cram Haven and Anna Bahlman, Edith's secretary, made a library-wide inventory in the summer of 1907 and culled 688 "soiled or worthless" volumes to make way for new books.[187] Assistant librarian Kate Spencer, undoubtedly, took part in all these activities.

Then, on July 9, 1909, Edith Wharton wrote Spencer from England. "I am so surprised and sorry, to hear of your decision to leave the library, and so especially regretful to learn that your doing so is owning to ill-health."[188] The letter, addressed to the library, was forwarded to Terra Marine Bungalow, Huguenot Park, Staten Island, New York, a salubrious spot for invalids. Kate's brother Herbert had recently moved to Staten Island and probably influenced her coming there to recuperate.

That summer of 1909 was a troubled time for Edith. She was still suffering from unrequited attachment to the entrancing and self-absorbed Morton Fullerton, who also dangled his own cousin/adopted sister in a vague

"engagement." For Edith, this was also a period of tension with the manic Teddy. They had rented The Mount for the season, so she never came to her beloved gardens in Lenox. Next door to the library at the Curtis Hotel, Teddy's mother was dying.

Edith was missing one bright spot of her old Lenox life: her work at the library. She wrote to Spencer: "I regret very much not being at Lenox this summer, & more especially not having my usual occupation at the library. It is such interesting work, & it has been so pleasant to watch it develop as it has in the last few years."

Meanwhile, Edith stored up the sledding episode for future use. When she wrote *Hiver*, the first short version of *Ethan Frome* (1907), as a writing exercise in French, she had not yet incorporated a suicidal sled ride into the bleak, romantic tale.

In 1911, when the newly published novel *Ethan Frome* arrived at the Lenox Library, Kate Spencer was not there to shelve it. She never returned to library work and lived a secluded and long life (she died in 1976) on Tucker Street with her mother and bachelor brother Edmund, the town's postmaster and later James Cameron's assistant at the Lenox Savings Bank.[189]

The other two girls who survived the crash also never married. Chrissie Henry (1885–1947) was the most seriously hurt and apparently never made a full recovery. She remained in her parents' household on the Groton Place property. Lucy Brown (1888–1972), on the other hand, was a beloved, active and enterprising Lenox figure, whose limp always reminded Lenox people of the terrible accident.[190] The daughter of a grocer, she managed Frederick Delafield's real estate and insurance office and, after his death in 1935, carried it on alone for another twenty-five years.

The only survivor of the accident who married was Mansuit Schmitt. His descendants still operate the electrical engineering business, M.L. Schmitt, he established in 1923 in Springfield, Massachusetts.

# The Perils of the Pétrolette
# or the Lenox "Motor Wars"

At the dawning of the twentieth century, while Edith and Teddy Wharton were building The Mount, the burning issue in Lenox was control of the new-fangled automobile. Two larger-than-life local personalities—Richard Goodman Jr. and Cortlandt Field Bishop—polarized the battle for peace on the roads of Lenox.

From a modern perspective, it is hard to fathom what a change the automobile, at first just a "toy for the rich" and eventually a mass-marketed vehicle, would bring. As it transformed travel, it also forever altered the historic tranquility of the country road. Even the most placid cart horse would be alarmed by a sputtering mechanical conveyance zooming up from behind or approaching around a curve in front. Much depended on the judgment of the motorist and the skill and strength of the horseman controlling a panicked equine. No one had yet imagined stop signs, speed limits and driver's licenses.

In Lenox, the challenge came earlier than most other places, due to the Bishop brothers, two privileged "daredevils" able to import experimental vehicles from France. Five years after Cortlandt Field Bishop began to terrorize the roads of Lenox on a pétrolette, or motorized tricycle, Edith Wharton stepped into a car for the first time. She and Teddy were exploring remote corners of Italy in 1903 while researching *Italian Villas and Their Gardens*. It was an old friend with Berkshire ties who took them for their introductory excursion to the inaccessible Villa Caprarola. The American ambassador in Rome, George Meyer (brother of Elinor Frothingham of

Overlee in Lenox), enthusiastically offered his services (as well as those of his chauffeur, who could serve as a mechanic in case of a breakdown). Edith recounted the adventure in *A Backward Glance*:

> *I had never been in a motor before, and could hardly believe that we were to do the run to Caprarola and back (fifty miles each way) in an afternoon, and still have time to inspect the villa and gardens…The car was probably the most luxurious, and certainly one of the fastest, then procurable; but that meant only a sort of high-perched phaeton without hood or screen, or any protection from the wind. My husband was put behind with the chauffeur, while I had the high seat like a coachman's box beside the Ambassador.… We tore across the Campagna, over humps and bumps, through ditches and across gutters, wind-swept, dust-enveloped, I clinging to my sailor-hat, and George Meyer (luckily) to the wheel. It was... blissful not to have to worry about tired horses or inconvenient trains.*

The horse-loving Whartons were captivated and immediately wanted a car of their own. "Duchess" and "Countess" were soon sharing their quarters in The Mount's stable with a Pope Hartford. Teddy bought the car from Lenox "jack-of-all-trades" Thomas S. Morse in July 1904 in time to ferry around the visiting Henry James three months later.[191]

Others in Lenox were slower than the Whartons to embrace this new mode of conveyance. Leading the anti-automobile traditionalists in Lenox was the patrician "gentleman of the old school" Richard Goodman (1845–1911). His young adversary was his neighbor, the equally patrician "enfant terrible" Cortlandt Field Bishop (1870–1935), who faced him from his parents' house across the Old Stockbridge Road. At the peak of the controversy, from 1900 to 1905, the Whartons had to pass through this war zone coming up to the village first from their rented house, The Poplars, and after 1902 from The Mount.

Richard Goodman Jr., a bachelor, lived with his two unmarried sisters at Yokun, a venerated late eighteenth-century Lenox gambrel-roofed landmark. Yokun was built on a prime site chosen by its first owner, Judge William Walker. From Yokun's windows, the Walkers, and later the Goodmans, could see both Laurel Lake and the Stockbridge Bowl.

Back in the halcyon days of the 1880s, the Goodman family had sold parts of their farm to the Bishops, and the families were apparently on cordial terms. Cortlandt Bishop's parents built the shingled and turreted Interlaken, and his reclusive aunt, Matilda Bishop White, built a neighboring house,

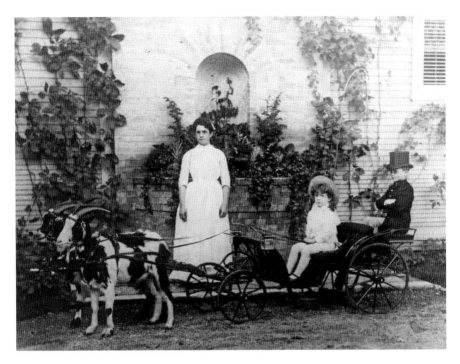

Under the watchful eye of their nanny, two Lenox boys, possibly David and Cortlandt Bishop, pose with a cart and a pair of piebald goats, circa 1880. *Lenox Historical Society.*

Maplehurst. In between the two Bishop houses, the Goodmans retained twelve acres of pastureland protecting their own view of Laurel Lake.

The Bishop boys and the motor car came of age at the same time. In 1897, the Goodmans began to be annoyed by the sound of the teenaged Cortlandt Bishop and his brother David revving up their French motorized pétrolettes. Each summer, they arrived in some new contraption. By 1900, they were careening around on four-wheeled "gasoline carriages."[192] Who knew where this was leading?

In many external ways, Richard Goodman and his younger nemesis Cortlandt Bishop were similar. Both were sustained by old money fortunes. Goodman had graduated from Harvard Law School in 1871 and Bishop from Columbia Law School in 1894. Both had given up big-city law practices for lives of leisure. Both were energetic, articulate, intelligent and public-spirited in their own peculiar ways. The Whartons, like many in Lenox's small social colony, were friends of both families.

Richard Goodman Jr.'s parents, Electa Cheney and Richard Goodman Sr., settled in Lenox shortly after the Civil War when young Richard was

at Amherst College. A natural writer, Richard Jr. founded a student newspaper at Amherst and wrote letters and articles on politics and farming for the rest of his life. After five mind-numbing years as a city lawyer, first in Boston and later New York, thirty-two-year-old Goodman retired to raise Jerseys in Lenox with his gentleman farmer father. (He was particularly proud to have an article published on Jersey breeding and butter making in the breed's own homeland, the Isle of Jersey.)[193] Goodman and his father had many interests in common, from pedigrees of Jersey cattle to genealogies of leading New York social families. Mrs. Goodman's family, on the other hand, the practical and prosperous silk-manufacturing Cheneys of Manchester, Connecticut, found these pursuits effete and tedious.[194]

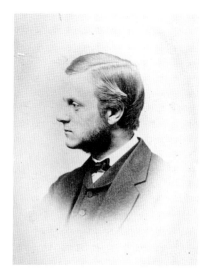

Richard Goodman Jr., Lenox foe of the automobile. Due to a hunting accident to his left eye, Goodman always posed in profile. *Lenox Library Association.*

For over a fifty-year period, from the 1860s through the 1910s, one Goodman or the other, either Richard Senior or Junior, served the Lenox Library on the board of managers.[195] The library's accession books, dating from Edith Wharton's era, show Richard Goodman Jr.'s tastes aligned with Wharton's—many books on gardening, architecture, donations of French translations of the novels of Mrs. Gaskell and John Ruskin's *Thoughts on Beauty.* An early conservationist, Goodman was active in two new Boston-based preservation organizations of the era. He was one of the founding members of Charles Eliot's Trustees of Reservations in 1891 and an early supporter of William Sumner Appleton Jr.'s Society for the Preservation of New England Antiquities.[196] Deeply devoted to gardening, Goodman helped found the Lenox Garden Club just months before he died.

Goodman had an aura that some found pretentious but others found inspiring and spellbinding. A vivid description of Goodman as a Harvard law student in his twenties survives. His childhood Lenox friend and fellow Harvard law student Frank Walker Rockwell was boarding with Goodman in Cambridge. Rockwell wrote his future wife, Mollie, depicting a typical evening with Goodman as "a literary treat":

*Richard read poetry, we smoked, studied, thought, expressed our little ideas on the great themes....From him I learn so much—to hear us talking you would call our conversation broken, perhaps but half expressed, at times—yet it has this merit I often think, it is suggestive. Whittier, Lowell, Longfellow, Bryant, Emerson gave shape to our thoughts....These little readings with Richard are my bright spot.*[197]

Thirty years later, British ambassador Sir Mortimer Durand was intrigued by the rarified middle-aged Goodman and his sisters, Lillian and Rosalie. Durand noted in his diary a Sunday afternoon tea at the Goodmans', one of his first social engagements on arriving in Lenox in June 1904. It was a hot weekend with intermittent thunderstorms, and he and Mrs. Durand had lunched that day with the Whartons. The ambassador failed to elaborate on The Mount lunch party, but after tea at Yokun, he wrote, "Tea with the Goodmans, nice people—with perfect English accent like many New Englanders."[198]

The elevated setting of Yokun charmed many. Boston architect Robert Peabody, the future architect of Elm Court next door, sketched Yokun's noble Georgian front façade and praised it in the pages of the *American*

Yokun as sketched in 1877 by Boston architect Robert Peabody. *From* American Architect and Building News.

*Architect* in the winter of 1877.[199] Facing the Old Stockbridge Road and overlooking Laurel Lake, this grand pedimented doorway surmounted by a Palladian window was a public spectacle. Inside, the intimate paneled rooms were furnished with simple, fine American antiques, the library with well-worn, beloved books. A luminous Sanford Gifford painting of *Sunset on the Hudson*, bought from the artist in 1877, hung amid family portraits.[200] Guests would pass through a tunnel in the vast central chimney to the newer wing of the 1880s with the capacious dining room filled with Lowestoft china and overlooking the spectacular second view of gardens, tree-shaded lawn and two bodies of water.[201] Tea in the rustic summerhouse, built atop an icehouse, afforded the best vantage point of Lily Pond in the foreground and the Stockbridge Bowl in the distance.[202]

At these small gatherings, the Goodmans assembled interesting intellectual neighbors and their friends. The Whartons were frequently there. On Henry James's autumnal visit in 1904, they brought him to the Goodmans' for tea with various Sloanes, Gilders, Durands and Frelinghuysens. In June 1906, basking in the success of *The House of Mirth*, Edith was joined at a Goodman lunch party by her lawyer/novelist friend Robert Grant.[203]

On another occasion, in September 1905, the sensitive, discriminating eccentric Grenville Winthrop and his mother, the imposing Kate Taylor Winthrop, had tea at Yokun with Mr. and Mrs. Charles Bonaparte.[204]

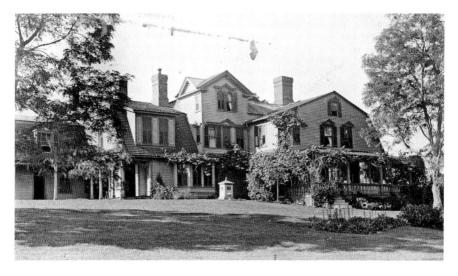

The enlarged Yokun of the 1890s as seen from the lawn. The eighteenth-century gambrel-roofed section is at right. K.T. Sheldon, photographer. *Lenox Library Association.*

The vine-shrouded Yokun summerhouse, the setting for many Goodman tea parties, overlooking Lily Pond and the Stockbridge Bowl. *Lenox Library Association.*

Goodman and Bonaparte were "motor war" allies. Although progressive politically as Roosevelt's secretary of the navy and later attorney general, this great-nephew of Napoleon was long remembered in his hometown Baltimore for resisting intrusive new technologies—especially the motorcar but also electricity and telephone.

Meanwhile, on the Old Stockbridge Road, when the Bishop boys were in town, the tranquility of these afternoon teas at Yokun would be shattered by the sound of Cortlandt's "Red Devil" and David's "White Ghost."

While Goodman was a settled Lenox gentleman, the Bishops led peripatetic lives in France, New York City and Lenox. Cortlandt Field Bishop was formidably bright. He had a law degree and a PhD from Columbia and specialized in a study of elections in colonial America. In 1899, Bishop married Amy Bend, a shallow beauty who had made a career in breaking hearts and engagements. She commemorated the twenty-five rejected marriage proposals on a charm bracelet with twenty-five charms.[205] The handsome, rich and impatient Cortlandt Field Bishop was smitten. Their courtship had been carried on partly in Lenox, where Amy was often a houseguest of the Sloanes at Elm Court, across the Old Stockbridge Road. Her stockbroker father, a one-time president of the New York Stock Exchange, had lost his fortune in the 1893 depression.

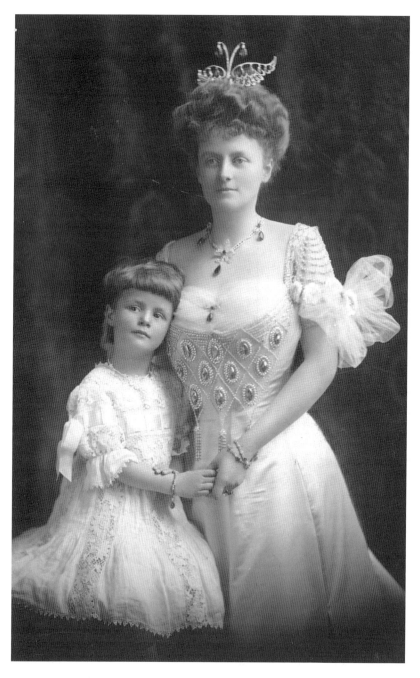

Amy Bend Bishop and daughter Beatrice, circa 1908. Among Mrs. Bishop's jeweled adornments, she may be wearing the famous charm bracelet commemorating her former suitors. *Lenox Library Association*.

Amy's marriage to Bishop recouped the Bend fortunes and produced a single daughter, Beatrice, in 1902, but it was not a conventional, happy, extended family. Beatrice later remembered her two grandmothers icily avoiding each other from their respective pews at Grace Church in New York.[206] Cortlandt and Amy built a grand French-inspired townhouse at 15 East Sixty-Seventh Street in New York with architect Ernest Flagg. From here, the dynamic Bishop and his vacuous wife globetrotted between long-distance automobile races around the East Coast and Europe, grand hotel life in Paris and Rome and winter adventures in the Sahara.

Goodman gritted his teeth when the Bishops came roaring up to Lenox in their latest motor. It was not just a matter of noise and not just a Lenox problem. Accidents were happening all over the country as the motorcar began to share the road with traditional horse traffic. Arrested in New York City for reckless driving and finding he could not bribe his way out with a clueless offer of French francs, Cortlandt's brother David spent the night in the 125th Street Police Station in 1901. He had been in a hurry to get to an automobile race in Buffalo.

In Lenox, anti-automobilist citizenry began putting up signs of the Bishops' whereabouts on the columns of the Curtis Hotel porch—"Seen at 8 this Morning Headed for Stockbridge"—but soon Goodman took a legal course.[207] In 1900, the Lenox Selectmen passed an ordinance decreeing "no vehicle propelled by any motive power other than Horses, Mules, Donkeys, Cattle, or Dogs shall be allowed to pass over the streets or public ways of the Town of Lenox at a rate of more than Six (6) miles per hour."[208] The Goodman versus Bishop "motor war" had begun, and the *Horseless Era*, an early motorcar magazine, noted that Lenox had a reputation for "extreme anti-automobilist sentiment." By 1902, Massachusetts and other states were beginning to establish speed limits.[209]

More and more Lenox residents were joining in the new sport of motoring. Under the influence of his Lenox neighbor Albert R. Shattuck, president of the Automobile Club of America, Cortlandt Bishop tried a conciliatory role. In the summer of 1902, the *Horseless Era* reported that Bishop and Shattuck had started a "school for horses." By August, the magazine reported they had accustomed "practically all the horses in the vicinity of Lenox to the motor vehicle."[210] Of course, there were still terrible scares and accidents, most notably for Edith Wharton the 1905 death of her friend Ethel Cram after her horse bolted at the sight of Carlos de Heredia's car on the precipitous Court House Hill.

In the next few years, Goodman retained the vain hope that certain roads could be reserved for owners of horses. He obviously lost the battle with

Cortlandt Bishop in evening dress (*upper left*) at an Aero Club of America event with Orville (*seated far left*) and Wilbur Wright (*seated far right*), 1906. The other two gentlemen were noted balloonists. *From* Navigating the Air by the Aero Club of America.

Bishop, but he had become a beloved local martyr in the process. When he died of pneumonia in 1911, the *Berkshire Eagle* headline ran "LENOX LOSES FINE TYPE OF COUNTRY GENTLEMAN." "Goodman rode occasionally in an automobile himself" read the adulatory obituary, "but never made a practice of it."[211]

By this time, Cortlandt Field Bishop and Amy had moved completely into the exciting new world of aviation. In 1906, Bishop was photographed with other Aero Club members in the company of Wilbur and Orville Wright. Now, instead of the *Horseless Era*, he was in the pages of *Aircraft Magazine*. The March 1910 issue hailed him as a "Big Man of the Movement." He had financed two important recent American victories in Europe: Glenn Curtiss's victory in the Aviation Cup Race in Rheims and Edgar W. Mix's triumph in an international balloon race in Zurich, which landed him in the arms of the Russian police in Poland. Amy claimed that Cortlandt had a secret fear of flying, but she delighted in it. As an old lady, she cherished press clippings of herself aloft in a balloon over the English Channel or waving from a cockpit landing on a primitive strip at Le Mans.[212]

Back in Lenox in February 1930 in the upstairs front bedroom of Yokun, still decorated with 150-year-old original Parisian wallpaper, the last member of the Goodman family, Electa Lillian, died. Cortlandt Field Bishop, at last,

*Left*: Cortlandt Bishop's bookplate, with an open book and bowl of roses in the foreground and his view toward Laurel Lake. The two buildings appear to be The Mount on the right and the stables on the left. Engraver, Sidney Lawton Smith, 1909. *Fahnstock Bookplate Collection, Lenox Library Association.*

*Right*: Amy Bend Bishop's bookplate, with a spaniel in the place of honor, an equestrian group, an automobile track and the latest aeronautical inventions. Engraver, Sidney Lawton Smith, 1909. *Boston Athenaeum.*

got his revenge on her sainted traditionalist brother. She was hardly cold in her grave when Bishop bought and demolished the historic house.

In fairness to Bishop, he had always coveted the Goodmans' land on his own side of the road. Over the years, the Goodman trio had stubbornly refused to sell in order to protect their view of Laurel Lake. When Lillian's executor, Connecticut cousin Frank Cheney, made the decision to sell Yokun and all the Goodman property undivided, it was a foregone conclusion that Bishop would buy the house. At first, he claimed he would take off the nineteenth-century additions and preserve the old Georgian front section, but onlookers feared the worst. Bishop had a long record of tearing down houses standing in his way—two family residences, Interlaken and Maplehurst, as well as old Lenox landmarks, including a pre-Revolutionary tavern that later served as the town's first jail and Fanny Kemble's house, the Perch.[213]

Desperate letters to Bishop called attention to the significance of the Goodmans' grand old house. Among the preservation advocates were Pittsfield architect Joseph McArthur Vance and George B. Dorr, a Maine

The Goodmans' view from Yokun toward Laurel Lake coveted by Cortlandt Bishop. *Lenox Library Association.*

nurseryman and conservationist and an old horticultural friend of Edith Wharton. Dorr remembered the historic farmhouse from his Lenox childhood and had hired a Boston architect to measure the dwelling years ago to replicate it in Maine.[214]

But Bishop had his own authorities. Hiram Parke and Otto Bernet came up to Lenox for a weekend to stay with their important financial backer and client. (In the coming years, Bishop underwrote their auction house Parke-Bernet.)[215] The *Springfield Republican* reported that on New Year's Eve, Parke and Bernet wandered through the frigid, half-demolished old house and recommended salvaging some hardware and wainscoting as well as the wallpaper in the northeast bedroom, where Lillian had died.[216]

Thus, as 1931 began, the last skirmish in the rancorous 1900 Lenox "motor war" ended in a heap of hand-hewn timbers, mantels and paneling by the side of the Old Stockbridge Road.

# First Motor-Flights into the Country

## The Nortons at Ashfield

"Come up—come up," Edith Wharton begins her sonnet honoring Harvard fine arts professor Charles Eliot Norton (1823–1908) on his eightieth birthday in Ashfield. Her exhilarating trips with Teddy and houseguests deep into the hill towns north of Pittsfield to visit Norton and his family were high points of each season at The Mount.

Looking for a country place back in the 1860s, Charles Eliot Norton had every reason to settle in Lenox or Stockbridge. His wife, Susan Ridley Sedgwick, was well endowed with Berkshire cousins in charming country houses. Her father, Theodore, had been one of novelist Catharine Maria Sedgwick's clan of siblings. Susan was orphaned at an early age and brought up in Cambridge and Stockbridge by her mother's sister, Anne Ashburner, whose elegant brick house, Bombay Hill, still stands on Ice Glen Road.

At the time of their marriage in 1862, Charles Eliot Norton brought Susan into the family fold in Cambridge at the ancestral home, Shady Hill, described by her delighted aunt Catharine Sedgwick as "the temple of the Boston aristocracy."[217] While they honeymooned at Shady Hill, the rest of the Norton family discreetly departed for the Berkshires. Charles's sister Louisa married his one-time business partner and close friend, East India merchant William Bullard, and they had recently purchased Highwood, a magnificent place (now part of the Boston Symphony Orchestra's Tanglewood property) with a view over the Stockbridge Bowl.[218]

When it came to house-hunting for themselves, however, Charles and Susan Norton sought to make their own niche. They found it in Ashfield,

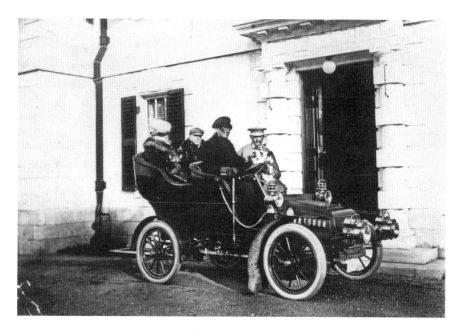

Edith Wharton, Henry James and Teddy with an armload of dogs set out from The Mount on a motor flight in October 1904. Their "imperturbable" chauffeur Charles Cook is at the wheel. *Lilly Library, Indiana University, Bloomington, Indiana.*

a remote, little-known New England town, forty miles northeast of Lenox in Franklin County. In the summer of 1864, they began by renting an old farmhouse with a beautiful high pasture beside it on the edge of the village and loved the place. By the end of the summer, they offered to buy it. The Nortons soon welcomed their New York literary friends George William Curtis and his wife, Anna Shaw, as seasonal neighbors.[219] Both families would have long associations with their adopted home. When the Whartons, in their "stuttering, shrieking" motor, started coming up from The Mount at the turn of the century, the Nortons were pillars of the community who had spent years enriching various local institutions, including the school and library.

Edith met the Nortons through their long ties with Teddy and the Wharton family. There were also other links as time went on. Many of Edith Wharton's male friends, including Walter Berry and Morton Fullerton, had been Norton's students at Harvard, and in time, she gained a private education from the eminent art historian. Charles Eliot Norton appreciated her depth of knowledge on Italian architecture and antiquities and supplied her with just the right books for her ambitious first novel set in feudal eighteenth-century Italy, *The Valley of Decision* (1902).[220]

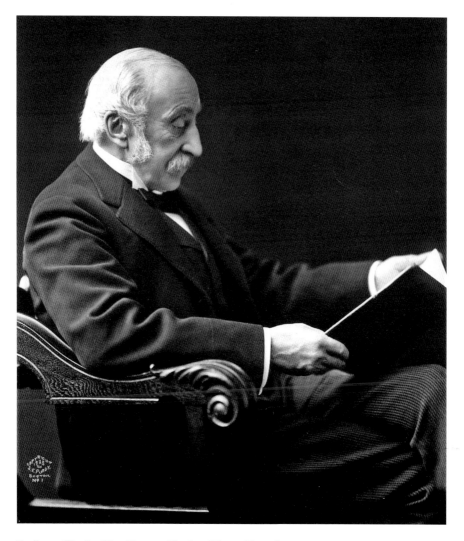

Professor Charles Eliot Norton. *Houghton Library, Harvard.*

Edith and Sally Norton (1864–1922) were contemporaries and became close intellectual allies, sharing a passion for esoteric reading ranging from Darwinism and James Joyce's *Ulysses* to Nietzsche and Goethe (read in German). Edith would critique Sally's poems, and Sally read the "advance sheets" of *The Valley of Decision*, which Edith was too timid to impose on the admired professor.

The Whartons' visits to Ashfield included climbs up the high pasture to find the rare woodland pyrola plant and summer evenings reading poetry

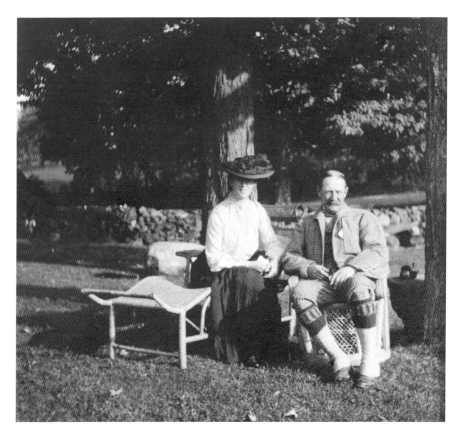

In autumnal sunshine by a stone wall in Ashfield, Edith photographed Teddy sitting in a wicker chair with Sally Norton, circa 1905. *Houghton Library, Harvard.*

after dinner. Bringing Henry James to see Norton in 1904 and 1905, the Whartons gave the two old gentlemen, who had been boyhood friends in Cambridge, final visits together. These drives between Lenox and Ashfield in the open and unreliable Pope Hartford were always filled with drama, adventure and, in Henry James's words, "a bath of beauty."

Sally Norton visited The Mount regularly, but both Edith and Teddy wanted the old professor to see the place. In the summer of 1906, Teddy eagerly offered to drive up with his chauffeur, Charles Cook, to ferry him down: "[I]t is only three hours + I should like you to see 'The Mount' to prove to you that Puss is good at other things besides her, to me, rather clever writing. Do say yes + we will fetch you."[221]

That same summer, Edith sent Norton a postcard of The Mount embellished with a few witty lines in hopes of eliciting some poems, if

not a visit. Later, in the spring of 1907, the trio—Henry James, Edith and Teddy—was traveling in obscure corners of France and thinking of Norton. They signed a joint postcard of a column capital in the choir of a church at Chauvigny with a message written in James's hand: "[W]e affectionately think + talk of you + wish you were here to tell us more about it."[222]

In her closing lines of the 1907 sonnet "High Pasture," Edith conveys her gratitude for Charles Eliot Norton's elevating influence on her life:

> *He calls us still by the familiar way,*
> *Leaving the sodden tracks of life behind,*
> *Befogged in failure, chilled with love's decay—*
> *Showing us, as the night-mists upward wind,*
> *How in the heights is day and still more day.*

Charles Eliot Norton lived only a year longer, but the home he created remained an oasis of calm, beauty and intellectual heights for Edith, even when she was far away. In the terrifying first months of the Great War, she wrote from Paris to Sally in Ashfield:

> *[I]t seems strange to be sending such tales to peaceful Ashfield, I can see the lovely blue September distances, the golden trees, the autumn glitter on the meadows—I can smell it & touch it!—I am glad your father went without seeing what we are seeing now.*[223]

18

# A Sympathetic Editor

## Richard Watson Gilder in Tyringham

On the darkening terrace at The Mount overlooking Laurel Lake, Edith Wharton brooded as she crafted a poem, "Moonrise over Tyringham":

*The lake is a forgotten streak of day*
*That trembles through the hemlocks' darkling bars,*
*And still, my heart, still some divine delay*
*Upon the threshold holds the earliest stars.*

Tyringham, a secluded valley seven miles away, was the country home of Richard Watson Gilder (1844–1909), editor of the *Century Magazine* from 1881 until his death in 1909. He recognized Edith Wharton's talent early and helped her emerge from literary obscurity. In the pages of the *Century*, he combined fiction and nonfiction, short stories and poetry (including "Moonrise over Tyringham" in 1908) interspersed with articles on art, travel and history. Competing with two other literary monthlies, *Lippincott's* and *Scribner's*, he was a perceptive editor who nurtured new talent. He and his artist wife, Helena de Kay, offered the indigent Walt Whitman a couch to sleep on in their studio; he published fledgling women writers—some, like Constance Cary Harrison, Eleonora Kinnicutt and Maria Hornor Lansdale, forgotten today and others, like Emma Lazarus, Francis Hodgson Burnett and Helen Keller, celebrated.[224]

Gilder accepted one of Edith Wharton's earliest poems, "The Sonnet," in 1889 (strangely, it was not published until 1891) and an early short story,

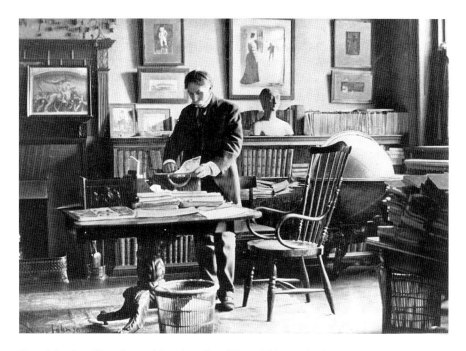

Bound for the office, *Century Magazine* editor Richard Watson Gilder packs his briefcase at home. An image of Saint-Gaudens' bas relief of the Shaw Memorial is displayed on the mantelpiece. *Four Brooks Farm Collection*.

"The Valley of Childish Things and Other Emblems," in 1894, but their serious collaboration began in the next few years.

Wharton's first novel, *The Valley of Decision* (1902), was a three-year labor of love. Set in eighteenth-century Italy, it depicts the conflict between idealistic young intellectual aristocrats and an entrenched and debauched feudal court. The novel elicited critical reactions from many who thought it too erudite and too long. Gilder, however, relished every word and asked for more: "Night after night I have made 'a little journey' to Italy under your guardianship. I found so much of wit & insight and subtlety of expression… that I felt defrauded when the last…pages came."[225]

He suggested she get right to work on a sequel, which she started but put aside, dissuaded by others and distracted by the construction of The Mount. "Our Italian floors will be ready for inspection next week and I hope to see you and Mrs. Gilder as soon as you return," Edith wrote her vacationing editor in August 1902.[226]

The following year, Gilder saw a way to use Edith Wharton's prodigious Italian knowledge. He proposed she write a series of articles that would also

become a book, *Italian Villas and Their Gardens.* Her articles would accompany drawings by Maxfield Parrish, who had recently illustrated her gruesome Italian tale "The Duchess in Prayer" in *Scribner's.*[227] Edith was intrigued, and with Teddy, who shared her Italiaphilia, they dedicated the winter of 1903–4 to ferreting out obscure Italian villas and their *giardini tagliati,* or formal gardens, traveling for the first time in a motorcar.

In *Italian Villas and Their Gardens,* Edith strove to inspire the reader to incorporate something of "the old garden magic to his own patch of ground at home."[228] Back in the Berkshires in the summertime, both she and Gilder were working on their own gardens and visiting each other to admire the results. At their rambling Four Brooks Farm, the Gilders built a walled garden punctuated by a jet of water in a marble-lined rectangular garden pool. The much more elaborate Mount gardens were costing Edith serious money, and she wrote Gilder on July 29, 1903, hoping for a royalty check from the *Century,* "I am doing things with my garden on the strength of the articles & I find it a very voracious animal indeed."[229] On the proceeds from *The House of Mirth,* she built her own exquisite walled garden around a round pool.

In the summer of 1902, Edith Wharton came to hear Richard Watson Gilder speak at the cornerstone laying for a new library building in Tyringham.[230] A handsome young Brooklyn historian, John A. Scott, whose family summered in Tyringham, led the drive to build a permanent home for the itinerant library collection and fell in love with the village librarian, Lucy Margaret Moore. Lucy's father, an entrepreneurial innkeeper, Lucian Moore, was chairman of the library building committee. Her brother, Herbert, was the Gilders' farm manager at Four Brooks.

Years later, when writing *Summer* in 1917, Edith Wharton recalled the romance between John Scott and Lucy Moore in her vividly drawn architectural student Lucius Harney who courts the country librarian, Charity Royal, with suggestions for improving the quaint, old library. In real life, while the Tyringham Library was still under construction, John Scott married Lucy in a festive springtime wedding reported in the local paper as "heightened by decorations from the nearby woods of Nature's own providing."[231] In *Summer,* however, the captivating out-of-towner Harney deserts the pregnant Charity to marry his socially acceptable girl from the city.

In the course of time, Edith Wharton had no difficulty getting her works in print and was under contract to publish in *Scribner's* associated with her book publisher, but she continued to send occasional stories to the *Century*—"The

*Left*: Lucy Moore, the Tyringham bride of Brooklyn, New York historian and librarian John A. Scott. Edith Wharton later incorporated their romance in *Summer*. *Tyringham Historical Commission Archives*.

*Below*: Richard Watson Gilder and travel writer Maria Hornor Lansdale in the walled garden at Four Brooks Farm, 1907. *Four Brooks Farm Collection*.

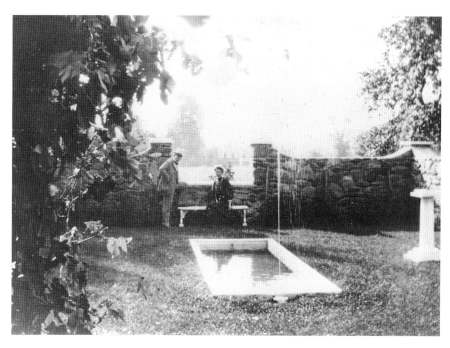

Choice," with its pathetic depiction of a Teddy-like husband in decline, in November 1908 ("not Christmassy," Edith would grimly note in her cover letter to Gilder) and a ghost story, "Afterward," in the fall of 1909, when Edith's marriage was unraveling.

Unknown to Edith or his family, Gilder's health was also unraveling. He fell sick quite suddenly in the midst of the family's New York move to a new Gramercy Park apartment. He died at the age of sixty-five while temporarily lodging nearby with architecture critic and friend Mariana Schuyler Van Rensselaer.

Back in 1902, at the time of the laying of the cornerstone at the Tyringham Library, Edith Wharton's first novel, *The Valley of Decision*, had only just been published. Her writing career was by no means assured, but Richard Watson Gilder believed in her. In the course of his speech, he listed distinguished "Berkshire sojourners for little or long"—Jonathan Edwards, Catharine Sedgwick, Fanny Kemble, Henry Ward Beecher and others. The list was familiar, and Edith might have dozed until she heard the editor conclude with praise for the newest local author: "Edith Wharton, who so finely maintains the literary traditions of Lenox."[232]

# The Folsom Library at Sunnyridge

Edith Wharton's 1910 ghost story, "Afterward," starts with a young couple seeking a country house where the library was "the central, pivotal 'feature.'" In *Hudson River Bracketed* (1929), the mesmerizing private library of a long-closed house becomes practically a character in the narrative. Certainly, the hushed, well-used library, with easy chairs beside a fireplace, formed the heart of any house Edith herself admired or owned.[233]

Many a Lenox house had a magnificent library, but the library of George Winthrop Folsom (1846–1915) at Sunnyridge was in a class of its own, and it is likely that Edith saw it on her earliest Lenox visits. The room was filled with rare seventeenth-century tomes printed by the venerable Dutch Elzevir family and collected in the 1850s by Folsom's father in his diplomatic days at the Hague. From Folsom's grandson's perspective, the antiquarian library was magical, "shelf after shelf of dark brown books from floor to ceiling, and leather armchairs to hide behind, and above all, library steps to push about and to climb."[234]

Georgette, the sixth of the seven Folsom daughters, described this inner sanctum of family life in her childhood:

> *By a table with a green shaded lamp stood Papa's big, leather arm chair. We always went into the library to kiss him goodnight and very often he read to us or we would ask him to tell us the story of Pit-a-Pat…an enormous cat, [that] had all kinds of adventures. But the most wonderful part of the story was that it <u>always had a different ending</u>. I can see my*

George Folsom sipping his after-lunch demitasse in the Sunnyridge garden. *Susan Hockaday Jones.*

*father now, the four of us clustered round him, on his knees and the arms of his chair, holding up and wagging one finger as he got to the exciting end for which we breathlessly waited. When we kissed him goodnight his beard smellt of cigar smoke which seemed, somehow, to have something to do with Pit-a-Pat.*[235]

138

Photographed by their father, six of the seven Folsom girls pose on a French roadside in the mid-1890s. *Susan Hockaday Jones*.

When Edith Wharton, famously uninterested in the antics of children, came to visit the Folsoms, she came for adult conversation. The three elder sisters—Helen, Ethel and Marguerite—were in charge of keeping the four younger ones out of the way. "Run along up to the nursery now. Mrs. Wharton doesn't wish to be bothered with a lot of little girls."[236]

The younger girls—Maud, Winifred, Georgette and Constance—were growing up in the late 1880s and early 1890s, and Edith Wharton was probably visiting their Gramercy Park house in New York. By the 1900s, when she was regularly in Lenox at The Mount, Edith and Teddy, as well as the senior Mrs. Wharton,[237] were coming to lavish wedding receptions for one girl after another at Sunnyridge.[238]

For over forty years, George W. Folsom was central to life in Lenox in both conventional ways (he was a pillar of Trinity Church, the Lenox Library Association, the Village Improvement Society, the Lenox Club) and unconventional ones. The quiet bibliophile organized events like a bicycle gymkhana, exhibited obscure vegetables at flower shows and served as Lenox road superintendent. Spaces in the twenty-two-room Sunnyridge were set aside for easels and darkroom equipment; the sloping lawn was the setting of archery meets and coasting parties; on more level terrain, there was a croquet lawn and the tennis court, the scene of many a Lenox Club match.

The house was filled with pampered cats, frisky West Highland terriers and a long-lived bilingual parrot.

George Folsom's wife, Frances (1842–1925), the niece of the noted editor and journalist Margaret Fuller, presided over Sunnyridge with a combination of style and practicality. Early in World War I, when Edith Wharton appealed for help from her Berkshire friends for an ambulance for the French army, Frances Fuller Folsom, by then a new widow, teamed up with Emily Tuckerman. Mrs. Folsom served as treasurer for the endeavor, which they achieved in a matter of months.[239]

On an April morning in 1925, Sunnyridge burned down. At the heart of the inferno was the library with its priceless collection of Elzevir editions. Undaunted, Mrs. Folsom commissioned her grandson, Sidney Coolidge Haight (also the grandson of the house's original architect, Charles Coolidge Haight), to design the second Sunnyridge, which stands on the Cliffwood Street site today.[240]

Forty years later, another grandson, writer Constantine FitzGibbon, recalled the aroma of the ancient leather books of his childhood. "The smell…was unforgettable. Whenever I enter a library of that sort, I am instantly, if only for a second, back in old Sunnyridge, before the fire."[241]

# Pity for Poor "Inarticulate" Animals

### The Whartons and the Sturgises

The mutual love of dogs was a bond between Edith and Teddy Wharton. In their childless home, the Whartons lavished attention on Jules, Mimi, Miza, Mitou and Nicette, a succession of small, bouncy, yapping terriers, Chihuahuas and Papillons, whose little bodies rest on a shady, periwinkle-covered knoll at The Mount.[242]

Edith claimed to have almost a psychic ability to understand "the little four foots," and late in life when contemplating her "ruling passions," she ranked dogs well above both books and architecture.[243] Writing from his exile at the Groton Inn after a serious blow-up at The Mount in August 1911, the distraught Teddy cited the dogs in his plea to Edith for "one more chance." "I beg of you, Puss, in memory of the good years, do it for me. I am so sad without you and miss you all so much: you, the doggies, my home."[244]

In Newport and Lenox, another privileged, childless couple, Frank and Florence Sturgis, were kindred spirits. A leading New York stockbroker with a penetrating, stern gaze and a soft heart for the plight of mistreated animals, Frank Knight Sturgis (1847–1932) was three years older than Teddy Wharton. He was a member of the New York branch of the distinguished old Boston Sturgis family and was related to a host of merchants, bankers and architects intermarried with other Boston Brahmins: Shaws, Codmans and Perkinses. Among his Sturgis cousins were Edith's longtime literary friend Howard Sturgis and Howard's much older half brother, the Boston architect John Hubbard Sturgis. A mid-nineteenth-century practitioner in the High Victorian style (which Edith would later scorn), John Hubbard

Frank K. Sturgis. *From* The Coaching Club *by Reginald W. Rives.*

Sturgis was the original architect of her Newport house, Land's End. In Lenox, he designed Tanglewood in 1867 for yet another of the Sturgis clan, Caroline Sturgis Tappan.[245]

Ogden Codman was also a cousin of Frank K. Sturgis, and in the first decade of the twentieth century, he designed two houses for the Sturgises: an elegant classical townhouse at 15 East Seventy-First Street just off Fifth Avenue in New York and an uncharacteristic half-timbered house in Newport they called Faxon Lodge.

Frank Sturgis was the epitome of a gentleman sportsman, but unlike Teddy Wharton, he also had business skills as a stockbroker and instinctive leadership qualities. A well-known figure on Wall Street, he was a longtime member of the New York Stock Exchange and its president for two terms at a challenging time during the Panic of 1893, when the American economy suffered a serious depression. He was remembered as one of the hardest working committee members on the "new" Madison Square Garden, the splendid Beaux Arts landmark of 1890 designed by Stanford White.[246] Inside the completed New York City sports arena, Sturgis organized national horse shows and then took those skills to the country, where he spearheaded smaller shows in both Newport and Lenox.[247] He was a guiding force and eventual president of several elite equine organizations of the day: the New York Coaching Club and the Jockey Club.

Sturgis, however, did not confine himself to the sleek, expensive, well-bred animal world. He was an activist through the Society for the Prevention of Cruelty to Animals for the kind treatment of overburdened work animals and neglected domestic animals. In an era when used-up cart horses were left by the side of city streets to die, Sturgis saw to it that ASPCA ambulances rescued the animals, even on Sundays.[248] He had been active in Newport's SPCA since its early days and, in the last decade of his life, from 1921 to 1931, led the national organization ASPCA in New York City.

Edith and Teddy Wharton were involved in the work of ASPCA in the early 1900s, when Sturgis was on the board and organizing events like the

Decoration Day Work Horse Parade up Fifth Avenue from Washington Square. From the viewing stand in front of the SPCA headquarters, the judges were instructed to consider the competitors for soundness and whether "their manners show they have been kindly treated, and whether their harness is comfortable and well-fitting."[249] Sturgis's stern advocacy of horses over the new disruptive, noisy automobiles was epitomized in his notorious horsewhipping of young Hermann Oelrichs of Newport for spooking Sturgis's horse with a motorcar on Bellevue Avenue in Newport.[250]

Edith Wharton transferred the episode onto an 1890s Long Island polo field in her novella *The Spark*, when the normally unexcitable banker Hayley Delane witnessed a younger player, who had just lost the match, whip his shivering, terrified pony. Retribution fell "like a thunderbolt, descending on the wretch out of heaven. Delane had him by the collar, had struck him with his whip across the shoulders, and then flung him off like a thing too mean for human handling."

*The Spark* was one of Wharton's reminiscent works in *Old New York*, written in France in 1924, but she had been observing Frank Sturgis since their Newport days in the 1890s. In their early years of marriage, Edith and Teddy Wharton participated in annual gala coaching drives Sturgis organized. To the trill of the coach horn, the Whartons drove through applauding spectators lining Bellevue Avenue and Ocean Drive. They were often passengers with the Louis Lorillards on Prescott Lawrence's coach. On such occasions, Frank and Florence Sturgis, in one of the lead coaches, were a striking pair. Frank was "handsome and dapper, with the manner of a man who carries grave responsibilities even to the top of a coach," and beside him Florence was elegantly turned out in "canary silk with pale blue."[251]

Florence Lydig Sturgis was one of seven siblings who grew up summering on the grounds of what is now the Bronx Zoo. As New York City grew, the family gravitated to more remote resorts. The Sturgises were regulars in Newport and Lenox beginning in the 1880s. In 1890, one of Florence's brothers, David, with his wife, Hannah, built a house in Lenox: Thistlewood on Walker Street.

Like Edith Wharton, Florence Sturgis was a founding member of the all-female assistant board of managers at the Lenox Library, which brought a whirlwind of new books and energy to the library beginning in 1902. Edith Wharton and Florence Sturgis had serious disagreements over the color of the new carpeting for the elegant front room vacated by Lenox National Bank. (Half a century later, the hushed library halls still quivered over that issue in the memory of librarian Julia Conklin Peters.) But these two forceful

ladies collaborated in many ways, building up the library's holdings. The accession books record countless donations by Mrs. Sturgis, books on subjects that interested her—a complete set of Thoreau, *The Art of Garden Design in Italy*, *The History of Lace*, *Furniture in Olden Time*. In 1908, the library received three copies of a new political novel, *Mr. Crewes Career*, by a now-forgotten American writer named Winston Churchill. The three donors were Edith Wharton, Dr. Greenleaf and Florence Sturgis.[252] At the time of Florence Sturgis's death, library president Grenville Winthrop remembered her for all her library activities over a nineteen-year period—frequent visits and donation of furniture and funds, as well as the many personally chosen books.[253]

In 1906, Florence Sturgis and Edith Wharton also participated in a Village Improvement Association competition for "the best kept grounds." They excluded any summer residents and focused the competition among local property owners. Mrs. Morris Jesup donated twenty dollars in prizes for the front yards of Housatonic Street houses down to the railroad station, Mrs. Sturgis another twenty dollars along Hubbard Street out to East Street. Edith Wharton's three prizes totaling twenty-five dollars were for "best in the village," while Anna Blake Shaw offered six five-dollar prizes for "Honorable Mention" for best upkeep and show of flowers throughout the village.[254]

A collector of unusual pottery and historic textiles, Florence Sturgis was a charter member of the Needle and Bobbin Club. This rarified group of lace and fabric authorities was born in a classroom at the Metropolitan Museum early in World War I. They were motivated to collect and preserve fine lace at a time when the lace-making culture of Belgium was being wiped out by the German invasion. In the midst of the conflict, Edith Wharton was employing destitute refugee lace makers in her Paris *ouvoir* to make lingerie and wedding veils to sell to her American friends.[255]

At Needle and Bobbin Club meetings in New York, Florence Sturgis was joined by others in Edith's old Lenox circle—Charlotte Barnes, Henrietta Cram Haven, Mabel Fahnstock and Mary Parsons. Another Lenox figure of the Needle and Bobbin Club was the lone male member, Richard Cranch Greenleaf, who grew up at Windyside. His neighbor, Mary Parsons of Stonover, was the club's president from 1923 to 1928.[256]

Like her husband, Florence Sturgis was a ready and generous supporter of animal causes. She was a patroness of the 1896 Cat Show at Madison Square Garden, one of the first of its kind to draw attention to these often abused and neglected domestic animals. In 1905, she rallied with ornithologists at the Museum of Natural History against the slaughter of birds for the millinery trade. Like Edith and Teddy, Florence's life revolved around her

alert, loyal and exotic lapdogs—Japanese Chins. In its chronicles of Lenox's idle rich, the *Pittsfield Sun* of November 14, 1908, noted that David Dunn, the Sturgises' Lenox gardener, had been dispatched to New York to bring the Japanese spaniels up to Lenox.

Sensitive not only to animal causes but also to human suffering, the Sturgises were in Lenox at the time of a local disaster. They were staying at the Curtis Hotel on Easter weekend in 1909, when farther down Main Street a 1:00 a.m. fire incinerated the three-story Clifford Block and damaged two adjacent buildings. Six Lenox residents, including a twelve-year-old girl trapped upstairs, died in the inferno as ill-equipped and inadequately trained bystanders tried to help. Survivors were brought to the Curtis, and by morning, Florence Sturgis, the Alexandres and other horrified guests had begun raising money for the injured and homeless.[257] (The elderly Nancy Wharton, who in her Platner cottage days lived next to the site of the fire, was among the early fund contributors.)[258] Hours after the fire, Frank Sturgis was working with a new committee to improve fire protection in Lenox.[259] The Lenox Fire Department was formed in June, and plans began for an engine house next to the town hall.

The Sturgises' Kemble Street house, Clipston Grange, was not an ordinary Lenox "cottage." It was an interesting amalgam of an early nineteenth-

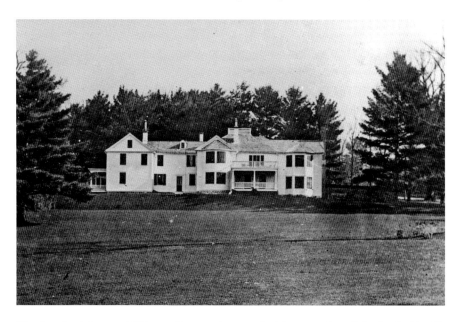

The Sturgises' shuttered Clipston Grange photographed by a member of the Jay family off-season in 1896. *Jay Album, courtesy of William Patten.*

The picturesque Clipston Farm complex on Plunkett Street (demolished some years ago) was beginning to age when sketched in the 1960s by Jerry LaVallea. *Liz Celli.*

century village house, relocated from Main Street and enlarged by the entrepreneurial George G. Haven, Sturgis's New York partner. Haven's own house, Sunnycroft, stood next door. He sold his speculative house to Florence and Frank Sturgis in 1894 after they had been renting places in Lenox for over a decade.[260] They kept their yachts—*Varuna* and later *Palmer*—in Newport, but in Lenox, they sought farmland to breed coaching horses.

Clipston Farm was half a mile away from the Sturgis house. It was on the Cross Road (as Plunkett Street was then called) in capacious up-to-date stables on some one hundred acres on John O. Sargent's former farm. At the time that the Whartons were constructing The Mount nearby, Sturgis had as many as seventy horses grazing in the pastures under the watchful supervision of his manager, Guy Ward. "The horse breeding experiments of Mr. Sturgis at his Massachusetts estate were far more extensive than has generally been realized," wrote the *New York Times*, some years later, when assessing Frank Sturgis's credentials as president of the Jockey Club. "No one knows the value of good blood in a coach horse better than he."[261]

In the early years of the ASPCA, when transportation depended on horses, one agenda item was clean, available drinking water for horses and even dogs. In Lenox's Triangle Park, at the foot of the steep Church Hill, the square, rusticated granite horse trough in memory of sculptor Emma Stebbins was reconstructed in 1897. At the base, a little dog trough inscribed "from the dogs of Clipston Grange" reveals the generosity of Frank and Florence Sturgis.

*Right*: Marble horse watering trough at the Church on the Hill given in 1909 by Teddy Wharton in memory of his mother. *Nannina Stearn*.

*Below*: Dog water bowl attached to the horse trough in Triangle Park. *Nannina Stearn*.

Twelve years later, after the death of his mother, Teddy Wharton made a similar and grander donation at the top of the hill. For horses that had toiled up to the Church on the Hill, an exquisite, classical drinking fountain in local marble awaited them. In 1909, the horse traffic was dwindling, and like so much in Teddy's life, the kind gesture was soon a hopeless anachronism.

# Grace Kuhn

## The "Gallant" Invalid on the Hill

In her hillside home overlooking the village, Grace Cary Kuhn (1840–1908) was slowly dying of cancer. Between 1906 and 1908, Edith Wharton brought books, news and flowers to her quiet, intellectual friend whenever she could. While working on her novel about medical ethics of dying patients, *The Fruit of the Tree*, Wharton was moved by Mrs. Kuhn's "gallant spirit…through the prison bars of illness and suffering."[262] She marveled at Grace Kuhn's interest in public affairs, particularly the recent reversal of the Dreyfus sentence, a cause that Edith was closely following. She was touched that the invalid, who had morphine at her bedside, chose to take her mind off her pain by memorizing sonnets, including Wharton's own "High Pasture," about Charles Eliot Norton and his place in Ashfield.

From Pau in the winter of 1907, Edith suggested to their mutual friend Sally Norton that Mrs. Kuhn would enjoy *The Memoirs of Madame de Boigne*, "an amazing picture of the Ancien Regime and of the why of the French Revolution."[263] Wharton's first novel, *The Valley of Decision* (1902), depicts the struggles of an idealistic Italian aristocrat to reform his dukedom in the pre-revolutionary era. She must have discussed her work with Mrs. Kuhn and known that her frail friend, whose eyesight must have failed, would be interested in *Madame de Boigne*. Edith wondered if Mrs. Kuhn had a helper who could read out loud in French.

Thirty-seven years earlier, in 1871, when she built Hillside, her Lenox house, Grace Cary Kuhn had caused a furor among the townspeople. She was an outsider, a wealthy young widow, coming to Lenox with deep pockets

and a four-year-old son. Her husband, Hartman Kuhn of an old Philadelphia family, had died in the previous year, breaking his neck when his horse failed to clear a jump in the meadows of Acqua Cetosa outside Rome.[264] She left behind his lonely grave amid the cypresses and mossy monuments in the Protestant cemetery in Rome and set off for Lenox.

Her late lamented husband was a comrade of the Lenox Philadelphians—the Rogerses, Devereuxes and Biddles. She was a Boston friend of the locally established Tappans and Bullards, and in the course of the 1870s, more relatives would come. Nancy Wharton, Teddy's mother, was related by marriage, and Lucius Tuckerman of Ingleside in Stockbridge was a cousin.

Grace Kuhn paid a record-breaking price for a prominent triangular parcel of land on Main and Greenwood Streets just below the Church on the Hill, and the house she built caused a stir. Old-timers liked to linger between services on the marble steps of the church and survey the spectacular open view of the village and surrounding hills. They were affronted to see a "party-colored" gambrel-roofed house under construction so near the church. A literary local commentator ranted in *Valley Gleaner*, "It is not agreeable to have almost under one's eyes an object so flaming as a house with its gables as conspicuous as the cross-garters of Malvolio."[265]

Soon Lenox people, however, grew fond of the quiet, thoughtful widow and her little boy and conceded she had managed to create "a charming nest" with a splendid southern terrace. Boston friends visiting Lenox loved her place. In 1872, in a letter to Teddy Wharton's cousin Lilly Cleveland, Kate Storrow extolled the new house and its unassuming front approach, "stepping stones across the grass."[266] When Lilly visited, she sketched it from a vantage point at the Haggertys' Vent Fort. Touring the unfinished house with Mrs. Kuhn in 1871, Lenox's Judge Rockwell was initially skeptical but soon appreciated that she was copying an old local landmark, the Davis House at the foot of the hill. He described the "eyrie on the meetinghouse hill" in a letter to his absent daughter: "It is old-fashioned, but suits her."[267]

The gambrel-roofed cottage suited Grace Kuhn so well that she built a similar shingled one with Boston architect Willard T. Sears in 1897 on Campobello Island in New Brunswick, Canada. It still stands today, a shrine to Franklin Roosevelt, whose neighboring mother befriended Grace Kuhn and acquired the house for Franklin and Eleanor after Mrs. Kuhn's death.

Grace Kuhn's son, Hamilton, was a promising biology student at Harvard, and in 1892, the *Pittsfield Sun* depicted him as "a young lawyer, clever,

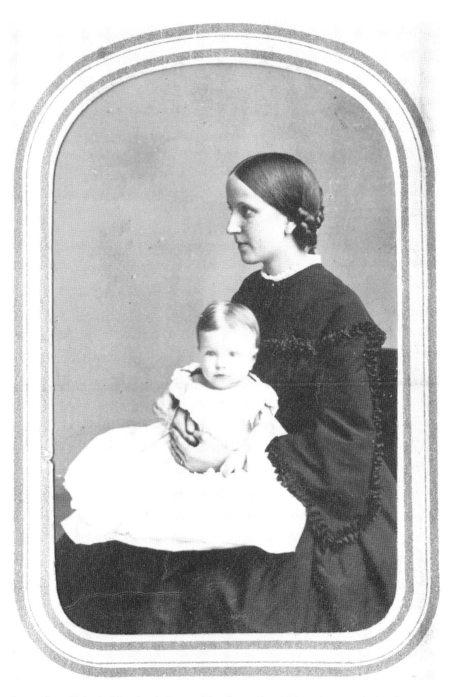

Grace Cary Kuhn holding her baby son, Hamilton, circa 1867, a few years before her husband's fatal riding accident in Rome and her move to Lenox. *Album of Ellen Schermerhorn Auchmuty, Lenox Library Association.*

Watercolor by Teddy Wharton's cousin Lilly Cleveland showing Grace Kuhn's house as a prominent feature near the Church on the Hill, circa 1872. *Lenox Library Association.*

ambitious and public spirited," who might run for selectman.[268] He suffered, however, from an unspecified debilitating illness.[269] Mrs. Kuhn desperately sought healthier climates for him—with summers at Campobello and winters in Nassau—but in January 1902, at the age of thirty-five, he died in their Bahamian retreat. The death certificate recorded his demise was caused by "disease of kidneys" and "anaemia."

Grace Kuhn's energetic niece Kate Cary (1864–1945) was a contemporary of Hamilton, and three years after his death, she became a full-time resident in Lenox, living at Butternut Cottage (now Garden Gables Inn) on her aunt's property. A daring and fearless horsewoman, she built a stable for her many horses and enlivened her aunt Grace's last years with a reliable pony and an invalid carriage to take her around the uneven terrain of the Hillside property.

During her long years in Lenox, Grace Kuhn lived with the Church on the Hill cemetery outside her windows, but in death, she was returned to Boston to be buried among her Cary and Perkins relatives at Mount Auburn Cemetery.

Aside from her tombstone, no memorial commemorates the modest Grace Kuhn. At St. Paul's Within the Walls Episcopal Church in Rome, the Italian sun filters through a magnificent pair of stained-glass windows in memory of her husband, the reckless equestrian. At Harvard, a host of

Grace Kuhn in an invalid carriage with her niece Kate Cary on the grounds of Hillside, circa 1906. Photo by Lenox electrician Benjamin Rogers. *Lenox Library Association.*

scholarly "Hamilton Kuhn professors" keep alive the name of her only child. In her will, Mrs. Kuhn left most of her large fortune to establish a chair in biological chemistry in memory of Hamilton.

After her aunt's death, Kate Cary divided the property and sold the big house to the Ross Whistlers. They renamed it "Hidden House" and made a half-hearted renovation in the Tudor style by adding steep gables and recladding it in stucco, but portions of Mrs. Kuhn's once-offending gambreled Hillside still peek out. Today it is known as Whistler's Inn.

# Lily Bart's Final Prescription

## Dr. Kinnicutt

Afriend of mine has made up her mind to commit suicide & has asked me to find out…the most painless & least unpleasant method of effacing herself," wrote Edith Wharton to her trusted doctor-friend, Francis Parker Kinnicutt.

It was the day after Christmas 1904, and Wharton was hard at work on *The House of Mirth*, the novel that would launch her into fame and financial success. *Scribner's* was serializing the book, beginning with the January 1905 issue, but the novel was yet to be finished. "I have a heroine to get rid of and want some points on the best way of disposing of her," Edith wrote Dr. Kinnicutt about Lily Bart. "She has just started on a seemingly brilliant career in the pages of *Scribner's* magazine, but the poor thing seems to realize that she is unequal to contending with the difficulties which I have heartlessly created for her."[270]

Edith's advisor, Dr. Francis Parker Kinnicutt (1846–1913), was an influential New York doctor in his late fifties with a private practice; he was also an attending physician at Presbyterian Hospital and a professor at Columbia Medical School. Many of his grateful patients were high-powered New Yorkers, including the William C. Whitneys, Joseph Choates and various summer Lenox neighbors like the Burdens, Jesups and George Morgans of Ventfort Hall. J.P. Morgan relied on him, and in January 1912, the ailing Morgan included Kinnicutt on an excursion up the Nile.[271]

Kinnicutt's reputation, however, went well beyond that of a dapper, tactful and comforting "society doctor." One of his oldest medical friends wrote, "To the poor or the outcast in the hospital he was the same courteous

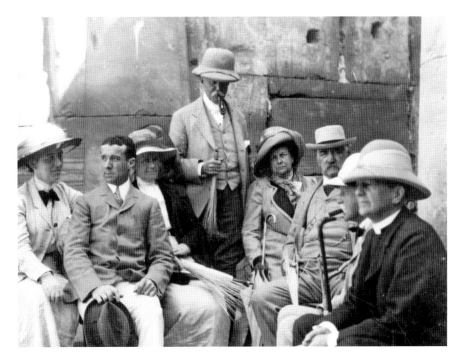

Fly swatter in hand, the pipe-smoking Dr. Kinnicutt stands with J.P. Morgan and his guests in a shady nook at Hibis Temple in the Kharga Oasis. Dr. Markoe's wife, Annette, looks weary, and on Morgan's other side is Bishop William Lawrence, 1912. *Metropolitan Museum of Art, New York.*

gentleman….To nurses and students he was an example of what every physician should aim to be….He kept abreast of progress, quick to see the bearings of new principles and methods." In his circle of New York physicians, Kinnicutt's enthusiasm and thoroughness were "a source of wonder to all, and of despair to some friends."[272]

Edith knew in writing Kinnicutt she would get the details she needed to make Lily Bart's suicide vivid and believable:

> [C]ould you suggest a book or two on the chloral habit & the sensations & after effects of death from an overdose? She is supposed to begin taking it for insomnia—but is chloral still given for insomnia, except in novels? What soporific, or nerve-calming drug would a nervous and worried young lady in the smart set be likely to take to & what would be its effects if deliberately taken with the intent to kill herself? I mean how would she feel and look toward the end?[273]

A friend, both in New York and Lenox, Dr. Francis Parker Kinnicutt was more than Edith Wharton's medical advisor for fictional details. He was, as Edith described to Bernard Berenson in 1910, "[the doctor] who has followed Teddy's case since his first attack six or seven years ago & who has more common sense than any other of the clan that I know & more influence over Teddy & his family."[274]

In Lenox, the Whartons saw Frank Kinnicutt and his wife, Eleanora, in their rambling clapboarded Colonial Revival house on Cliffwood Street overlooking the golf course. Back in 1886, the Kinnicutts, then in their forties, had bought the land from another doctor friend and fellow sportsman, Richard C. Greenleaf. The Kinnicutts hired New York architect Bruce Price to design the house they called Deepdene.

In 1894, Dr. Kinnicutt became the founding president of the Lenox Golf Club, one of the earliest golf courses in the United States. After considering various locations, Kinnicutt and his fellow golfers and neighbors, Joseph Burden and Dr. Richard Greenleaf, chose the pastureland around Greenleaf's

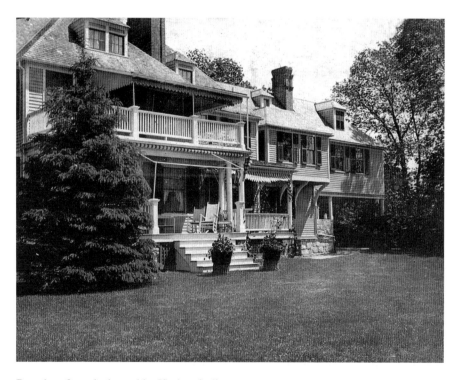

Deepdene from the lawn side. *Kinnicutt family.*

156

house. The pleasant porches of Deepdene overlooked the first three holes of the new course. On a summer morning, Dr. Kinnicutt could have a round of golf before breakfast.

Soon Deepdene was cluttered with the golf clubs and riding boots of Dr. Kinnicutt and his two active teenage sons, Hermann and Francis Jr., but Mrs. Kinnicutt does not appear to have had any country pursuits. She was an urban crusader.

Born into a successful German American merchant family in New York, Eleanora Kissell Kinnicutt founded the Street Cleaning Aid Society in 1891 at a time when Dr. Kinnicutt was rising in New York City's medical world.[275] Inspired by the example of street cleaning in Berlin, Eleanora Kinnicutt rallied influential friends to her cause and transformed the city's corrupt Street Cleaning Commission with the appointment of a new leader, the charismatic sanitary engineer from Newport, Colonel George E. Waring.[276] Waring attacked the proliferation of household garbage, construction trash and abandoned vehicles clogging the city streets with three thousand newly trained sanitation workers in brisk white uniforms. At a time of reform against machine politics, this was a popular civic campaign with military and evangelistic overtones. Waring's workers, the "White Wings," were hailed as "soldiers of cleanliness and health."

Buoyed by her recent street cleaning experience, Eleanora Kinnicutt took to the pages of both *Harper's* and the *Century* in November and December 1894. In her remarkable manifesto, "American Women in Politics," she challenged women to get informed on issues and take a role in politics.[277] Mrs. Kinnicutt was an activist, not a suffragist. Like many of her reform-minded friends at this era, she argued that women, as well as many newly enfranchised immigrant men, first need education.[278] A champion of women's higher education, she was a longtime trustee of Barnard College. She was one of the first two women appointed to the New York State Lunacy Commission when it was created by Governor Levi Morton in 1896.[279] She served on the board of the Manhattan State Hospital on Ward's Island, and her reports show her practical mind addressing details ranging from fire escapes and plumbing to the summertime tents for patients suffering from tuberculosis.[280]

Richard Watson Gilder continued to publish Eleanora Kinnicutt's works in the pages of the *Century*. During an unexpected hospitalization in Europe in 1895, the ever-inquisitive Eleanora was impressed by her extraordinarily competent and motivated nurse. This woman, like Florence Nightingale, had been trained at the innovative Protestant nursing school in Kaiserswerth

in Germany. The November 1895 issue of the *Century* ran Mrs. Kinnicutt's article on the life of its dedicated founder, Theodor Fliedner.[281]

Aside from Deepdene in Lenox, the Kinnicutts had country houses in Morristown, New Jersey, and Isleboro, Maine, and traveled regularly abroad. Both appear to have been fluent in German. In 1905, Dr. Kinnicutt oversaw the English translation of Swiss hematologist Hermann Sahli's influential work *Treatise on Diagnostic Methods*, published a decade earlier in German. In London, they frequented the American Embassy during Joseph Choate's term there. Creber, Choate's English butler, greeted Kinnicutt jovially as "Dr. Connecticut."[282] Shopping in London in 1902, Eleanora found the perfect print for their friend Theodore Roosevelt, now in the White House. A confident and opinionated woman, she was never shy in advising him on political tactics.[283]

Eleanora Kinnicutt died in 1910. "Is Dorothy going to marry Mr. Straight?" is said to have been her death-bed utterance, inquiring about the engagement of her friend William C. Whitney's daughter.[284] Dr. Kinnicutt's demise occurred two years later, surrounded by his peers at a medical society meeting in New York. He had just given a paper highlighting cases in his practice when apparently minor tooth and gum infections were at the root of life-threatening illnesses. "Oral Sepsis is a interesting subject," he opened his last paper to his colleagues.[285] Concluding, the eminent doctor sat down on a sofa and slumped over with a fatal heart attack.[286]

Despite their differing traits (he was said to be un-methodical by nature, she evidently a dynamo of Teutonic organization), the energetic, multitalented Kinnicutts were evidently a close and interdependent couple, in contrast to the Whartons.

Surviving letters record Dr. Kinnicutt's advice to Edith as Teddy's manic depression worsened in the course of their Lenox decade. At first, he advised her to seek various treatments and keep Teddy involved in the rural life he loved at The Mount. In 1909, Kinnicutt wrote, "My fear is that on his return to Paris, in an environment which does not appeal to him apart from the helpfulness of your presence, there may be another swing back of the pendulum."[287]

By late 1911, when the Whartons sold The Mount, Kinnicutt had given up hope for Teddy to function on his own. "I think we must accept the fact that Mr. Wharton is suffering from a psychosis, and the prognosis is an unfavorable one." He advised that "[a sanitarium] would be really helpful to him, not perhaps as regards to the ultimate outcome, but in relieving some of his unhappiness."[288]

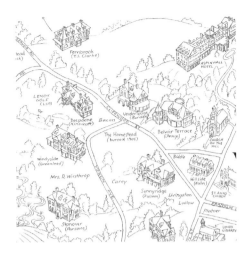

This was not to be. With Edith's departure, Teddy's siblings, Nannie and William, became reluctantly responsible for their troubled brother. The specter of their father's suicide at McLean's Hospital may have been too traumatic for them to consider institutionalizing their brother. Instead, they kept him in the care of private nurses in New York and Lenox for the remaining seventeen years of his sad and sometimes violent life.

# Nannie Wharton

## The Village Improver

S prinkling the dusty streets, burying new-fangled electricity lines, planting shade trees and removing others obscuring iconic lake vistas—all these were the preoccupations of Nancy "Nannie" Craig Wharton (1845–1921), Teddy's unmarried elder sister, during her Lenox summers. As president of the Village Improvement Society, she was a natural leader, capable of bringing together the various constituencies in Lenox. Her fellow board members included hotel owner William D. Curtis, grocer Murray Brown (father of Lucy who survived the famous coasting accident of 1904) and selectman George Ferguson, who managed Pinecroft for Augustus Schermerhorn. The membership consisted of various civic-minded tradesmen and cottagers, including her close friend Harriet Burden of Cliffwood Street.[289]

Stockbridge's Laurel Hill Association, founded in 1853, is considered the oldest village beautification society in America. It was the model for numerous such groups in the third quarter of the nineteenth century. Inspired by landscape and sanitation reformers like Frederick Law Olmsted and Colonel George Waring, these societies brought fresh ideas to remote rural places, often poorly drained and denuded of trees. They provided an organizational structure for the summer residents, who could not vote in town elections, to participate in village affairs. In 1876, even before the founding of an improvement society, a group of summer Lenox residents hired sanitary engineer Colonel George E. Waring to establish a pilot "separated" sewage system.[290]

The Lenox Improvement Society was formed in 1881, and Nannie Wharton, according to her obituary in the *New York Tribune*, led it for some thirty years.[291] Occasionally, she took a year off as president when traveling abroad but always returned to an active role. Nannie came from a culture of civic action. In the summertime, her cousin Bishop Doane of Albany was running the Improvement Society in Northeast Harbor, Maine. Her mother's closest friend, Annie Robbins, who, like Nannie, never married, founded a women's charity hospital in Boston, and the whole Wharton family contributed in various practical ways to its operation.

Fundraising for improvements, juggling complaints of the disenfranchised cottage owners on the cost of taxation, Nannie worked with town officials as well as top landscape consultants. In addition to Waring of Newport, in 1904, Charles Sprague Sargent of Arnold Arboretum culled trees

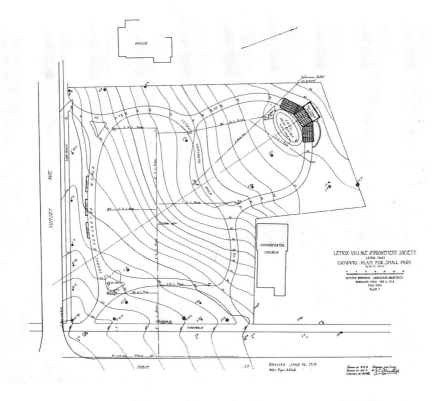

Lenox Village Improvement Society activist Nannie Wharton encouraged the Olmsted Associates plan for a new village park (now known as Lilac Park), June 1914. The pond, pergola and toolshed were never created. *Courtesy of the National Park Service, Frederick Law Olmsted National Historic Site.*

encroaching on treasured local views, and the Olmsted firm of Brookline made plans for diagonal parking by the Curtis Hotel and a new village park between 1907 and 1914.[292]

Colonel Waring urged communities to attend to details: "What most detracts from the good appearance of any village is the slovenly look which comes from badly hung gates, crooked fences, absent pickets, and general shiftlessness about private places."[293] Nannie recruited her sister-in-law Edith to participate in Lenox Improvement Society's awards for village properties, especially along Depot Street (now Housatonic Street), seen first by newcomers arriving by train.

The work of the Lenox Improvement Society sometimes involved new experiments. Abating the dust generated by the new automobile traffic was an issue in Nannie's time. In July 1909, acting on a state recommendation, she and Albert Shattuck, president of the American Automobile Association, made an unsuccessful trial using calcium chloride instead of the normal street sprinkling with water.[294]

In June 1912, Nannie Wharton endorsed John E. Parsons's proposal to create a small park on the grounds of the old Servin house, and soon the Village Improvement Society hired the Olmsted Associates to create today's Lilac Park.[295] The Platner cottage, where Nannie lived in the 1890s, faces this village greensward.

Nannie Wharton was five years older than her brother Ted. During their years abroad as children, she was infected by her parents' enthusiasm for Europe. Sightings of titled heads never happened on a random day in Brookline. In the winter of 1858, at the age of thirteen, she wrote to her cousin Lilly Cleveland: "Every time one goes out, one sees something new. We have seen the Emperor and Empress three or four times."[296]

By the next year, Nannie was a complete Francophile, writing Lilly, "France is the land of my affections."[297]

Back in Boston in the following decade, Lilly Cleveland provides a vivid account of Nannie as a flirt among the eligible bachelors. The future Supreme Court justice Oliver Wendell Holmes Jr. was pursuing Nannie in 1869. "Nannie's friendship with Wendell Holmes continues in full force," Lilly observed. "He takes the highest metaphysical flights and talks of unity of soul. Nannie cheerfully brings him down *plump* on matter of fact ground, saying 'I don't believe you half understand *yourself* what you are talking

about!'"[298] Nannie was clearly not an intellectual—not a good omen for her future relationship with her sister-in-law Edith.

The next bachelor Nannie did not marry was another intellectual, Henry Adams. In 1871, as Adams was breaking the news of his engagement to his brother, he wrote, "[T]ry to guess the person…Clara Gardner? No! Nanny [sic] Wharton? No. It is however a Bostonian…Yes! It is Clover Hooper!"[299]

In 1885, Nannie's witty, talented and troubled friend, Clover Hooper Adams, committed suicide by drinking photography chemicals in her darkroom in the Adamses' grand house in Washington, D.C. In Boston Brahmin circles, the ravage of mental illness among the Hooper clan was well known. More than once in the 1870s, Clover's first cousin Alice Hooper, cataloger of the entire holdings of the Lenox Library, was committed to the Hartford Asylum. The Whartons' struggle to cope with Nannie's evidently manic-depressive father was understood by many in this circle of Boston and Lenox friends.

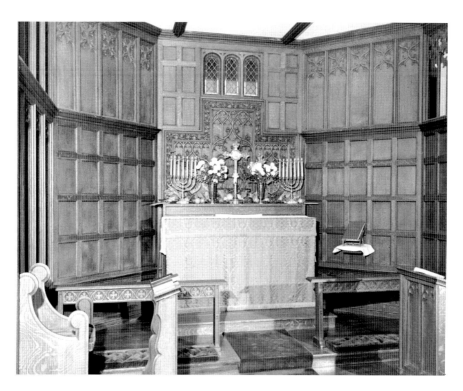

Chapel at the Hospital of the good Samaritan in Boston, endowed by Nannie Wharton in 1905. *Boston Children's Hospital Archives.*

In Boston, Nannie was active in support of the Annie Robbins Hospital of the Good Samaritan. The hospital, founded in 1860, provided treatment and palliative care for sick and destitute Boston women. In 1905, Nannie gave the hospital a fully appointed chapel, and when she died, in 1921, she left an endowment for altar flowers and the chapel's maintenance.

In Lenox, Nannie's practical and leadership skills blossomed through her activities with the Village Improvement Society. Through her work, she knew a cross-section of the Lenox community. She was not a horsewoman but enjoyed riding with others in the Lenox Tub Parades, autumnal displays of decorated carriages through the streets of Lenox. Like her younger brother, Ted, she took up bicycling, but in 1896, at age fifty-one, she broke her leg in a violent fall near Trinity Church.[300] Teddy teased her about gaining weight. She was a ready volunteer for noble local and international causes—pouring tea with Grace Tytus at the St. George's Church Fair in Lee in 1907[301] and sewing surgical supplies in 1916 under Etheldred Folsom's leadership for the Lenox branch of the American Fund for the French Wounded.[302]

In later years, Nannie lived comfortably, but not lavishly, on two trust funds from her aunt Mary Perkins and the beneficent Annie Robbins. The Pine Acre household was staffed with Scandinavian servants, a Swedish maid Hedwig Frykman and gardener Theodore J. Voorneveld. The family retained their Beacon Street house in Boston for many years, but they often rented it. Nannie's brother William and Susan settled at The Elms, one of the most conspicuous big houses in Groton, Massachusetts. After her mother's death, Nannie wintered in New York at 42 East Seventy-Fifth Street.[303]

Among Nannie's closest Lenox friends were a wealthy, childless couple, Annie Schermerhorn and John Innes Kane. Annie's parents were the William C. Schermerhorns of New York, benefactors of Columbia College and numerous New York City institutions. The Schermerhorns owned a grand double house in the city, a commodious mansard-roofed villa in Newport and also a modest village house in Lenox next to the library.[304] Daughter Annie and her husband John Kane rented various Lenox houses. In 1895, when the Kanes celebrated the fiftieth anniversary of Annie's parents, they were living at Hillside, Mrs. Kuhn's place. Nannie was among the younger

*Opposite, top*: The fiftieth wedding anniversary party for the William C. Schermerhorns on September 24, 1895. Nannie appears to be seated on the far left, next to Mr. Schermerhorn. Behind her stands Edith Rotch, wearing black due to the recent death of her architect brother, Arthur. *Lenox Library Association*.

*Opposite, bottom*: Annie Schermerhorn Kane with her bike on the Pine Acre driveway, 1897. *Jay Album, courtesy of William Patten*.

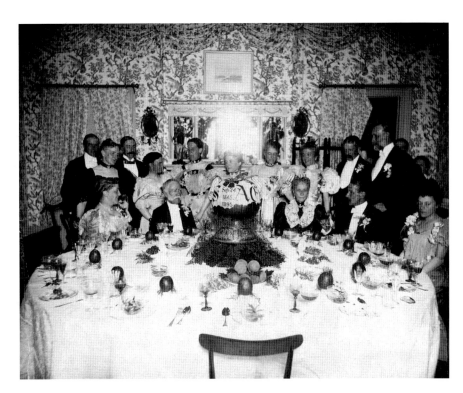

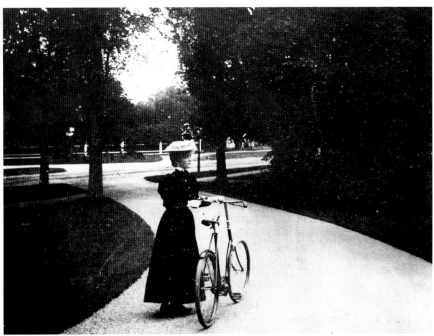

generation of family and friends clustered round the elderly Schermerhorn couple. (In the center of the table sits a festive pumpkin decorated by local craftsman Leonard C. Peters.) Two years later, in the summer of 1897, while Nannie and her mother were abroad, the Kanes rented Pine Acre.

Early in Edith Wharton's Lenox years, she and Nannie made token sisterly efforts to support each other's causes. Edith was there at Pine Acre when Nannie lit eighty-two candles for old Mrs. Wharton's birthday in October 1902.[305] In 1903, Nannie and Edith were patronesses of a concert held in the new, commodious Lenox Town Hall. The chasm, however, between their ages (Nannie was seventeen years Edith's senior) and their worldviews only broadened as the decade wore on.

Rather than relishing Edith's emerging talent as a writer, Nannie likely dreaded each new short story, bearing personal slights on her private world. There was an unsympathetic depiction of a fundraising bishop like her cousin Bishop Doane in "Expiation" (1904) and numerous pitiful portrayals of ineffectual husbands, like Teddy, culminating with "The Choice" (1908).

Teddy's siblings were mortified to learn of his misappropriation of her money in the course of 1909. In December 1909, Nannie wrote Edith's brother Harry from Pau:

> *I cannot express how sick I am with the grief and shame Teddy has inflicted on Pussy and the rest of us....I was not aware of the situation when I received Pussy's letter, for Ted had explained...that he had speculated with the trust funds and lost, but I do not believe he had an accurate estimate of the amount. He seemed only to comprehend vaguely what he had done...*

Nannie continued:

> *Ted has written me that you and Pussy were very decent to him, well beyond what he deserved, and that he is fully aware of what you have done for him. Fortunately we are able to cover for him, as no one aside from us need know about the business of money.*[306]

Edith often complained that Teddy's family was in denial of his illness. In a letter on December 2, 1909, she wrote Sally Norton of "Nannie's incredible blindness & stupidity & determination not to recognize *any* nervous disorder."[307] Three weeks later, however, Nannie's letter to Edith shows a fairly astute understanding of his mental condition. "I am very worried about Ted. With his personality, such an experience and the

humiliation he must be enduring over what he did, can only be awful for him." She speculates that he was suffering from "a reaction to the medication or partial side effect of the depression he suffered last winter in Paris, he was not in his right mind when he committed the acts that ruined his future forever—for he will never regain his self respect." She ends her letter to Edith, "I am crushed, and I feel great sympathy for you and great pity for him.…Tenderly, affectionately yours, Nannie."[308]

Nannie's letters to Harry and Edith both mention how glad she is her mother had not lived to fret over this family "nightmare." She depicts herself as facing this problem "alone," but in fact, she was in good company in Pau. Nannie's beloved cousin, Nancy Wadsworth Rogers, was facing erratic Teddy-like behavior in her forty-year-old bachelor-sportsman son "Waddy."[309]

The ominous fact was that Edith's patience with Teddy was running out, and Nannie would be expected to care for her troubled brother. This must have been on her mind, as Nannie floated down the Nile with Annie

Shielding themselves with parasols from the Egyptian sun, Nannie Wharton, Annie Kane and other ladies explore Abu Sinbil site with J.P. Morgan and his party, 1912. *Metropolitan Museum of Art, New York.*

and John Innes Kane in the winter of 1912. The wise and sympathetic Dr. Kinnicutt was also in the group on the Kanes' *dahabeah* (specially designed Egyptian river barge). At Luxor, as planned, they met J.P. Morgan with a retinue of Metropolitan Museum experts. In his memoirs, another travel mate and an old Brookline friend of Nannie, Bishop William Lawrence, wittily recounted the experience of sightseeing with the imperious, energetic, hypochondriac of a seventy-five-year-old banker-collector. (Morgan died the following March in Rome.) Before Morgan's culminating mission—a side trip into the desert to the Kharga oasis, on donkeys—the Kanes and Nannie bowed out to attend Annie's ailing sister in France.[310]

Edith and Teddy's divorce was finalized in April 1913, and Nannie, at sixty-eight, was once again a caregiver. On a Lenox visit in September 1918, Minnie Jones picked up from townspeople a grim report of the household at Pine Acre. The once-athletic Teddy was very weak and mostly bedridden and "nasty and abusive" to his sister.[311]

Nannie was the first to die, in October 1921. Her coffin was borne into Lenox's Trinity Church to the strains of the triumphant Easter hymn "The Strife Is O'er, the Victory Won." Her active pallbearers were townspeople with long ties—Ernest Curtis (of the hotel dynasty), Frank Hagyard (drugstore owner who supplied Teddy's medications), George Ferguson (former selectman and Village Improvement colleague), James Clifford (local builder) and L.C. Peters (fine carpenter who often worked for the Whartons). The old guard of cottage owners were honorary bearers—Giraud Foster, Grenville Winthrop, Henry White, S. Parkman Shaw, Clinton Gilmore and even Edith's cousin, Newbold Morris. Trinity's rector, Latta Griswold, was assisted by two leading New York City clergyman: Reverend Charles Slattery of Grace Church (soon to be bishop of Massachusetts) and Reverend Leighton Parks of St. Bartholomew's Church. Nannie's *New York Tribune* obituary noted that she "for half a century had been identified with the old conservative families of New York City."

Nannie was laid to rest at the Wharton plot at the Church on the Hill, and Teddy was left. The "strife was not over" for Teddy.

## 24

# *Teddy's Last Years*

A t the age of seventy-nine, Teddy Wharton died on February 7, 1928. Edith was in Hyères when she received the news in a cable from "Mrs. Billy" Wharton.

In the fifteen years since the divorce, Teddy had moved seasonally between Pine Acre and his New York apartment on Sixty-Eighth Street, a block from Central Park.

On good days in Lenox, he could be seen walking on Main Street to pick up his medications at Hagyard's Drug Store. His volpino, a rare and energetic little Italian dog (a breed Edith had owned as a child in Florence) named Pisa, was his constant companion on these strolls. For years, Teddy's automobile-driving exploits were the talk of the village. When taking driving lessons at Morse's Garage on Church Street, the hyper-enthusiastic student mistook his gears and drove through the side of the flimsy metal structure.[312]

As the years went on, Teddy, once "sunshine in the house," became an increasingly pathetic and solitary figure. After Nannie's death, he was attended by his faithful nurse, Pearl Barrett. The village elementary school stood behind Pine Acre, with separate girls' and boys' playgrounds at either side of the building. Their noisy antics may have provided pleasure for the child-loving Teddy, but in his last months, a request came from Pine Acre that the girls play at recess on the boys' side, farther from Mr. Wharton's hearing.[313]

Teddy would sit with his nurse by the hour on the upstairs porch of Pine Acre. From this lovely vantage point, he overlooked the triangular lawn

At the family plot at the Church on the Hill, Teddy Wharton's marble tombstone is in the foreground. His mother, Nancy, and sister Nannie's matching stone crosses are behind. *Nannina Stearn*.

and the angled Norman Romanesque Trinity Church. In his prime some forty years earlier, he had witnessed the church's construction, and now the massive stone structure had become a landmark. The evocative bells ringing in the great stone tower marked the passing hours.

In February 1928, Edith Wharton wrote letters to friends about Teddy ("the kindest of companions till that dreadful blighting illness came upon him"). From her terrace in Hyères, overlooking her own view of an ancient bell tower and Romanesque church, she reflected, "I am thankful to think of him at peace after all the weary agitated years."[314]

# Appendix A

# *New Public Buildings in Edith Wharton's Decade in Lenox*

Lenox was evidently a prosperous place in the decade during which Edith Wharton was in residence. Aside from private building projects, a huge new hotel—the Aspinwall—and the town hall were under construction at the same time as The Mount (1901–2). Both of these were constructed by Lenox builders the Clifford Brothers. The Aspinwall Hotel was the significantly highest taxpayer in Lenox by 1906. The elegant town hall and the new 1909 high school (today known as Cameron House) attest to the growing tax base in town. The brick high school trimmed with terra cotta was built on land given by George Hale Morgan of Ventfort Hall and designed by Springfield architect John William Donohue. Donohue had recently designed the Craftsman-style St. Vincent de Paul Catholic Church in Lenox Dale in 1904. The two-bay brick- and marble-trimmed firehouse beside the town hall was built in 1909 after the catastrophic Main Street fire on Easter morning of that year.

The new stone Catholic church on Main Street, St. Ann's (1911), reflects the substantial increase in Lenox's Catholic congregation. Many, but not all, Catholics were employees on the estates. A few, like Carlos de Heredia, the Alexandres, the Bristeds and the Shattucks, were cottage owners and generous supporters of the new church building. Francis Burrall Hoffman, the architect of St. Ann's, was a nephew of Mary and Albert Shattuck. The Shattucks had no children, and their Hoffman nephews were regular summer visitors to their various Lenox homes (at first Brookhurst and, after a fire in 1905, several rented houses, including The Mount). In 1911, the

St Ann Church. Lenox Mass.

*Above*: The neoclassical brick Lenox Town Hall with its distinctive gold-domed cupola, marble quoins and massive Corinthian portico was designed by Pittsfield architect George C. Harding in 1901. *Lenox Library Association.*

*Opposite, top*: The massive one-hundred-room Aspinwall Hotel was built on a promontory above the Church on the Hill in 1901–2, designed by Joseph Vance of Pittsfield. This view was taken from Bald Head. The hotel burned in 1931, and the site is now part of Kennedy Park. *Lenox Library Association.*

*Opposite, bottom*: The grand Romanesque St. Ann's Church with its carved doorway and porte-cochère was designed by F. Burrall Hoffman in 1911. *Lenox Library Association.*

year St. Ann's cornerstone was laid, the Shattucks purchased The Mount from the Whartons. Burrall Hoffman is best known for his private houses, especially in Florida, but he retained an affection for Lenox and St. Ann's Church. He and some of his brothers are buried in St. Ann's Cemetery.

# Appendix B

# *The Local Architectural Influence of The Mount*

In the decade after the construction of The Mount, Francis Hoppin was commissioned to design three more Georgian Revival country houses in the Berkshires. In 1908, he designed Brookhurst on West Street in Lenox for Edith Wharton's first cousin Newbold Morris and his wife, also a more remote cousin, Helen Schermerhorn Kingsland. Brookhurst

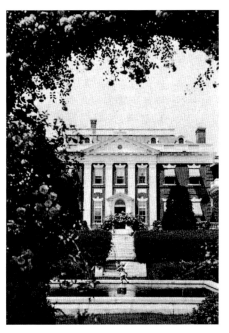

was barely finished when Hoppin began designing the brick and marble Eastover for Harris and Mabel Fahnstock. Edith's niece Beatrix Farrand planned the landscape at Eastover and may have also designed the grounds of Brookhurst. Both Brookhurst and Eastover survive today, but Hoppin's hillside Ashintully (finished in 1913) in Tyringham burned down in 1952. Like The Mount, the imposing house was faced with white stucco with a

Brookhurst. *Lenox Library Association.*

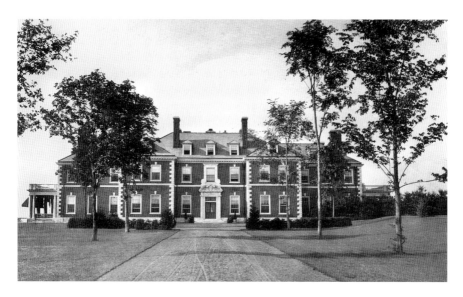

Eastover. *Dorothy Winsor.*

Ashintully. *Tyringham Historical Commission.*

crowning cupola and a wide terrace overlooking a magnificent Berkshire vista. It was built for Grace Henop and Robb de Peyster Tytus, who found Tyringham on their honeymoon in 1903 and first settled in a farmhouse. The Tytuses undoubtedly admired the Whartons' Mount.

# Cast of Lenox Cottages and Cottagers in Edith Wharton's Day

| | |
|---|---|
| Allen Winden, Old Stockbridge Road (demolished circa 1927, now Winden Hill) | Charles Lanier |
| Beaupré, West Street (burned 1961) | Major George and Elizabeth Lanier Turnure |
| Bellefontaine, Kemble Street (now Canyon Ranch) | Giraud and Jean Foster |
| Belvoir Terrace, Cliffwood Street (summer camp) | Morris and Maria Jesup |
| Birchwood, Main Street (inn) | Richard and Florence Dana |
| Blantyre, Blantyre Road (inn) | Robert and Marie Paterson |
| Breezy Corners, Cliffwood Street (private) | Emily Biddle |
| Brookhurst, West Street (burned 1905) | Albert and Mary Shattuck |
| Second Brookhurst, West Street (private) | Newbold and Helen S. Morris |
| Butternut Cottage, Main Street (Garden Gables Inn) | Kate Cary |
| Clipston Grange, Kemble Street (private) | Frank and Florence Sturgis |

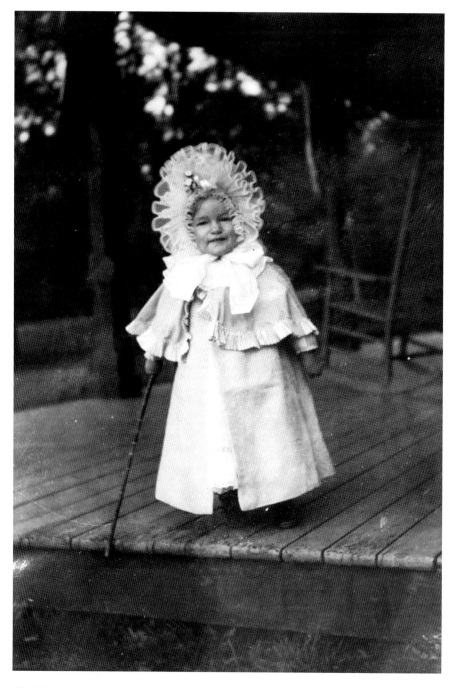

Clutching a stick and exquisitely dressed, one-year-old Irene Turnure poses on the porch of her family's West Street home, Beaupré, 1900. *Elizabeth Lanier Turnure album, Lenox Historical Society.*

| | |
|---|---|
| Coldbrook, Lee Road (part of Cranwell) | Captain John S. and Susan Barnes |
| Deepdene, Cliffwood Street (private) | Dr. Francis and Eleanora Kissell Kinnicutt |
| The Dormers, Pittsfield-Lenox Road (private) | Ellen Schermerhorn Achmuty |
| Eastover, East Street (inn) | Harris and Mabel Fahnstock |
| Edgecombe, Sunset Avenue (demolished 2015) | Clementina Furniss |
| Elm Court, Old Stockbridge Road (inn) | William and Emily Vanderbilt Sloane |
| Erskine Park, Stockbridge Road (demolished circa 1917, now Foxhollow) | George and Marguerite Westinghouse |
| Ethelwyn, Yokun Avenue (demolished circa 1928, second house now called Ethelwynde) | Katherine Taylor Winthrop |
| Fairlawn, West Street (demolished) | Adele Kneeland |
| Fernbrook, West Mountain Road (now Hillcrest Educational Center) | Thomas Shields Clarke and Adelaide Clarke |
| Groton Place, West Street (now Boston University Tanglewood Institute) | Grenville Winthrop |
| Gusty Gables, Yokun Avenue (private) | Mary dePeyster Carey |
| Henry Bishop Cottage, top of West Street (demolished) | rented regularly to various people, including Edith Wharton in the summer of 1902 |
| High Lawn, Stockbridge Road (private) | William B. Osgood and Lila Sloane Field |
| Highwood, West Street (Boston Symphony Orchestra) | Louisa Norton Bullard, rented to Cram family |

| | |
|---|---|
| Hillside, Greenwood Street (now Whistler's Inn) | Grace Cary Kuhn |
| Home Farm, Undermountain Road (private) | Dr. Henry P. and Caroline Ware Jaques |
| The Homestead, Cliffwood Street (burned 1905) | fire occurred with Dahlgren family renting |
| Interlaken, Old Stockbridge Road (demolished 1922) | Florence Bishop Parsons |
| Little Farm, Old Stockbridge Road (private) | John T. Parsons, after 1905, Frederick and Anita Delafield |
| Ludlow Cottage, Main Street (private) | James and Louisa Geary Ludlow |
| Maplehurst, Old Stockbridge Road (demolished) | Matilda Bishop White, after 1907, Cortlandt Field Bishop and David Wolfe Bishop Jr. |
| The Mount, Punkett Street (museum) | Edith and Teddy Wharton |
| Nowood, Cross Road (now Seven Hills Inn) | Robert W. and Adèle Chapin |
| Osceola, Cliffwood Street (private) | Edward and Sarah Pollock Livingston |
| Overlee, Old Stockbridge Road (Hillcrest Educational Center) | Elinor Meyer and Samuel Frothingham |
| Pine Acre, Walker Street (now enlarged as The Gables condominiums) | Nancy Spring Wharton |
| Pinecroft, Walker Street (demolished) | F. Augustus Schermerhorn |
| Pine Needles, Undermountain Road (private) | George and Margaret Blake |
| Plumsted, Old Stockbridge Road (private) | Devereux, after 1904, Joseph and Florence Whistler |

| | |
|---|---|
| The Poplars, Old Stockbridge Road (demolished) | Frothinghams rented frequently, Edith and Teddy in summers of 1900 and 1901 |
| Redwood, Old Stockbridge Road (private) | S. Parkman and Gertrude Shaw |
| Rocklawn, Cliffwood Street (private) | William B. and Elizabeth Stone Bacon |
| Shadowbrook, West Street (burned) | Spencer P. Shotter |
| Spring Lawn, Kemble Street (proposed inn) | John E. and Helen Webb Alexandre |
| Stonover, Yokun Avenue (moved and altered 1921, demolished 1942) | John E. Parsons |
| Stonover Farm, Undermountain Road (inn) | Herbert and Elsie Clews Parsons |
| Struthers' cottage, Walker Street (now Hampton Terrace Inn) | John and Virginia Bird Struthers |
| Sundrum, Kemble Street (now Kemble Inn) | Frelinghuysens renting to Thatcher Adams |
| Sunnybank, Walker Street (private) | General Francis C. and Ellen Shaw Barlow |
| Sunnycroft, Kemble Street (demolished 1970s) | George G. and Frances Arnot Haven |
| Sunnyridge, Cliffwood Street (burned 1925, second house extant) | George W. and Frances Folsom |
| Tanglewood, West Street (Boston Symphony Orchestra) | Mary Tappan and Ellen and Richard Dixey |
| Thistlewood, Walker Street (private) | David and Hannah Lydig |
| Twin Elms, Plunkett Street (private) | Georgiana W. Sargent |
| Underledge, Cliffwood Street (private) | Joseph and Harriet Burden |
| Valleyhead, Reservoir Road (burned 1987) | J. Frederic and Marie Louisa Stone Schenck |

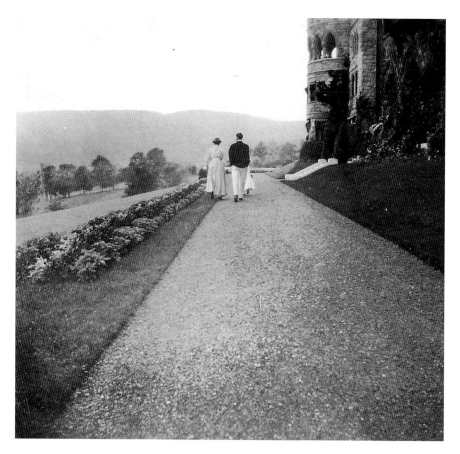

Young Spencer Shotter and his sisters on the Shadowbrook terrace, circa 1908. *Family of Mary Shotter de Caradeuc.*

| | |
|---|---|
| Ventfort Hall, Walker Street (museum) | George H. Morgan |
| Wheatleigh, Hawthorne Road (inn) | Georgie and Carlos de Heredia |
| Windyside, Yokun Avenue (now the Lenox Club) | Dr. Richard C. and Adeline Stone Greenleaf |
| Wyndhurst, Lee Road (now Cranwell) | John and Adela Berry Sloane |
| Yokun, Old Stockbridge Road (demolished 1931) | Richard, Lillian and Rosalie Goodman |

Chronology

# Edith Wharton's Lenox Years

## Writings

**OCTOBER 1900** "Line of Least Resistance"

**1901** "Angel at the Grave"

**1902** *Valley of Decision*

**1903** "Expiation"

**1903–4** *Italian Villas and Their Gardens*

**1905** *The House of Mirth*

**1907** *The Fruit of the Tree*

**1909** "The Choice"

**1911** *Ethan Frome*

**1917** *Summer*

## *Personal Life*

| | |
|---|---|
| 1899 | Edith and Teddy take an extended autumnal visit to Pine Acre. |
| 1900–1 | Edith and Teddy rent The Poplars, on the Old Stockbridge Road, in the summertime. |
| June 1901 | Edith's mother dies in Paris. |
| | The Whartons buy land from Georgiana Sargent. |
| Summer 1902 | Edith and Teddy rent H.W. Bishop House at the top of West Street. |
| 1901–2 | The Mount is under construction. |
| September 1902 | The Whartons move to The Mount. |
| Summer 1903 | Teddy begins to exhibit signs of serious depression. |
| October 1904 | Henry James first visits The Mount. |
| Winter 1904 | The Whartons purchase their first automobile in France. |
| June 1905 | Henry James visits The Mount a second time. |
| 1906–9 | Edith rents George Vanderbilt's apartment at 58 Rue de Varenne in Paris. |
| October 1907 | Morton Fullerton visits The Mount. |
| Summer 1909 | The Mount is rented to Albert and Mary Shattuck. Teddy embezzles $50,000 from Edith's trust fund and buys an apartment in Boston. |
| July 1909 | Edith is living at the Hotel Crillon in Paris and rents an unfurnished apartment, 53 Rue De Varenne. |
| August 1909 | Teddy's mother dies in Lenox. |
| Fall 1909 | Teddy's misappropriation of Edith's finances is revealed. |
| January 1910 | Edith moves into 53 Rue de Varenne (furniture moved from recently sold New York house). |
| October 1910 | Teddy is sent on a round-the-world trip with Johnson Morton. |
| July 1911 | Blow-up at The Mount—Teddy is diagnosed as psychotic. |
| September 1911 | The Mount is sold to the Shattucks. |
| 1912 | Edith begins divorce proceedings in Paris. |
| March 1913 | The Whartons' divorce is finalized. |

# Notes

## Introduction

1. See Gilder and Peters, *Hawthorne's Lenox*.
2. Kemble, *Records of a Later Life*, 101.
3. Mallary, *Lenox and the Berkshire Highlands*, 83.
4. Edith never mentions these quiet, childless cousins, Byam and Eliza Stevens, who bought Sunnyholme in Lenox in 1898. Byam Stevens, a New York lawyer, died in 1911, the year Edith and Teddy sold The Mount. Mrs. Stevens lived on until 1930. In later years, she was remembered in the village for her two sleek Rolls-Royces, driven by her chauffeur on alternate days.
5. Frederick W. Rhinelander, Edith's maternal uncle, was at the time of his death president of the Metropolitan Museum. As Edith's godfather, he stood in for her deceased father and escorted her down the aisle at her wedding in 1885. Edith Wharton [hereafter EW] to Sara Norton, September 27, 1904. Wharton (Edith) Collection, Beinecke Rare Book and Manuscript Library, Yale University.

## Chapter 1

6. Barnes, *From Then Till Now*, 220.
7. Lubbock, *Portrait of Edith Wharton*, 19.
8. *Berkshire Gleaner*, March 18, 1903.

9. *Roanoke Beacon*, "A Busy Literary Woman," September 11, 1908; *Berkshire Gleaner*, June 15, 1910; *New York Times*, August 2, 1908, described one of these entertainments. Cornelia Barnes performed a French recitation, and Charlotte accompanied Gertrude Parsons in French songs.

10. Tucker, *History of Lenox*, 49; Chague, *History of Lenox Furnace and Lenox Dale*, 9. The reading room opened on September 23, 1868, in a room on the south end of the Glass Works building. It later moved to Tillotson Hall over the coal company. The reading room closed after World War I. Many French residents of the Dale fought in the Great War, and some did not return.

11. "In Trust" appeared in *Appleton's Magazine* in April 1906. In Barnes, *From Then Till Now*, this letter is misdated 1907.

12. Barnes, *From Then Till Now*, 221–22.

## *Chapter 2*

13. Teddy Wharton was named after his mother's childhood guardian, Dr. Edward Robbins, who died just before he was born. Dr. Robbins's only child, Annie, the benefactress of the Hospital of the Good Samaritan, was treated by the Whartons as a family member.

14. R.W.B. Lewis assumes Edith introduced Teddy to travel. Lewis admits grudgingly, "He made the prescribed European tour after graduating and had been abroad once or twice since." Hermione Lee depicts Teddy as a conventional Bostonian with no European experience. (Lee, *Edith Wharton*, 72–75, 364).

15. Cabot, *Letters of Elizabeth Cabot*, vol. 1, 229–30.

16. ENP to Sarah Perkins Cleveland [hereafter SPC]. October 9, 1857, Cleveland/Perkins Papers, Box 9, Folder 11, Manuscripts, Archives and Rare Books Division, New York Public Library [hereafter NYPL].

17. Elizabeth Missing Sewell, children's book author and headmistress of a girls' school at Bonchurch on the Isle of Wight, was a noted figure in the High Church Anglican movement. SPC and she wrote each other every two weeks for decades. Edith Wharton's Newport neighbors, the Rutherfurds, sent their daughters to Miss Sewell's school.

18. Lilly Cleveland travel diary 1857, Cleveland/Perkins Papers, Box 17, NYPL.

19. Charles Callahan Perkins (1823–1886), the father of art education in the Boston public schools, was a man after Edith Wharton's heart. He wrote numerous books, including one on the Florentine Renaissance sculptor

Ghiberti; edited others, including *Cyclopedia of Painters and Painting* (1886); and coauthored two books on home decorating with Charles Eastlake (1872 and 1877). His sudden death in a carriage accident in Windsor, Vermont, occurred a year after Edith and Teddy's marriage and was a tremendous shock to the family.

20. Sherwood, "Certain Patriotic Exiles," 77.

21. Before setting off on his American travels that took him to Newport, Bourget had dedicated a short story, "The Gambler," to Ridgway. The elegant expatriate clubman is said to have inspired a number of characters in Bourget's early novels. [Thanks to Louisa Gilder.]

22. David Blackburn of Pau was an invaluable source for understanding the Wharton ties to this resort in the French Pyrenees.

23. The Park School on Goddard Avenue stands today on the site of the Whartons' farm. The only remnant of their era might be the low stone entrance wall.

24. Edward R. Wharton to ENP, April 15, 1887, Box 9, Folder 17. Cleveland Perkins Papers, NYPL. Possibly referring to the garden at the monastery of Certosa di Pavia.

25. Mary Gray (1764–1808) was brought up by her uncle Dr. Marshall Spring (Nancy Wharton's grandfather) of Watertown, Massachusetts. In 1793, she married Barnabas Bidwell of Stockbridge, son of Reverend Adonijah Bidwell, the pioneering clergyman of Tyringham. See Wilcox, "Fascinating Story of Mary Gray and Barnabas Bidwell."

26. Nancy Wadsworth Rogers (1844–1919) was the daughter of William Wharton's only sister, Mary, and her husband, James Wadsworth. She grew up at Hertford House in Geneseo in western New York State, where the Wadsworth family were large landowners and leaders in the political, social and sporting life of the region.

27. Gilder and Jackson, *Lenox Club*, 5–7.

28. The Platner cottage still stands today at 48 Main Street facing the Congregational shingled chapel.

29. *Valley Gleaner*, May 26, 1886.

30. Ibid., May 14, 1890.

31. ENP to Louisa [?], April 24, 1882, Cleveland/Perkins Papers, Box 9, folder 15, NYPL.

32. SPC to Louisa [?], November 8, 1885, Cleveland/Perkins Papers, Box 5 Folder 8, NYPL.

33. Lee, *Edith Wharton*, 73.

## Chapter 3

34. Emelyn Washburn to Elisina Tyler, September 3, 1938. as quoted in Lee, 74.

35. SPC to Grace Norton, March 22, 1885, Cleveland/Perkins Papers, Box 6, Folder 13, NYPL.

36. Lubbock, *Portrait of Edith Wharton*, 38–39.

37. This episode of Charlie and Mary Perkins falling through the ice probably occurred in 1876. See Lilly Cleveland's notes in Sarah Perkins Cleveland Papers, MS Am 1088.10, #281, Houghton Library, Harvard University.

38. Edward R. Wharton to SPC and Lilly Cleveland, May 20, 1884, as cited in Lewis, *Biography*, 50.

39. SPC to Grace Norton July 16th [1885], Sarah Perkins Cleveland Papers, bMs Am1088.10, #225, Houghton.

40. ENP to Louisa [?], December 9, 1885. Cleveland/Perkins Papers, Box 9 folder 15, NYPL

41. William Pickman Wharton (1880–1976). At Groton School, young Wharton's classmate Franklin Roosevelt dubbed him "Polly" for his interest in politics. The nickname adhered, but unlike FDR, Wharton took a different path. Independently wealthy through his mother's family, the Pickmans, he was a leading citizen of Groton, Massachusetts, and a farmer. For twenty-four years he served as president of the Massachusetts Forest and Park Association. In 1968, he gave 717 acres of Groton woodland, known as the Wharton Plantation, to the New England Forestry Foundation, an organization he helped incorporate in 1944. According to the *Groton Herald*, April 6, 1990, Wharton's "first and lifelong interest was birds, not trees." He was one of the first granted a bird-banding permit in 1914 and continued an active bird-banding station at his Groton farm into the 1960s.

42. In conversation with the author in 2010, two relatives spoke warmly of their memories of "Aunt Susie." Robert L. Walsh remembered Susan Lay Wharton, his grandmother's sister, as "an absolute angel" who never lost her temper, even when as a child he dug up her roses near the laundry at The Elms in Groton. His sister Suzanne described her great-aunt as funny and "a darling." Suzanne Walsh attended Foxhollow School. In 1948, she, being connected to Edith Wharton by marriage, had the bizarre experience of actually living at The Mount, which was then the senior dormitory for the Foxhollow girls. Conversations with the Walshes underlined the stresses in the Wharton family toward Edith after the divorce, the belief that she had deserted a loyal husband and that her writings were hurtful and negative to family and acquaintances.

43. EW to Anna Bahlman, Aug 8 [1896], as cited in Goldman-Price, *My Dear Governess*, 162.
44. EW to Anna Bahlman, May 21 [1896], as cited in Goldman-Price, *My Dear Governess*, 156–57.
45. Wharton, "A Little Girl's New York," 277.
46. OC to Sarah Codman, August 20, 1896, Codman Family Papers, Courtesy of Historic New England [hereafter HNE].
47. OC to Sarah Codman, January [?] 1896, Codman Papers, HNE.
48. Wharton, "A Journey," A Greater Inclination, 1899, 27, 29.
49. OC to Sarah Codman, October 14, 1905, Codman Papers, HNE.
50. *Berkshire Gleaner*, April 5, 1905.
51. Lee, *Edith Wharton*, 372.
52. *Berkshire Gleaner*, August 18, 1909.
53. In her will, Nancy Wharton left a small legacy to Reverend Leighton Parks.
54. *Berkshire Gleaner*, August 25, 1909.
55. Gunter and Jobestevan, *Dearly Beloved Friends*, 151.

## *Chapter 4*

56. "Journal of European Travels 1861–1862," John O. Sargent [hereafter JOS] papers, Reel 4, Massachusetts Historical Society [hereafter MHS].
57. "Journal of European trip 1863 of John O. Sargent," Porter-Phelps-Huntington Family Papers, Box 125, Folder 14, Amherst College Archives.
58. *Gleaner and Advocate*, October 15, 1874; October 12, 1876.
59. Nunley, *Berkshire Reader*, 179.
60. *Gleaner and Advocate*, July 21, 1882.
61. Owen Wister to JOS, May 1, [1890], May 22, 1890. In these two letters, Wister discusses a possible summer visit and recollected an earlier one in 1881. JOS papers, Reel 3, 61–64, MHS.
62. *Century Association Yearbook*, 1891, 20.
63. Berkshire Farmer [JOS pseud.], "Lucre and Luxury," 1.
64. Nancy S. Wharton to JOS, September 29, 1891. JOS papers, Reel 3, 107, MHS.
65. At the time of her death in 1946, Georgiana Sargent was still living in her birthplace, 28 East Thirty-Fifth Street, surrounded by memorabilia from foreign trips of her youth. Interior photos of the library of Sargent's New York house are in the Porter-Phelps-Huntington Family Papers, Amherst.

66. Georgiana Sargent [hereafter GS] to Catherine Huntington, n.d. Huntington, Porter-Phelps-Huntington Family Papers, Box 125, Folder 28, Amherst.
67. She continued to keep a cow for household needs in Lenox. The inventory at the time of Sargent's death records that the Twin Elms carriage house housed a solitary cow and the Buick. Berkshire County Probate Records #53940.
68. Under the terms of John O. Sargent's will, the house and garden were left to his daughter Georgiana for her lifetime. After her death, the property reverted to her father's trust. *Berkshire Eagle*, October 2, 1947. The carved front porch at Twin Elms is a reconstruction of a pre–Revolutionary War porch from Roxbury, Massachusetts. When that house was doomed for demolition, the porch was rescued by Lenox-NYC architect Richard Auchmuty (a descendant of the original builder.) Mrs. Auchmuty passed on the salvaged porch to her Lenox friend Georgiana Sargent, whose ancestor, Increase Sumner, also owned the house after the Revolution.
69. Botanist Charles Sprague Sargent (1841–1927), the first director of Harvard's Arnold Arboretum, was Georgiana Sargent's cousin.
70. Lenox Library Association Annual Report, 1946. Probably written by the Lenox Library president of that year, Mary Reynolds Bullard of Highwood.
71. Thanks to Deborah D. Smith, the archivist of the Lenox Garden Club, the author was able to study the club's minute books during Sargent's years.
72. David Huntington, great-nephew of GS, to the author, June 27, 2015.
73. Lenox Garden Club Annual Report, 1931–32.

## Chapter 5

74. EW to Helena de Kay Gilder, n.d. [September 1902]. Gilder Papers, Box 15, Lilly Library, Indiana University, Bloomington.
75. In an undated letter from the 1890s on Land's End stationery, EW writes Richard C. Dixey about an upcoming lunch party. Tappan Papers #427, Houghton Library, Harvard.
76. Like Teddy, Richard Dixey's life would ultimately be sabotaged by mental illness. In 1915, when his attendant was out of the room, he killed himself by jumping out of the window of their Boston house at 44 Beacon Street, next door to the Somerset Club. *Berkshire Eagle*, January 20, 1915.
77. Lubbock, *Portrait of Edith Wharton*, 20.

78. The author is indebted to Marjorie L. Cox of The Mount for her detailed research on M.T. Reynolds. After working for Edith Wharton, Thomas Reynolds spent the rest of his long professional life working for a prominent New Yorker, Moses Taylor Pyne, in Princeton, New Jersey. Reynolds returned to Lenox often, and in June 1914, he married Eliza Weston at Trinity Church. *Berkshire Gleaner*, May 20, 1914. The Lenox Horticultural Society members, mostly the estate superintendents, were closely connected socially. Fred Heeremans, superintendent of Elm Court, and Thomas Reynolds married sisters. Heeremans married Mary Weston in 1906 while Reynolds was still at The Mount.

79. *Roanoke Beacon*, "Busy Literary Woman," September 11, 1908.

80. Dwight, *Edith Wharton*, 116. For more about the fascinating Mr. Dorr see Epp, *Creating Acadia*.

81. Retired banker, one-time friend of the Transcendentalists and amateur of the arts Samuel Gray Ward (1817–1907) had built two great Lenox houses at various points in his career with Barings Bank (Highwood in 1846 and Oakwood in 1877). By 1903, as a widower, he was renting houses in the village in the summer.

82. French, *Memories of a Sculptor's Wife*, 206.

## *Chapter 6*

83. *Valley Gleaner*, June 25, 1890.

84. *New York Times*, April 29, 1899.

85. Henry Sloane, like Edith's counterpart, had odd eating habits and was prone to hypochondria, but unlike the hidebound and unimaginative husband in Edith's story, he was a business visionary who took the family company W&J Sloane to the West Coast. He served as treasurer of the company from 1893 to 1925. John Sloane, his brother, was president and led the company into its period of greatest prominence, expanding it to include antiques and custom-made furniture. William took a less active role in the family company.

86. OC to Sarah Codman, Codman Papers, HNE. As quoted by Dwight, *Edith Wharton*, 101.

87. The *Springfield Republican* of May 21, 1900, lists the Whartons among "new cottagers" renting the Poplars.

88. *Lenox Life*, July 15, 1899.

89. Reider, *Charmed Couple*, 210.

90. In his early biography of Edith Wharton, Lubbock stitches together reminiscences of those who knew her. He includes an account of an English friend who traveled in Italy with the Whartons in 1903 and witnessed the social "scenes" Edith created and left Teddy to resolve, 115–17.
91. Foreman and Stimson, *Vanderbilts and the Gilded Age*, 248.
92. Harrison, *Recollections Grave and Gay*, 311.
93. The *Springfield Republican* of September 13, 1906, indicates Edith Wharton competed in the driving classes with Kate Cary, Grace Tytus and Josephine Durand, the British ambassador's daughter.
94. For more about the Sloane Hospital see Speert, *Sloane Hospital Chronicle*.
95. Goldman-Price, *My Dear Governess*, 18.
96. William B. Osgood Field Papers, EW to WBO Field, Oct 10, [1903] Box 14, Folder 5, Manuscripts, Archives and Rare Books Division, NYPL.
97. WBO Field Papers, EW to Field, November 3, [1903] Box 14, Folder 5, NYPL.
98. Lee, *Edith Wharton*, 192
99. Lelia Webb's sister was Harriet Burden, wife of Joseph Burden. Her first husband was connected by marriage to both the Alexandres and the William Sloanes, and her cousin William E.S. Griswold would shortly marry Evelyn Sloane of Wyndhurst.
100. Eliot Gregory (1854–1915), portrait painter and satirical author.
101. OC to Sarah Codman, October 14, 1905, Codman Papers, HNE.
102. The Avery Library at Columbia University has Codman's rough sketches of the house.
103. OC to his brother, as quoted in Lee, *Edith Wharton*, 747.

## Chapter 7

104. *New York Times*, February 2, 1904.
105. *Rochester (NY) Democrat and Chronicle*, February 19, 1904.
106. *Boston Daily Globe*, July 19, 1904. The senior Morgans' marriage survived for another five years, but eventually, they parted. George H. Morgan died at his beloved Ventfort Hall in 1911.

## Chapter 8

107. This 1904 gymkhana does not appear to have been continued other years, but it is immortalized in a climactic chapter of a 1910 girls' adventure story, *The Automobile Girls in the Berkshires* by Laura Dent Crane.
108. HMD 1902–6 Diary, Durand Papers, file 30, SOAS, University of London.
109. *Springfield Republican*, August 13, 1905.
110. Unidentified clipping, October 24, 1906. Eliza Weston Reynolds' Scrapbook, The Mount Archives, gift of Dorothea Hellman.
111. Howard, *Theatre of Life 1905–1935*, 107–8. Howard movingly describes meeting the outgoing and devasted Sir Mortimer Durand in Washington in the "sad and sinister" ambassador's residence.
112. Thatcher M. Adams and his wife, Frances, rented houses in Lenox for some twenty years. Often in Edith Wharton's era they summered at the Frelinghuysens' house, Sundrum, on Kemble Street. Sir Mortimer Durand often dined there and would be served by his cricket mate, H. Jeffcott. (In *Lenox Life* cricket columns of 1899 and 1900, his name is spelled Jeffcoat or Jeffcoatt; in his diary, Durand spells it Jeffcott.)

## Chapter 9

113. EW to Giraud Van Nest Foster, July 28, 1904, Jane Foster.
114. Both Bellefontaine (1897) and Vernon Court (1900) were designed by architects Carrère and Hastings.
115. Obituary for Edwin Jenkins, undated clipping in a 1957 *Berkshire Eagle*.
116. One of the many anecdotes related to the author by Judy Conklin Peters, whose father was night watchman at Bellefontaine.
117. The story of the staff's names for the younger Giraud Foster and the speeding anecdote both were related to the author by Jane Foster, his daughter, in April 2015.

## Chapter 10

118. See Alsop, *34 Kensington Square*, 12–15, for a grandson's memories of Adèle Chapin.
119. Chapin, *Their Trackless Way*, 199–200.

120. *Valley Gleaner*, June 23, 1886.
121. Chapin, *Their Trackless Way*, 65.
122. Georgiana Sargent to George Huntington [1893], Porter-Phelps-Huntington Family Papers, Box 125, Folder 30, Amherst.
123. Chapin, *Their Trackless Way*, 200.
124. Barnes, *From Then Till Now*, 420.
125. Conversation with Dr. Reese Alsop, July 1998.

## Chapter 11

126. Lubbock, *Portrait of Edith Wharton*, 27.
127. Nevins, *Diary of George Templeton Strong*, vol. I, 1, 317.
128. Lubbock, *Portrait of Edith Wharton*, 16.
129. Goldman-Price, *My Dear Governess*, 97.
130. Thanks to Paul Miller of the Newport Preservation Society for verifying this, and other, Newport connections.
131. On her late mother's side, Charlotte Cram was the granddaughter of Edith Wharton's dear friend Egerton Winthrop.
132. Unpublished reminiscences of Katherine Haven Osborn, n.d., 4. Courtesy of Johnston L. Evans.
133. EW to Sally Norton, July 25, 1905. Wharton (Edith) Collection, YCAL 42 Series II, Box 29, Beinecke Rare Book and Manuscript Library, Yale University.
134. EW to Sally Norton, Sept 15, 1905, Beinecke.
135. Baldwin, "Natural Right to a Natural Death."

## Chapter 12

136. Gaillard Lapsley manuscript, 4. Percy Lubbock Papers, Wharton (Edith) Collection, Beinecke.
137. Lubbock, *Portrait of Edith Wharton*, 180–81.

## Chapter 13

138. EW to Sally Norton, August 6, 1904, Beinecke.
139. Martin, *Life of Joseph Hodges Choate*, vol. 2, 42.
140. French, *Memories of a Sculptor's Wife*, 242.

141. Richard Guy Wilson of UVA and Paul Miller of the Preservation Society of Newport helped immensely in narrowing down the architect of Ingleside.

142. Tuckerman, "Records of an Interesting Life," 42.

143. *Berkshire Gleaner*, December 31, 1874.

144. Lucius Tuckerman to Frederick Law Olmsted, October 16, 1881, Frederick Law Olmsted Papers, Library of Congress. James Bowditch's brother Ernest, also a landscape architect, worked with Dudley Newton at Wakehurst in Newport for James Van Alen in 1887.

145. Lucius Tuckerman to Frederick Law Olmsted, October 9, 1881, Frederick Law Olmsted Papers, Library of Congress.

146. Olmsted Research Guide Online, Job #00628, National Park Service. Olmsted's private commissions in Lenox in the coming years would include Julia Appleton McKim's Homestead (1884), the Sloanes' Elm Court (1886), the Frelinghuysens' Sundrum (1888) and the de Heredias' Wheatleigh (1892).

147. Tuckerman, *Notes on the Tuckerman Family*, 209.

148. Tuckerman, "Records of an Interesting Life," 43.

149. Francis James Child's wife, Elizabeth, was the sister of Susan Sedgwick Butler of Linwood, neighboring Ingleside. Emily's sister Lucy was married to Arthur Sedgwick, son of Theodore and nephew of Susan.

150. Tuckerman, "Records of an Interesting Life," 50.

151. Child, *Scholar's Letters to a Young Lady*, 81, 123. The letters began in 1883 and ended with Child's death in 1896.

152. Tuckerman, "Records of an Interesting Life," 47.

153. McKim designed for Lucius Tuckerman the "Tuckerman Hotel" (1876) at 41 East Fourteenth Street and a commercial building known as the Benedick/Tuckerman Building (1878), 78–80 Washington Square.

154. Tuckerman, "Records of an Interesting Life," 5.

155. Ibid., 74.

156. Ibid., 69.

157. Henry James to Edith Wharton, January 16, 1905, in Powers, *Henry James and Edith Wharton*, 44.

158. Horne, "'Reinstated,'" 58–59.

159. *Washington Post*, September 14, 1915.

160. Tuckerman, "Records of an Interesting Life," 62.

161. George G. Haven Sr. left his Lenox house, Sunnycroft, to his widow, Fanny Arnot.

162. The Haven House at 18 East Seventy-Ninth Street is now Acquavella Galleries.

163. Ethel Haven's granddaughters, Susan Menees and Eliza Mabry, always heard that Edith Wharton had a role in the family's alterations at Ingleside, further reinforcing the likelihood that Codman had some hand in the redesign of the drawing room at Ingleside.

## Chapter 14

164. OC to Sarah Codman, February 19, 1896, Codman Papers, HNE.
165. OC to Sarah Codman, March 13, 1896, Codman Papers, HNE. Among Adele Kneeland's Lenox relatives were the Haggertys of Vent Fort. Elizabeth Kneeland Haggerty (Mrs. Ogden) was Adele's great-aunt, sister of her grandfather Charles Kneeland.
166. EW to Anna Bahlman [October 1896], as cited in Goldman-Price, *My Dear Governess*, 166.
167. The Kneeland house was demolished in 1938, and the property, a block from Lenox's Main Street, was quickly subdivided. Today's Kneeland Avenue roughly follows the old driveway past Miss Kneeland's impressive gingko trees. Remnants of her high-maintenance hemlock hedge can be found encircling the place bounded by West Street, Yokun Avenue. The Sunset Avenue hemlocks have been removed recently.
168. Thanks to Findlay and Donald MacLean, who grew up on this property, the author has been able to picture this long-lost garden at Fairlawn.
169. *Country Life in America*, October 15, 1911.
170. *Berkshire Gleaner*, August 26, 1903.
171. *New York Times*, August 13, 1908.
172. Teddy and Edith also rented the Henry W. Bishop house in the summer of 1902, when The Mount was nearing completion.
173. *Berkshire Resort Topics*, August 6, 1904.
174. Anecdote of Julia Conklin Peters, April 1997.
175. *Berkshire Gleaner*, May 4, 1910.

## Chapter 15

176. Thanks to Louisa Thomas, who found this account in research for her book *Louisa: The Extraordinary Life of Mrs. Adams* (New York: Penguin Press, 2016).
177. Barnes, *From Then Till Now*, 50–51.
178. *Berkshire Gleaner*, March 16, 1904.

179. EW to Anna Bahlman, January 11 [1892?], as cited in Goldman-Price, *My Dear Governess*, 99.
180. *Berkshire Evening Eagle*, March 12, 1904.
181. Victoria Salvatore e-mail to author, December 3, 2015.
182. *Berkshire Evening Eagle*, March 12, 1904.
183. The NYU-educated Dr. Edward Preston Hale (1860–1935) served as the village doctor for years. In *Ethan Frome*, Edith Wharton names the all-knowing village lawyer Hale.
184. *Berkshire Evening Eagle*, March 12, 1904.
185. The John T. Parsons family, who at one time owned much of this section of Lenox, is not to be confused with the John E. Parsons family of Stonover. Louise's father, John T. Parsons, began life on the forty-acre family farm and in 1897 went into the coal business. In 1905, the year after the sledding accident, Frederick Delafield bought the old Parsons farmhouse at the foot of Court House Hill and called the place "Little Farm."
186. The meticulously handwritten Lenox Library accession books of this era record every new gift or purchase and name the donor.
187. *Annual Report of the Lenox Library Ending in June 30, 1908*, Lenox Library Association. The de-accessioned books were donated to Ethel Folsom's convalescent home in Lee and other local libraries.
188. EW to Catherine P. Spencer, July 9, 1909, Lenox Library Association.
189. Marshall, "Edith Wharton," 20–21.
190. Thanks to Ann Phillips, George Darey, Joe Nolan, Pat Fielding Jaouen and Victoria Salvatore of Lenox who remembered the survivors of the coasting accident and Catherine Palmer, Kate Naylor and Tim Kane, descendants of Mansuit Schmitt.

## *Chapter 16*

191. Lee, *Edith Wharton*, 224.
192. *Springfield Republican*, May 21, 1900.
193. *Obituary Record of the Graduates of Amherst College for 1912*, 47.
194. Cheney, "Descent in America," 33. Miss Cheney remembered her older cousins Lillian and Rosalie as "beautiful" and their brother Richard as "an unmitigated snob."
195. In the nineteenth century, the Lenox Library Board of Managers was all male. In 1903, when the Lenox National Bank moved out of the front room of the library building, the women's Associate Board of Managers

was formed. Their first task was to redecorate the old bank quarters, but they immediately became a force in book accessioning. The first female president of the Lenox Library was Mary Reynolds Bullard, who served during World War II.

196. The Society for the Preservation of New England Antiquities was founded in 1910 and is known today as Historic New England.

197. Frank Walker Rockwell to Mollie, Cambridge, Massachusetts, n.d., Box 13, Folder 35B, Rockwell Papers, Lenox Library Association.

198. Durand Papers, Box #5, #30. Durand engagement diary, 27 June, 1904. SOAS Archives, University of London.

199. Peabody, "Georgian Homes of New England," *American Architect and Building News*, 1877.

200. The Goodmans' Sanford Gifford painting now hangs at the Wadsworth Athenæum in Hartford, Connecticut.

201. *Springfield Republican*, November 23, 1930.

202. *Valley Gleaner*, June 23, 1886.

203. *Springfield Republican*, August 17, 1944 (refers to October 16, 1904 tea with Henry James); June 19, 1906.

204. *Berkshire Eagle*, September 14, 1905.

205. Berle, *Life in Two Worlds*, 6.

206. Ibid., 10.

207. Towner, *Elegant Auctioneers*, 354. This book is a great source on Cortlandt Field Bishop and his role in the New York and international art and antique auction world with the creation of Parke-Bernet Galleries. Regrettably, the author died before it was finished, and the book was published without footnotes.

208. *Berkshire Eagle*, June 16, 1952. Republished the ordinance of October 2, 1900.

209. *Horseless Era*, November 1, 1902.

210. Ibid., August 12, 1902.

211. *Berkshire Eagle*, November 7, 1911.

212. Towner, *Elegant Auctioneers*, 360. Researching *The Elegant Auctioneers* in the 1950s, Wesley Towner must have interviewed Mrs. Bishop (d. 1957) and Edith Nixon (d. 1972). Miss Nixon lived with the Bishops for many years as Mrs. Bishop's companion or "adopted daughter" and, some said, Mr. Bishop's mistress.

213. Cortlandt Bishop and his brother David inherited Maplehurst when their aunt Matilda White died in 1907, and Cortlandt became the sole owner after David's suicide in his Parisian townhouse just before Christmas

1909. In 1924, Bishop built Ananda Hall on the site of Maplehurst. He hired Beatrix Farrand to landscape the grounds. Ananda Hall was demolished after Bishop's death, but the high fieldstone wall opposite Winden Hill survives.

214. *Springfield Republican*, November 28 and 29, 1930. Ronald Epp, author of Dorr's biography, suggests that some details of Dorr's letter to Bishop must have been misreported. The newspaper indicated he hired the architect in 1873 in order to create a superintendent's house for Acadia National Park. The park was established in 1916, and Dorr's Old Farm became the superintendent's house.

215. Parke-Bernet was purchased by Sotheby's in 1964. Towner, *Elegant Auctioneers*, 401, includes a wintertime photo of Otto Bernet and Hiram Parke flanking one of Bishop's German Shepherds on the Ananda Hall terrace in Lenox. The caption reads "Mr. Bishop's three dogs."

216. *Springfield Republican*, December 31, 1930.

## Chapter 17

217. Turner, *Liberal Education of Charles Eliot Norton*, 174, cites letter of Sedgwick, May 11, 1862.

218. Ibid., 55–57.

219. Anna Shaw Curtis was one of Colonel Robert Gould Shaw's sisters. Another sister, Ellen, married General Francis Channing Barlow and built Sunnybank, which still stands on Walker Street in Lenox.

220. EW to CEN, Lenox, November 19 [1901], Norton Papers, bMS Am 1088, #7953, Houghton.

221. Teddy Wharton to CEN, July 19, 1906, Norton Papers, bMS Am 1088, #7969.1, Houghton.

222. HJ, EW, TW postcard to CEN, March 23, 1907, Norton Papers, bMS Am 1088, # 7961, Houghton.

223. Lewis and Lewis, *Letters of Edith Wharton*, 340.

## Chapter 18

224. Richard Watson Gilder's wide-ranging contacts with writers are buried in *The Letters of Richard Watson Gilder*. See also Esther Schor, *Emma Lazarus* (New York: Schocken Books, 2006).

225. EW to Richard Watson Gilder, April 1902, Beinecke, Yale.
226. EW to Richard Watson Gilder, August 19, [1902], Beinecke, Yale.
227. Dwight, *Edith Wharton*, 102.
228. Ibid., 110
229. EW to Richard Watson Gilder, July 29, 1903, Beinecke, Yale.
230. *Valley Gleaner*, July 2, 1902.
231. Ibid., April 29, 1903.
232. Ibid, July 2, 1902.

## Chapter 19

233. See George Ramsden, "Some Extracts from Edith Wharton's Writings Concerning Books and Libraries," in his catalogue, *Edith Wharton's Library*, 1999.
234. Fitzgibbon, *Through the Minefield*, 33. Constantine Fitzgibbon was Georgette Folsom's son.
235. Folsom, "Memories of Childhood," 15.
236. Fitzgibbon, *Through the Minefield*, 31.
237. Nancy Spring Wharton and George W. Folsom had a common burden. Folsom's sister, Margaret, was a patient at McLean's Hospital for over fifty years, before, during and after the decade in the 1880s when Teddy's father was an inmate.
238. Invitation list for wedding of Maud Folsom and Clark Voohrees, August 20, 1904, from Alida Fish.
239. *Springfield Republican*, July 15, 1915.
240. Charles Coolidge Haight, the original architect, was a great friend of the Folsoms. One of the seven daughters, Marguerite Folsom, married his son, Sidney.
241. Fitzgibbon, *Through the Minefield*, 33.

## Chapter 20

242. Some of the Fosters' horse and dog graves can be found at Canyon Ranch today, but the Folsoms' dog cemetery on the Yokun Street frontage of Sunnyridge became the site of a house in the 1970s.
243. Adams, *Shaggy Muses*, 186, 189.
244. Teddy Wharton to EW, August 1, 1911, from Lesage, "Home Away from Home."

245. By Edith Wharton's day, Mrs. Tappan's daughters, Ellen Dixey and Mary Tappan, owned Tanglewood.

246. Weeks, *Prominent Families of New York*, 539.

247. Patterson, *Best Families*, cites *Town and Country* of November 11, 1905.

248. *New York Times*, November 18, 1927.

249. Ibid., March 31, 1907.

250. Towner, *Elegant Auctioneers*, 354.

251. Rives, *Coaching Club*, 100, 106, 113–15.

252. Lenox Library accession books 1903–1909. The Missouri-born Winston Churchill (1871–1947) was unrelated to the British Sir Winston. In 1908, when he was popular with Lenox readers, he had recently run for governor of New Hampshire and was a member of the Cornish Art Colony, with five bestselling novels to his credit. Like Sir Winston, he was also an amateur landscape painter.

253. Annual Report of the Lenox Library Association, year ending June 30, 1922.

254. *Gleaner*, August 8 and 22, 1906.

255. Benstock, *No Gifts from Chance*, 306.

256. Mrs. Fahnstock's collection of lace is on display today at the Metropolitan Museum. Two items—a wedding veil and an 1819 sampler—from Florence Sturgis's collection are now at the Cooper Hewitt Museum, as well as Richard C. Greenleaf's exceptional collection of lace, textiles and silks.

257. *New York Times*, April 12, 1909.

258. *Berkshire Gleaner*, April 21, 1909.

259. Ibid., April 14, 1909.

260. In 1882, the Sturgises rented the Rackemanns' "lower house" (probably Nowood—now Seven Hills Inn—adjacent to their future farm) and from 1891 to 1894 Redwood on the Old Stockbridge Road, owned by Frank Sturgis's cousin Samuel Parkman Shaw.

261. *New York Times*, January 1, 1925.

## *Chapter 21*

262. EW to SN, April 8, 1906, Beinecke, Yale.

263. EW to SN, March 28, 1907, Beinecke, Yale.

264. *Daily Evening Bulletin*, Philadelphia, February 15, 1870.

265. *Valley Gleaner*, "Our Neighbors #20," January 21, 1875.

266. Kate Storrow to Eliza Cleveland, Sept 16, 1872, Cleveland/Perkins Papers, Box 7, Folder 6, NYPL

267. Judge Rockwell to Nellie [Rockwell], Sept. 22, 1871, Rockwell Papers, Lenox Library Association.

268. *Pittsfield Sun*, March 24, 1892.

269. Cabot, *Letters*, vol. 2; EC to Edmund Dwight, August 12 1895, mentions Mrs. Kuhn in Europe in "great trouble about her son."

## Chapter 22

270. EW to Dr. Francis Kinnicutt, December 26, 1904, courtesy of Amy Beckwith.

271. Both Kinnicutt and Morgan would die only months later: Morgan in Rome on March 31, 1913, and Kinnicutt in New York on May 2, 1913.

272. *Boston Medical and Surgical Journal* 168, no. 21 (May 1913): 781.

273. EW to Dr. Francis Kinnicutt, December 26, 1904, courtesy of Amy Beckwith.

274. EW to Bernard Berenson, October 3, 1910, as cited in Lewis, *Edith Wharton*, 222.

275. *New York Times*, November 18, 1891.

276. Hoy, *Chasing Dirt*, 78–79.

277. Kinnicutt, "American Woman in Politics," *Century Magazine*, December 1894, 302–4.

278. In 1906, Kinnicutt was a leader in the New York Association Opposed to the Extension of Suffrage to Women. Helena De Kay Gilder was one of the vice presidents. Others active in the cause were Mrs. Andrew Carnegie and Jeannette Gilder, sister of the *Century* editor.

279. *New York Herald*, February 4, 1896.

280. *First Annual Report of the State Charities Aid Association of the State Lunacy Commission*, December 1, 1893, 65–66.

281. Kinnicutt, "Kaiserwerth and Its Founder," *Century Magazine*, November 1895, 84–79.

282. Martin, *Life of Joseph Hodges Choate*, 203.

283. TR to Mrs. E. Kinnicutt, June 28, 1901, http://pds.lib.harvard.edu/pds/view/20356299?n=45.

284. Sandberg, *Whitney Father, Whitney Heiress*, 306.

285. Stedman, *Medical Record*, September 13, 1913, 1.

286. *New York Times*, May 3, 1913.

287. Dr. Francis Kinnicutt to EW as cited in Lewis, *Edith Wharton*, 268.
288. Ibid., 316.

## *Chapter 23*

289. Harriet Burden was apparently undertaking a history of the Village Improvement Society around 1910. It has never been found.
290. Hoy, *Chasing Dirt*, 66. According to Hoy, Lenox's sewer system of 1876 was the first of its kind in the United States. It was soon applied on a large scale in Memphis in 1879 after a yellow fever epidemic.
291. *New York Tribune*, October 26, 1921.
292. Mallary, *Lenox*, 291.
293. Ibid., 286.
294. *Springfield Republican*, July 16, 1909. Albert and Mary Shattuck were renting The Mount that summer from Edith and Teddy Wharton and purchased it from them in 1911.
295. *New York Times*, June 16, 1912. Glassmaker Andrew J. Servin had been active in the Village Improvement Society.
296. Nancy Wharton to Eliza Cleveland, February 14, 1858, Cleveland/Perkins Papers, Box 7, Folder 3, NYPL.
297. Nancy Wharton to Eliza Cleveland, March 24, 1859, Cleveland/Perkins Papers, Box 7, Folder 4, NYPL.
298. Eliza Cleveland to Grace Norton, January 31, 1869. Sarah Perkins Cleveland Papers, MS Am 1088.10, Houghton.
299. Dykstra, *Clover Adams*, 55.
300. *Valley Gleaner*, October 7, 1896.
301. *Berkshire Gleaner*, July 24, 1907.
302. *New York Times*, June 25, 1916.
303. Nannie Wharton apparently spent some time in Washington, D.C. Lenox lawyer Tom Post's address book lists her at 1908 Q Street.
304. The site of the old William Schermerhorn house is now the Lenox Library park.
305. *Berkshire Gleaner*, October 15, 1902.
306. Nancy C. Wharton to Harry [Jones], Pau, December 17, 1909, in Lesage, "Home Away from Home."
307. Lewis and Lewis, *Letters*, 194.
308. Nancy C. Wharton to Edith Wharton, Pau, December 21, 1909, in Lesage, "Home Away from Home."

309. On December 4, 1913, Waddy Rogers disappeared in Paris as reported in the *New York Times*. He was found, but the next three years of his life before his death were spent in and out of sanatoriums.
310. Lawrence, *Memoirs of a Happy Life*, 321–29.
311. OC to SBC, September 25, 1918, Codman Papers, HNE.

## Chapter 24

312. It is hard to date this vivid anecdote told to Judy Conklin Peters by the longtime Lenox fire chief Oscar R. Hutchinson, an assistant at Morse's Garage. A 1905 Williston Academy graduate, Hutchinson's yearbook quote next to his picture was appropriately "And reek'd of gasoline," indicating that even as a teenager he may have worked for Morse. Morse's Garage was behind the old town hall building on the corner of Church and Housatonic Streets.
313. Julia Peters told the playground story from her school days. The author's mother, Louisa Ludlow Brooke, and Josephine Pignatelli both remembered Teddy as a hunched figure, wrapped in blankets, sitting on the upstairs porch.
314. EW to Robert Grant, as cited in Lewis and Lewis, *Letters*, footnote, 515.

# Bibliography

## Books and Periodicals

Adams, Maureen. *Shaggy Muses*. Chicago: University of Chicago Press, 2007.

Alsop, Robert Chapin. *34 Kensington Square*. New York: Vantage Press, 2012.

Barnes, James. *From Then Till Now*. New York: D. Appleton-Century, 1934.

Benstock, Shari. *No Gifts from Chance: A Biography of Edith Wharton*. Austin: University of Texas Press, 2004.

Berle, Beatrice Bishop. *A Life in Two Worlds*. New York: Walker, 1983.

Cabot, Elizabeth Dwight. *Letters of Elizabeth Cabot*. Boston: privately printed, 1905.

Chague, Jan. *History of Lenox Furnace and Lenox Dale*. Lenox, MA: privately printed, 2015.

Chapin, Adèle Le Bourgeois. *Their Trackless Way*. New York: Henry Holt, 1932.

Cheney, Dorothy. *The Descent in America of the Founders of the Cheney Silk Industry in Manchester, Connecticut*. Norwalk: Connecticut Printers Inc., 1930.

Child, Francis James. *A Scholar's Letters to a Young Lady*. Boston: Atlantic Monthly, 1920.

Crane, Laura Dent. *The Automobile Girls in the Berkshires*. Philadelphia: Henry Altemus Company, 1910.

Dwight, Eleanor. *Edith Wharton: An Extraordinary Life*. New York: Harper Collins, 1994.

Dykstra, Natalie. *Clover Adams: A Gilded and Heartbreaking Life*. Boston: Houghton Mifflin Harcourt, 2012.

Epp, Ronald. *Creating Acadia: The Biography of George Bucknam Dorr*. Bar Harbor, ME: Friends of Acadia, 2016.

Fitzgibbon, Constantine. *Through the Minefield*. New York: W.W. Norton, 1967.

Foreman, John, and Robbe Pierce Stimson. *The Vanderbilts and the Gilded Age*. New York: St. Martin's, 1991.

French, Mrs. Daniel Chester. *Memories of a Sculptor's Wife*. Boston: Houghton Mifflin, 1928.

Gilder, Cornelia Brooke, and Julia Conklin Peters. *Hawthorne's Lenox*. Charleston, SC: The History Press, 2008.

Gilder, Cornelia Brooke, and Richard S. Jackson. *The Lenox Club Sesquicentennial History*. Lenox, MA: Lenox Club, 2014.

Gilder, Rosamond, ed. *The Letters of Richard Watson Gilder*. Boston: Houghton Mifflin, 1916.

Goldman-Price, Irene, ed. *My Dear Governess: The Letters of Edith Wharton to Anna Bahlman*. New Haven, CT: Yale University Press, 2012.

Gunter, Susan E., and H. Jobestevan. *Dearly Beloved Friends: Henry James's Letters to Younger Men*. Ann Arbor: University of Michigan Press, 2004.

Harrison, Mrs. Burton. *Recollections Grave and Gay*. New York: Charles Scribner, 1911.

Hicks, Paul DeForest. *John E. Parsons: An Eminent New Yorker in the Gilded Age*. New York: Prospecta Press, 2016.

Howard, Esmé. *Theatre of Life 1905–1935*. London: Hodder and Stroughton Ltd., 1936.

Howe, M.A. DeWolfe, ed. *The Later Years of the Saturday Club*. Boston: Houghton Miflin, 1927.

Hoy, Suellen. *Chasing Dirt: The American Pursuit of Cleanliness*. New York: Oxford University Press, 1995.

Jackson, Richard S., and Cornelia Brooke Gilder. *Houses of the Berkshires*. New York: Acanthus Press, 2011. Second edition.

Kemble, Frances Anne. *Records of a Later Life*. New York: Henry Holt, 1882.

Lawrence, William. *Memoirs of a Happy Life*. Boston: Houghton Mifflin, 1926.

Lee, Hermione. *Edith Wharton*. New York: Alfred A. Knopf, 2007.

Lesage, Claudine. "A Home Away from Home: Edith Wharton's Life in France." Unpublished manuscript, 2013. Publication forthcoming.

Lewis, R.W.B. *Edith Wharton: A Biography*. New York: Harper & Row, 1975.

Lewis, R.W.B., and Nancy Lewis, eds. *The Letters of Edith Wharton*. New York: Simon and Schuster, 1988.

Lubbock, Percy. *Portrait of Edith Wharton*. New York: D. Appleton-Century, 1947.

Mallary, Reverend DeWitt. *Lenox and the Berkshire Highlands*. New York: G.P. Putnam's Sons, 1902.

Marshall, Scott. "Whatever Happened to Teddy Wharton?" *Vista from the Mount* (Winter 1987–88).

Marshall, Scott, and Jack Waite. *The Mount: Home of Edith Wharton*. Lenox, MA: Edith Wharton Restoration Inc., 1997.

Martin, Edward Sanford. *The Life of Joseph Hodges Choate*. New York: Charles Scribner's, 1920.

Nevins, Allan, ed. *The Diary of George Templeton Strong*. 4 vols. New York: Macmillan, 1952.

Nunley, Richard. *The Berkshire Reader: Writings from New England's Secluded Paradise*. Stockbridge, MA: Berkshire House Publishers, 1992.

Patterson, John E. *The Best Families: Town and Country Social Directory 1846–1996*. New York: Harry Abrams, 1996.

Powers, Lyall H., ed. *Henry James and Edith Wharton: Letters: 1900–1915*. New York: Charles Scribner's, 1990.

Ramsden, George. *Edith Wharton's Library*. Settrington, UK: Stone Trough Books, 1999.

Reider, William. *A Charmed Couple: The Art and Life of Walter and Matilda Gay*. New York: Harry Abrams, 2000.

Rives, Reginald. *The Coaching Club: Its History, Records and Activities*. New York: privately printed, 1935.

Sandberg, W.A. *Whitney Father, Whitney Heiress*. New York: Scribner's, 1980.

Speert, Harold. *The Sloane Hospital Chronicle*. Philadelphia, PA: F.A. Davis, 1963.

Towner, Wesley. *The Elegant Auctioneers*. New York: Hill & Wang, 1970.

Tucker, George H. *A History of Lenox*. Lenox, MA: Lenox Library Association, 1992.

Tuckerman, Bayard. *Notes on the Tuckerman Family of Massachusetts and Some Allied Families*. Boston: Privately printed, 1914.

Tuckerman, Emily. "Records of an Interesting Life." Unpublished manuscript, circa 1923.

Turner, James. *The Liberal Education of Charles Eliot Norton*. Baltimore, MD: Johns Hopkins University, 1999.

Weeks, Lyman Horace, ed. *Prominent Families of New York*. Revised edition. New York: Historical Company, 1897.

# Archival Sources

Boston Athenæum, Boston, MA.
Boston Children's Hospital Archives, Boston, MA.
Cleveland-Perkins Family Papers. Manuscripts and Archives. The New York Public Library. Astor, Lenox and Tilden Foundations.
Codman Family Papers, Historic New England.
Durand Family Papers, School of Oriental and Asian Studies, University of London.
Frederick Law Olmsted Papers, Library of Congress.
Freer Gallery of Art, Smithsonian Institution, Washington, D.C.
Georgette Folsom, "Memories of Childhood," manuscript.
Gilder Papers, Lilly Library, Indiana University, Bloomington, Indiana.
Historical Collection of the Stockbridge Library.
John O. Sargent Papers. Massachusetts Historical Society.
Lenox Garden Club Annual Reports.
Lenox Library Association Annual Reports.
Letters to Charles Eliot Norton, Houghton Library, Harvard University.
Olmsted Archives, Frederick Law Olmsted National Historic Site, National Park Service.
Porter-Phelps-Huntington Family Papers, on deposit at Amherst College Archives and Special Collections, Amherst, MA.
Private collections of Amy Beckwith, Jane Foster, Johnston L. Evans.
Sarah Perkins Cleveland letters to Catherine Eliot Norton and Grace Norton, Houghton Library, Harvard University.
Wharton (Edith) Collection, Yale Collection of American Literature, Beinecke Library, Yale University.
William B. Osgood Field Papers. Manuscripts and Archives. The New York Public Library. Astor, Lenox and Tilden Foundations.

# Articles and Pamphlets

Baldwin, Simeon. "The Natural Right to a Natural Death." *Journal of Social Science* 37 (1899): 1–17.
A Berkshire Farmer [John O. Sargent pseud.]. "Lucre and Luxury. A Tract for Our Times: 1887." 15 page pamphlet.
Horne, Philip. "'Reinstated': James in Roosevelt's Washington." *The Cambridge Quarterly* 37, no. 1 (March 2008).

Kinnicutt, Eleanora. "The American Woman in Politics." *Century*, December 1894.

————. "Kaiserwerth and Its Founder." *Century*, Nov. 1895.

Marshall, Scott. "Edith Wharton, Kate Spencer, and Ethan Frome." *Edith Wharton Review*, Spring 1993.

Peabody, Robert S. "Georgian Homes of New England." *American Architect and Building News*, October 1877, February 1878.

Sherwood, Mrs. "Certain Patriotic Exiles." *The Smart Set: A Magazine of Cleverness*, January 1901.

Wilcox, Rick. "The Fascinating Story of Mary Gray and Barnabas Bidwell." *Bidwell House Museum Newsletter*, Spring 2014.

## Newspapers and Periodicals

*Berkshire Eagle*
*Berkshire Resort Topics*
*Country Life in America*
*Gleaner and Advocate, Valley Gleaner, Berkshire Gleaner*
*Horseless Era*
*New York Herald*
*New York Times*
*New York Tribune*
*Pittsfield Sun*
*Roanoke Beacon*
*Springfield Republican*
*Washington Post*

# Index

# About the Author

A lifelong Berkshire resident, Cornelia Brooke Gilder was educated at Vassar College and Cambridge University. She grew up in Lenox and has lived in Tyringham since her marriage to George Gilder forty years ago. Among her books on Berkshire history are two coauthored with Richard S. Jackson Jr.: *Houses of the Berkshires* (Acanthus Press, 2006, revised edition 2011) and *The Lenox Club: A Sesquicentennial History* (2014). She also wrote *Hawthorne's Lenox* (with Julia Conklin Peters), published by The History Press in 2008.